P9-DGF-717

A PLUME BOOK

100 DIAGRAMS THAT CHANGED THE WORLD

SCOTT CHRISTIANSON is a prize-winning author and investigative reporter who also works in documentary film. He lives in Great Barrington, Massachusetts.

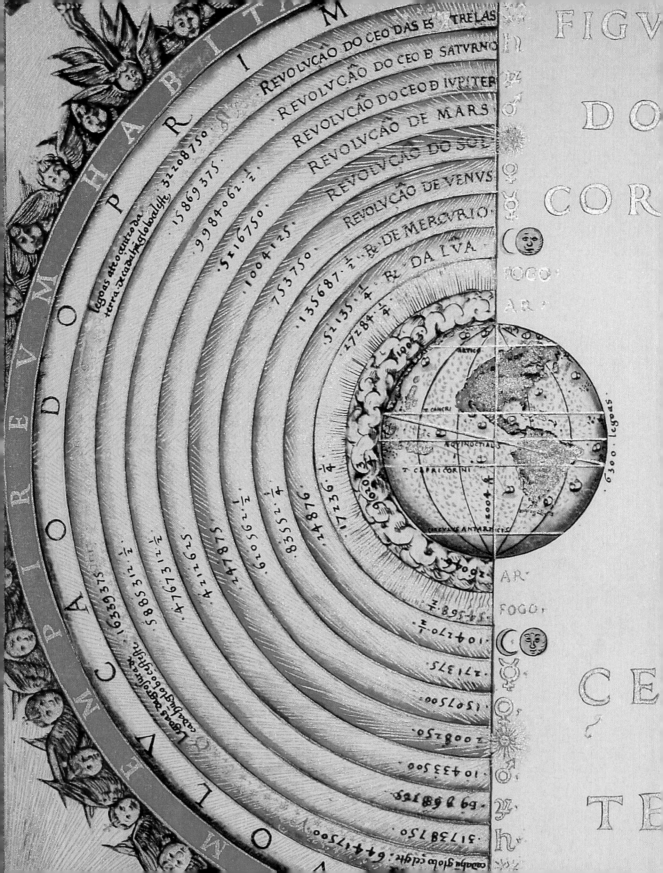

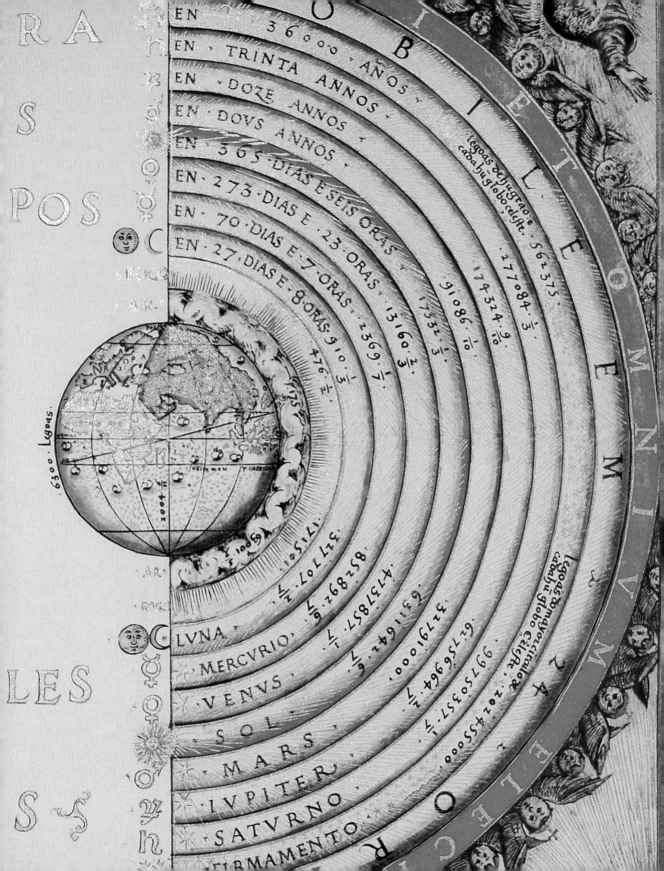

PLUME
Published by the Penguin Group
Penguin Group (USA) Inc., 375 Hudson Street, New York, New York 10014, U.S.A.
Penguin Group (Canada), 90 Eglinton Avenue East, Suite 700, Toronto, Ontario, Canada
M4P 2Y3 (a division of Pearson Penguin Canada Inc.)
Penguin Books Ltd., 80 Strand, London WC2R 0RL, England
Penguin Ireland, 25 St. Stephen's Green, Dublin 2, Ireland (a division of Penguin Books Ltd.)
Penguin Group (Australia), 707 Collins Street, Melbourne, Victoria 3008, Australia
(a division of Pearson Australia Group Pty. Ltd.)
Penguin Books India Pvt. Ltd., 11 Community Centre,
Panchsheel Park, New Delhi – 110 017, India
Penguin Group (NZ), 67 Apollo Drive, Rosedale, Auckland 0632, New Zealand
(a division of Pearson New Zealand Ltd.)
Penguin Books, Rosebank Office Park, 181 Jan Smuts Avenue,
Parktown North 2193, South Africa
Penguin China, B7 Jaiming Center, 27 East Third Ring Road North,
Chaoyang District, Beijing 100020, China

Penguin Books Ltd., Registered Offices: 80 Strand, London WC2R 0RL, England

First published by Plume, a member of Penguin Group (USA) Inc. Produced
by Salamander Books, an imprint of Anova Books Company Ltd.,
10 Southcombe Street, London W14 0RA, U.K.

First Printing, November 2012
10 9 8 7 6 5 4 3 2 1

ISBN 978-0-452-29877-4
CIP data available

Printed in the United States of America

100
diagrams
that changed the world

From the Earliest Cave Paintings
to the Innovation of the iPod

Scott Christianson

A PLUME BOOK

For Kenny Umina (1942–2011) and Sawyer Whitney

Contents

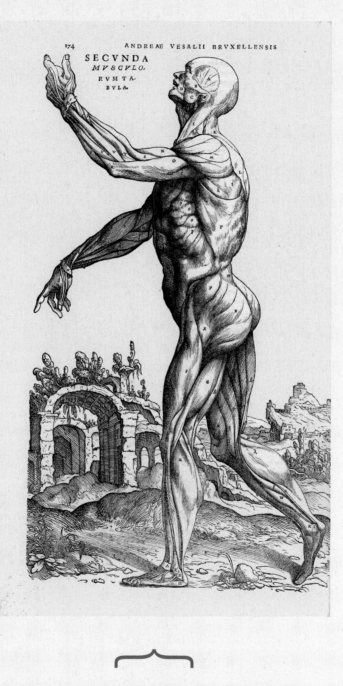

ABOVE: *On the Structure of the Human Body, Andreas Vesalius (page 84).*

diagram

From the Latin *diagramma* (figure) from Greek, a figure worked out by lines, plan, from *diagraphein*, from *graphein* to write.
First known use of the word: 1619.

1. A plan, a sketch, drawing, or outline, not necessarily representational, designed to demonstrate or explain something or clarify the relationship existing between the parts of the whole.
2. In mathematics, a graphic representation of an algebraic or geometric relationship. A chart or graph.
3. A drawing or plan that outlines and explains the parts, operation, etc. of something: a diagram of an engine.

Introduction

It all begins with a diagram. Everything from family trees to seating arrangements at a wedding to bank heists start with a roughly sketched plan.

In architecture, it is the grand design and floor plan; in mathematics, it is the graphic representation of an algebraic or geometric relationship; in physics, diagrams may serve as the tool to aid the scientist in making enormously complex calculations. Diagrams are all around us and we use them constantly. We turn on our television set and see charts and graphs of the latest economic reports or opinion polls, and switch channels to find the weather map. We travel across the city by following pictogram signs or a color-coded subway map. In the workplace, we illustrate our office memoranda with flowcharts or line graphs. Meanwhile, our students are diagramming sentences or equations, or studying the periodic table and maps of the solar system. Consumers purchase a product and consult an assembly guide with an exploded-view diagram to help them figure out how to operate it.

Over time we have become so accustomed to diagrams in our life, we hardly notice them. Human beings have used forms of them since the Stone Age. Where would we be without them?

This book tells (and shows) the story of 100 diagrams that changed the world. The saga spans 32,000 years, ranging from the daubed Stone Age paintings discovered on cave walls in Chauvet, France to the futuristic design for the sleek and elegant pocket iPod media player that Apple introduced in 2001.

The diagrams featured here include incredibly intricate figures that were carved into stone to convey some essential meaning; immense and mysterious geoglyphs that were cut into the Peruvian desert; historic maps of various sorts; innovative drawings made by great artists; classical architectural plans; original diagrams of earth-shaking scientific experiments; neat patent

drawings for several great inventions that transformed the world; revolutionary navigational tools that led to important discoveries; precedent-shattering charts of the universe and records of great astronomical observations; iconic images that brought important political changes or were used to facilitate conquest or worship (or both); diagrams of the wonders of the human body; schematic

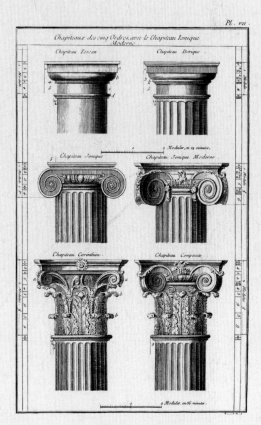

*ABOVE: **The classical orders of architecture: Doric, Ionic, and Corinthian (page 32).***

representations of developing theories of evolution or psychology; and new graphic tools for displaying statistics, to name a few.

Many of their creators were famous figures: Euclid, Leonardo da Vinci, Galileo Gailiei, Charles Darwin, Florence Nightingale, Sigmund Freud, Alexander Graham Bell, Thomas Edison, Albert Einstein, and James Watson. Some are lesser known: Reinerus Gemma-Frisius, John Harington, Robert Hooke, William Playfair, and John Logie Baird, for example. And many are unknown: the unidentified, anonymous artists, scribes, navigators, stone carvers, or other workers who left behind an extraordinary diagram that somehow changed history.

Each story describes events that occurred in the context of a specific time and place—ancient Egypt in the time of the Pharaohs, Alexandria of ancient Greece in the second or third century BC, seventh-century China,

eleventh-century Persia, fifteenth-century Renaissance Padua, sixteenth-century Flanders, eighteenth-century London, or Silicon Valley, California in the late twentieth-century—oftentimes when those places were enjoying some sort of cultural heyday. (And indeed, in some instances perhaps the heyday may have been driven by these diagrams, not the other way around.)

Diagrams may be, as one scholar (Bert S. Hall) put it, "simplified figures, caricatures in a way, intended to convey essential meaning." But that does not mean these particular ones came easily or in isolation. It appears that no great diagram is solely authored by its creator. Most of those described here were the culmination of centuries of accumulated knowledge. Most arose from collaboration (and oftentimes in competition) with others. Each was a product and a reflection of its unique cultural, historical and political environment. Each represented specific preoccupations, interests, and stakeholders. The Micronesian stick chart enabled thousands of islanders, over hundreds of years, to maintain social organization and networks beyond the tiny atolls that sustained limited numbers of people. Ancient calendars, stone monuments and celestial clocks tracked the cycles of days, seasons, and observable universe, encompassing science with religious cosmology and ritual. Trees, circle diagrams, graphs and charts organized knowledge itself, providing frameworks for visualizing relationships that led to paradigmatic leaps in many disciplines.

The great diagrams depicted in the book form the basis for many fields—art, astronomy, cartography, chemistry, mathematics, engineering, history, communications, particle physics, and space travel among them. More often than not, however, their creators—mostly known, but many lost to time—were polymaths who are creating new technologies or breakthroughs by drawing from a potent combination of disciplines. By applying trigonometric methods to the heavens, or harnessing the movement of the sun and the planets to keep time, they were forging powerful new tools; their diagrams were imbued with synergy.

Creating science or art for its own sake was not what motivated the great thinkers and doers depicted here. There were higher and more practical purposes involved. As Albert Einstein remarked in an address at the California Institute of Technology in 1931: "Concern

for man and his fate must always form the chief interest of all technical endeavors, concern for the great unsolved problems of the organization of labor and the distribution of goods—in order that the creations of our mind shall be a blessing and not a curse to mankind. Never forget this in the midst of your diagrams and equations."

Ironically, some of the great discoveries and inventions diagrammed in the book were not appreciated in their own time; it may have taken decades or even centuries for them to take hold. (The flush toilet offers one example.) Some had their life cut short by the sudden end of their culture. Ancient Egyptian civilization, for example, was nearly eradicated by the suppression of its history; it was not until centuries later, when the Rosetta Stone allowed for the deciphering of hieroglyphics, that parts of that history could be rediscovered. The Aztec calendar lay hidden for four hundred years as well. Some diagrams (such as Galileo's drawing of the telescope) were quickly adopted by seafarers, astronomers, military leaders and others, and had an almost immediate effect on the world in a wide variety of ways; whereas the greatest impact of the Chauvet cave paintings would not occur until more than 30,000 years after their creation, when their rediscovery suddenly sparked new insights about prehistoric humans. And in other instances, the diagram came after the discovery, not before. (For example, the Marshall Islanders conducted their voyages and then constructed their navigational stick charts.)

The diagrams featured here were the end result of deep and sustained observation, experimentation, reflection, research and artistic practice that recognized—often intuitively—the interdependency of the intellectual and creative. Perhaps such urges and abilities have always existed in the human race. The proof goes back very far. Picasso the great inventor of abstract painting did not live to see the cave paintings of Chauvet, but after viewing those at Lascaux in 1940 he admitted to being awestruck and remarked, disappointedly, "We have invented nothing."

In the end, these diagrams are the essence of abstract thought, representing fundamentally what it means to be human.

ABOVE: *René Descartes' Movement of Objects from Principles of Philosophy (page 100).*

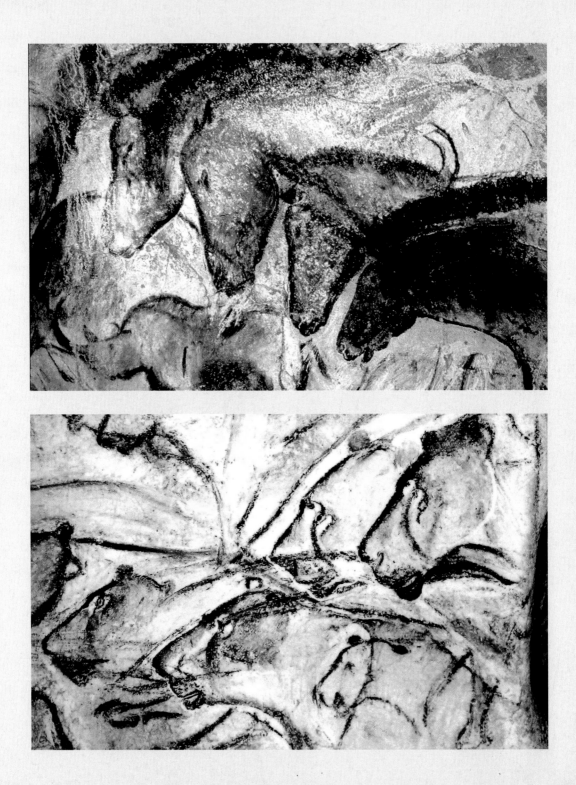

Chauvet Cave Drawings

The recently discovered cave drawings of Chauvet, France are the earliest known examples of Paleolithic art—nearly twice as old as those found at Lascaux and other sites. Yet they display a level of artistic mastery that has boggled the minds of 21st-century viewers.

On December 18, 1994, three French spelunkers were exploring the limestone cliffs above the former bed of the Ardèsche River in south-central France when they discovered a large cave. Its floor was littered with fossilized animal bones and human and animal footprints. The chamber's walls were decorated with detailed drawings of wild species that had long been extinct in that region: African lions, bison, rhinos, megaceros, ibex, bear, and other large creatures. These representational images provide an unparalleled window into human artistic expression during the Paleolithic age, and are masterful expressions of movement, drama, and struggle. Immediately after the discovery, scientists began studying the site using the most sophisticated digital technology. They were able to determine that the artists used charcoal and ochre, mixed with spittle and fat, to create the paintings. In addition to the breathtaking array of paintings, the artists also utilized other techniques such as scrapings, stumping (the creation of a series of dots by means of stamps of hide or other material), and hand tracings.

Based on more than eighty radiocarbon dating tests, the cave appears to have been used by humans during two distinct periods. Most of the artwork dates to the Aurignacian era (30,000 to 32,000 years ago), making it twice as old as the Lascaux cave paintings discovered near Montignac, France, in 1940. Other markings, including the bare footprints of a pre-adolescent boy, seem to have been created 25,000 to 27,000 years ago in the Gravettian occupation, making them the earliest known markings left by a human and indicating that the cave was visited over a very long span. (The boy also seems to have been accompanied by a dog or wolf.) Analysis of mitochondrial DNA taken from bear remains found at the site has also pointed back more than 30,000 years. Torch swipe marks found throughout the cave have provided additional clues about humans who visited the area, possibly including some of the original artists.

Nearly all of the subjects shown involve animals that were hunted in that vicinity. As is typical of Paleolithic art, there are no humans depicted. One diagram, however, appears to abstractly represent a woman's legs and genitals, possibly suggesting a fertility symbol. Other abstract markings, including groups of dots or butterfly-shaped images, may indicate a ritual or shamanistic aspect to the drawings. Experts believe the cave diagrams may have served to initiate young males into hunting and were intended to acquaint them with some of the game they would encounter. What is certain, is that the Chauvet artworks represent the vast symbolic capacity and potential possessed by our early fully human ancestors.

OPPOSITE: *Horses, rhinos, and lions are just a few of the wild animals depicted at Chauvet. Experts believe that the cave drawings may have served to initiate young males into hunting by showing them what game they might encounter.*

Triple Spiral

Five hundred years before the building of Egypt's Great Pyramid of Giza, Neolithic people in prehistoric Ireland constructed an immense passage tomb with a recurring symbol engraved on its stones: the triple spiral, which has endured as the most iconic carved image in megalithic art.

Constructed in about 3200 BC, the huge stone and turf mound containing a 60 ft (18 m) long passage leading to a cruciform (cross-shaped) chamber that stood 20 ft (6 m) high, was forgotten over time and not rediscovered until the end of the 17th century. In 1699, Edward Lhuyd (1660–1709) came to Ireland from Oxford as part of an archaeological study and was astounded by what he saw. His famous account and drawings of the place he called Newgrange established the site as both ancient and mysterious.

Between 1962 and 1975, a team of Irish archaeologists conducted major excavation and restoration of Newgrange and another nearby passage tomb, Dowth, and 37 smaller satellite tombs which form the Brú na Bóinne complex in County Meath. The Newgrange mound measures 340 ft (103.6 m) across and 40 ft (12.2 m) high, and it is retained within a circle of 97 large curbstones topped by a high inward-leaning wall of white quartz and granite. The recesses in its cruciform chamber hold large stone basins thought to have held the ashes of persons unknown. Thus far the remains of only five individuals have been found. However, Newgrange served as more than a burial tomb. Like Stonehenge, it was designed as a giant calendar that sacralized and tracked the movements of the sun.

The triple spiral carving occurs on the tomb's entrance slab, along the passage, and again inside the chamber. While the deep meanings of the symbol remain unknown, the structure of Newgrange contains a clue: at the winter solstice sunrise, the sun illuminates the narrow passageway and directly strikes the raised triple spiral at its end. The dominant motif of this ingenious "sundial" must in some way relate to the sun's rebirth and thus the ritual renewal of the universe. The triple spiral passed into Celtic culture as an expression of a sacred cosmology which upheld the number three as primordial to the integration and renewal of the seasons and cycles, and embodying the male and female qualities of the pre-Christian gods.

Today the Newgrange site is the most visited archaeological monument in Ireland. Newgrange has changed history by becoming recognized as one of the world's oldest buildings and for containing what is probably the oldest calendar clock. Scholars have become more aware that its Stone Age creators were very competent in a wide range of fields including geology, engineering, architecture, art and astronomy. The immense construct forms a carefully planned diagram of sorts, adorned with the iconic triple spiral; together they offer clues to understanding the ancient pre-Celtic complex view of life.

OPPOSITE: *The triple spiral or "triskele" is a recurrent theme in Celtic art. Due to the dramatic solstice illumination of the tomb at Newgrange, it is assumed that the entry stone's spiral carvings relate to a primitive solar cult.*

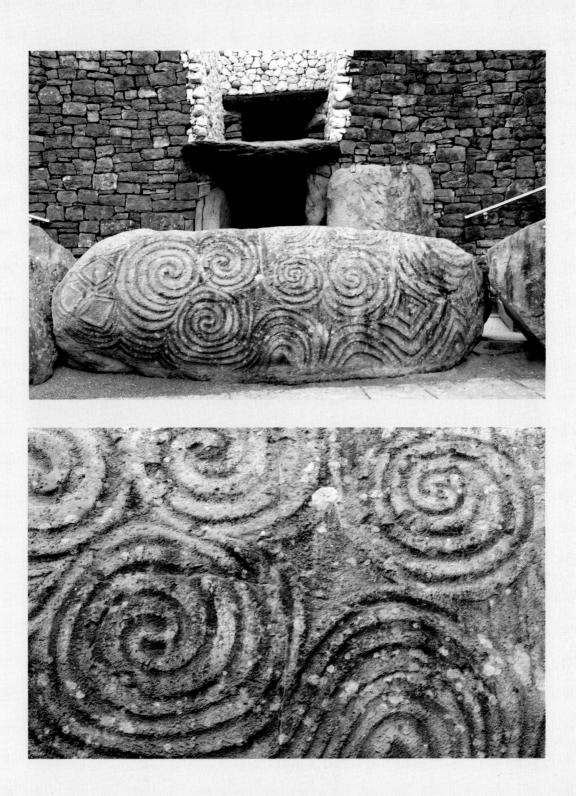

Marshall Islands Stick Navigation Charts

As many as 4,000 years ago, some human beings left Asia and voyaged in canoes over the vast Pacific Ocean to the islands of Micronesia. Using indigenous knowledge of their maritime environment, they developed an ingenious cartographic system that enabled them to navigate among their islands.

The ancient inhabitants of the tiny low-lying atolls of eastern Micronesia known as the Marshall Islands lived amidst the vast and ever-changing Pacific that was devoid of landmarks and fraught with danger. Their scattered atolls were so close to the water that they were visible from a canoe only a few miles away. To travel between islands, the Marshallese needed to be master navigators who understood the movement of the sea, in conjunction with the trade winds, stars, birds and variable colors of water.

The islanders ingeniously fashioned their own navigational tools from the same limited resources that comprised all of their material culture. The charts were designed from pieces of the narrow center rib of a palm leaf, cowrie shells (representing specific atolls), and a few curved sticks of pandanus lashed together with strands of coconut fiber. These pieces were arranged to form distinctive geometric patterns that depicted the curve, refraction, and intersection of waves when they hit the islands. The navigators guided their seafaring canoes by lying on the vessel's floor and feeling the movement of the swells, watching the sky and following other natural signs. Upon their return, they made their own stick charts.

The Marshallese passed along their wave-piloting knowledge via a rich oral tradition involving songs, chants, poems and rhymes that utilized these stick charts as instructional and memory aids. They were not meant to be taken on voyages, but were mnemonic devices to train prospective navigators on land. Three general types of stick charts were used: *rebbelib*, a small-scale chart for major island groups; *meddo*, a larger-scale chart displaying one or two island chains in greater detail; and *mattang*, an abstract chart for instruction. Only a few of the best learners were designated as master navigators. These chosen ones were traditionally rivals and attached to various warring chiefs who patronized them. Maritime knowledge was jealously guarded and interpreting the charts depended on extended instruction from the individual navigators who created them based on their own seafaring experience.

The stick navigational charts were part of a complex body of knowledge—and the social system—that enabled the Marshall Islanders to survive on isolated islands for thousands of years. Since World War II, outboard motors, navigational equipment, and telephones have supplanted canoes and navigational charts as the means by which the islanders communicate and travel.

OPPOSITE: This 27 x 27 in (68.6 x 68.6 cm) chart is made of sticks and shells that have been tied together with palm fibers. The curved sticks represent ocean swells and currents; the shells are islands in the neighborhood of Jaluit Atoll in the Marshall Islands.

Babylonian "Pythagoras Theorem"

Diagrams that were engraved on stones for mathematical calculation purposes show that Babylonian scribes utilized a method of calculating accurate estimates of square roots over a thousand years before Pythagoras. The artifacts indicate that the Mesopotamians possessed a more sophisticated understanding and practical usage of complex mathematics than many Western historians have assumed.

The sixth century BC Greek mathematician Pythagoras has long been considered the world's first pure mathematician, in part because of his brilliant geometrical theorems. His most famous equation states: The square of the hypotenuse (the longest side) of a right triangle equals the sum of the other two sides. Reflecting a widely held belief, the famous Polish physicist and author, Jacob Bronowski (1908–74) once called the theorem of Pythagoras "the most important single theorem in the whole of mathematics."

Yet the recent analysis of some 20th-century archaeological finds has called into question the long-held belief that Pythagoras was the first to offer proof for his theorem. Hundreds of clay tablets containing mathematical equations from ancient Mesopotamia were discovered in the area now known as Iraq. Most of the recovered artifacts date from 1900 to 1700 BC, and cover topics that include fractions, algebra, multiplication tables, and quadratic and cubic equations.

The Babylonians' mathematical system relied on scribes, who were young wealthy men formally trained in reading, writing, and mathematics. Some scribes worked in accounting, building-project planning, and at other professions in which skills in mathematics were considered essential. They used an abstract form of writing consisting of cuneiform (i.e. wedge-shaped) symbols, which they inscribed by means of a stylus on wet clay tablets, which were later baked in the hot sun. However, some brilliant minds before them must have come up with the mathematical formula; the scribes were simply using such established knowledge in their work. Based on recent study of such tablets, experts now believe that the ancient Babylonians were much more advanced in mathematics than modern scholars had assumed. Some scholars contend that such diagrams show that the Babylonians utilized methods for accurately estimating square roots and knew a version of what is now called the Pythagoras theorem.

OPPOSITE: This fired clay tablet is one of the few that contains a purely geometrical diagram. The mathematical exercise it contains shows that Babylonian scribes were able to calculate square roots.

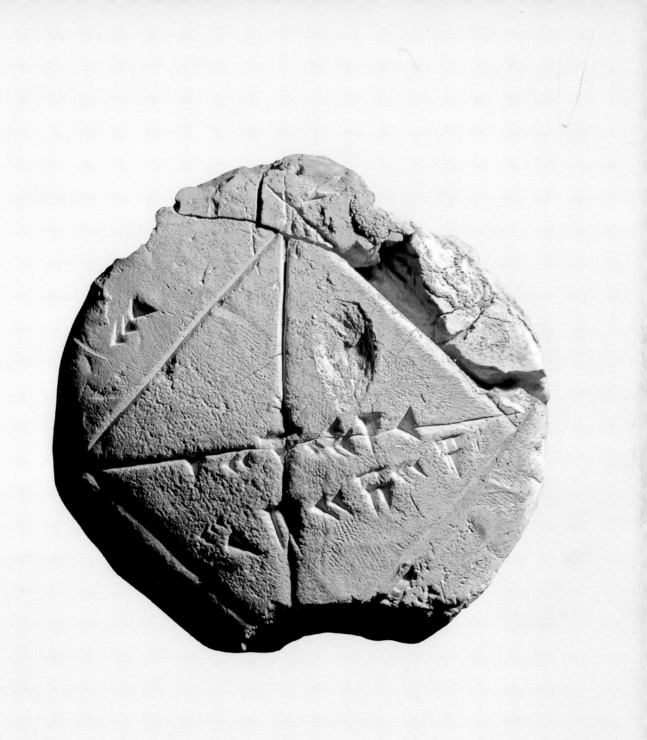

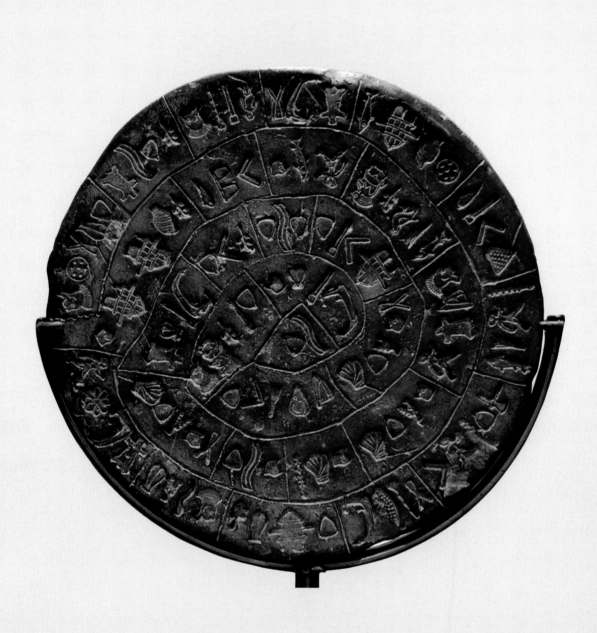

Phaistos Disc

A clay disc that is inscribed with hieroglyphic-like symbols and dated by some to the second millennium BC continues to baffle experts. Some question its authenticity; others think it may be the earliest typewritten work.

On July 3, 1908 an Italian archaeologist, Luigi Pernier (1874–1937) was conducting an excavation of a former basement "temple depository" of the first Minoan palace of Phaistos near Hagia Triada on the south coast of Crete. Part of the structure appeared to have collapsed in a volcano-spurred earthquake that occurred in about 1628 BC. Pernier later reported he had recovered from the mix of rubble and plaster dust a remarkably intact "dish," about 5.9 in (15 cm) in diameter and uniformly just over 0.4 in (1 cm) thick. Made of fired clay, the circular disc was stamped on both sides with many symbols in a spiral pattern. Pernier logged the object and took it to a laboratory for examination, setting off a mystery that continues to this day.

The Phaistos Disc features 241 tokens, comprising 45 different glyphs. Most of the glyphs represent clearly recognizable every-day things such as a human figure, a fish, various birds, insects, plants, a boat, a shield, and other objects common to that society. Most experts believe the symbols have some sort of hidden meaning, theorizing that its message may have been a geometric theorem, a board game, a prayer, or a mythological story. Some linguists speculate that the pictograms may have been used phonetically, in a manner similar to Egyptian hieroglyphics. However, no other samples of the script have been found and efforts to decipher the text have proved unsuccessful.

The glyphs were apparently made by pressing pre-formed hieroglyphic-type "seals" into a disc of soft clay in a clockwise sequence spiraling towards the disc's center. Then it was baked at high temperature. Some experts contend that the employment of reusable characters to make and reproduce a body of text means that the Phaistos Disc represents the earliest known example of ancient movable type printing.

The object remains on display at the archaeological museum of Heraklion in Crete, Greece.

> OPPOSITE: *The stamps that created the symbols on the Phaistos Disc may represent the earliest recorded instance of printing anywhere in the world. The disc is unique because no other examples of the pictographic language it employs have been found.*

Egyptian Book of the Dead

Ancient Egypt's super-elite depicted their sacred beliefs about death and the afterlife in colorful images painted on papyrus rolls that served a variety of funerary purposes. In the mid-19th century, a German scholar published a selection of such texts from the Ptolemaic era as *Book of the Dead*, introducing elements that are now an integral part of modern Egyptology.

Ancient Egyptian civilization developed an extremely complex set of sacred beliefs and rituals related to the afterlife. Certain members of the social elite, who were deemed worthy of life after death and whose families could afford the funeral expenses, commissioned scribes to compile elaborate texts for the deceased. These colorfully illustrated texts described the prevailing conception of the afterlife along with a collection of hymns, spells, and instructions that were designed to allow the deceased to make the difficult journey to the join the gods in the hereafter. They were written on a papyrus scroll and placed in the coffin or burial chamber of the deceased.

From the time of the Crusades, some Western visitors to Egypt became aware of the existence of such texts in burial places, and many assumed that the richly diagrammed works held special sacred significance. However, the fact that the writing appeared in alien hieroglyphics or hieratic script precluded any accurate understanding of their message until several centuries had passed.

The first modern facsimile edition of Egyptian funerary texts was published in Europe in 1805 and was brought by Napoleon's staff when they invaded Egypt. In 1842 a prominent German anthropologist-explorer, Karl Richard Lepsius (1810–84), published his translation of a selection of funerary texts from the Ptolemaic era, which he called *Book of the Dead*. The compilation contained the most extensive formulae for securing eternal life that he had found; it was taken from the funerary manuscript of a man named Iufankh. Lepsius introduced the spell (chapter) numbering system, which is still in use, identifying 165 different spells. (Today 192 are known.) Some spells were intended to give the deceased a mystical knowledge in the afterlife, protect him or her from hostile forces, instruct the survivors in how to prepare the body, or serve many other functions. In one common vignette, a colorful diagram depicts an ideal plot of land in the mythical realm of Osiris wherein the deceased will be working in the afterlife. Subsequent scholars have continued to build on modern knowledge about ancient Egyptian funerary spells and other practices surrounding the dead. Lepsius, the explorer of burial tombs, became known as a founder father of Egyptology.

> OPPOSITE: *The Weighing of the Heart is a recurrent theme in Book of the Dead scrolls. The heart was seen as the most important organ in the body. It was believed that after death the heart was weighed in the underworld to judge the worth of a person's life.*

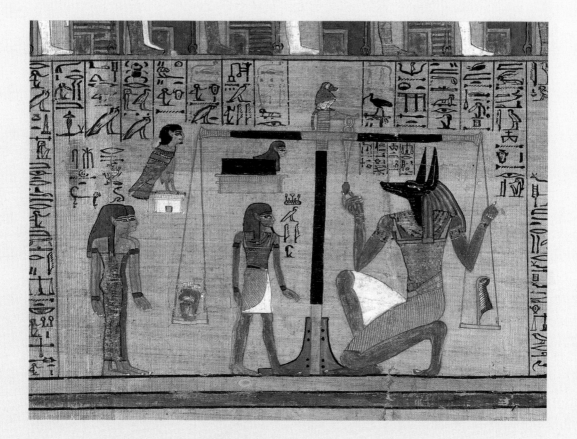

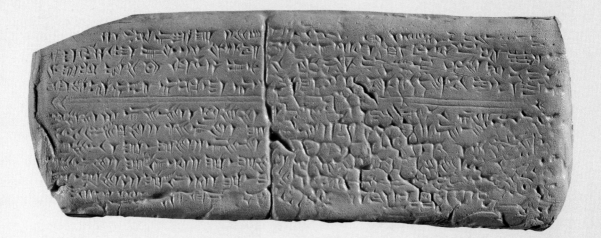

Sheet Music

The earliest known piece of "sheet music," found on a clay tablet dating from about 1400 BC, includes the music notes for a hymn as well as instructions for a singer and harpist. Later milestones in music publishing include the first printed sheet music book in 1457 and the first book of sheet music printed with movable type in 1501.

In the 1950s a group of French archaeologists in the coastal town of Ugarit, Syria unearthed 29 clay tablets at the site of the former Library of the Royal Palace. All were found to contain music notation but only one—H6—was intact enough to enable a nearly complete reconstruction. Dated to about 1400 BC and bearing cuneiform signs of the ancient "Hurrian" language, the Ugarit Tablet is the oldest known piece of music notation in the world. In 1972, Prof. Anne D. Kilmer of the University of California at Berkeley completed the first transcription; other experts have also offered their interpretations. Many agree that while the language is from the end of Hurrian civilization (modern day Anatolia), the origin of the music is unknown and may have been much older.

The music is a hymn to the moon god's wife, Nikkal, the goddess of the orchards. Remarkably, the tablets also contain detailed performance instructions for the piece to be performed by a singer accompanied by a harpist; there are also instructions on how to tune the harp. A few archaeomusicologists and musicians have actually brought the hymn to life in their own modern-day performances. The Ugarit Tablet is now housed in the National Museum of Damascus.

For thousands of years, music was written by hand, and figuring out how to translate it the new technology of printing posed many special challenges. The first printed book to include music, the *Mainz psalter*, was printed in Germany by Johann Fust and Peter Schoffer in 1457, with the music notation added in by hand. The first machine-printed music notation appeared around 1473. Another great breakthrough occurred in 1501 when Ottaviano Petrucci published *Harmonice Musices Odhecaton A*, containing 96 pieces of printed music in clean, readable and elegant form.

OPPOSITE: *The Ugarit Tablet (above) contains the oldest known piece of music notation in the world. The 1501 publication of Ottaviano Petrucci's Harmonice Musices Odhecaton A (below) was the first sheet music printed with movable type.*

Battering Ram

The awesome effectiveness of one of the Neo-Assyrians' most fearsome weapons of war—the battering ram—was immortalized in numerous graphic gypsum reliefs at the North-West Palace at Nimrud showing its role in legendary military conquests.

Under the Neo-Assyrian Empire in Mesopotamian history (934–605 BC), Assyria was the most powerful nation on earth, conquering the Near East, Asia Minor, Caucasus, North Africa and east Mediterranean with brute force. The Assyrians' ferocious battle tactics and their ensuing slaughter, rape, pillage and enslavement of the vanquished earned them a special place in the annals of terror. The victors commemorated their blood-drenched exploits through sculptures and other means that may have been intended to instill fear in the subjugated population as much as the art celebrated their victories.

In an age of mighty fortress cities, the Assyrian attackers had to overcome enormous obstacles: rings of formidable defenses surrounding high stone walls, from which the adversaries rained down thickets of arrows and torrents of boiling oil. But their sieges usually succeeded due in part to one ingenious invention: their

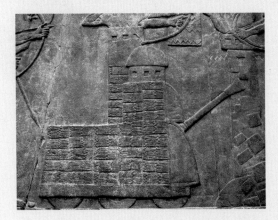

ABOVE: This gypsum relief from Nimrud Palace shows a battering ram attacking a stone wall fortress.

signature battering ram. Unlike their predecessors' simple sturdy logs or other smashing tools, the Assyrians kept improving on the basic concept to make their favorite siege devices more and more sophisticated until it had become a combination of many weapons in one. The heavy vehicle ran on four or six wheels and was engineered to be extremely rugged and maneuverable. By the ninth century BC, these battering rams were typically bound with strengthening metal bands and capped by a specially hardened, metal-capped head (like a ram's head), which was swung in a harness secured to a fixed wooden scaffolding and guided by a phalanx of specially trained warriors charging the wall or gate. Some rams were also tipped with solid steel blades that were used to pry apart the stones or splinter the fortress doors. The attacking soldiers were enveloped within a shell of thick wicker work sheathed in fire-resistant wet hides that protected them from most of their enemy's arrows, spears, missiles, and incendiaries.

One gypsum relief, from the ancient Assyrian palace at Nimrud (in Iraq), depicts the deployment of a battering ram in a siege. The ram has turrets from which the soldiers can observe or shoot their weapons while defenders on the wall are trying to torch the battering device before it obliterates their fort. Such ancient diagrams speak volumes about the nature of war in those times.

Military historians consider the Assyrian battering ram a forerunner of the modern armored vehicle or tank. Some scholars have speculated that the famous Trojan wooden horse may have been some type of elaborate battering ram.

The sculptors' bold and detailed diagrams showing the design and use of their army's key siege weapon has enabled generations of archaeologists and military historians to better understand why the ancient Assyrians were such a dominant military force.

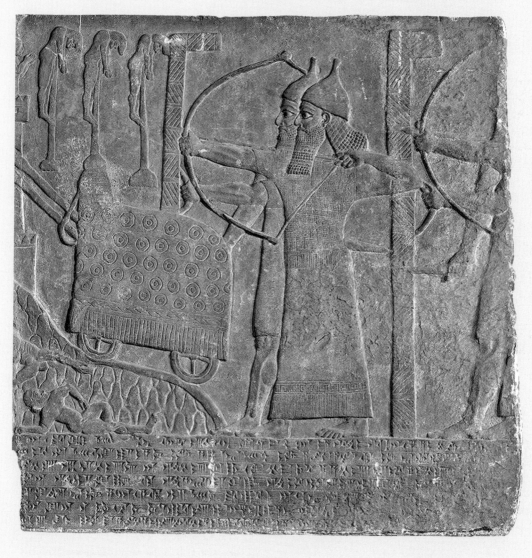

ABOVE: *This relief shows Assyrian soldiers attacking the city of Lachish. Sappers can be seen far left undermining the wall foundations that the battering ram ascends. Impaled captives and archers armed with composite bows give a vivid impression of the ferocity of warfare and the consequences of rebelling against the Assyrian empire.*

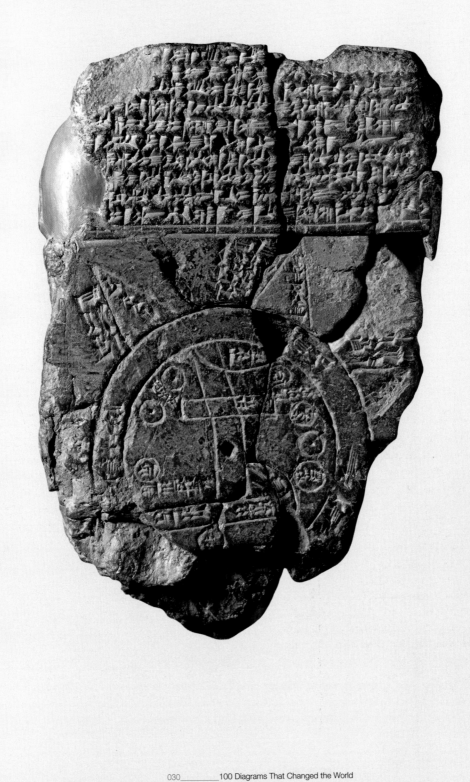

Babylonian Map of the World

Long considered the oldest extant map of the world, this ancient Mesopotamian artifact offers a symbolic or cosmological representation of the world as the Babylonians saw it, indicating a broader interest in geography than other civilizations had shown.

At the end of the 19th century, an important object from antiquity was discovered at Sippar, Persia, in what is now Iraq. The small, damaged fragment of dark-brown clay tablet measured 4.8 x 3.2 in (12.2 x 8.2 cm) in size. Dated to the sixth century BC, it became known as the Babylonian map of the world, or the Imago Mundi. While other Babylonian clay tablet maps had been found, the oldest dating as far back as 2300 BC, those earlier battered relics had been very limited in scope, not extending beyond a small district or city. This tablet, however, was dramatically different in its scope and understanding of the world, and became famous for being the first known diagrammatic and labeled international map.

Although the tablet is cracked and broken around the edges, analysis of it has yielded many important and revealing insights. Various symbolic markings and a section of cuneiform text are incised into its surface. Parallel lines running down the center of the map show the Euphrates, crossed by a rectangle that is marked in cuneiform writing as "Babylon." The diagram presents a bird's-eye view of a flat, round world with Babylon at its center. This world is shown as two concentric circles, with triangular areas radiating from the outer circle. The area within the inner circle represents the central continent where Babylon and Assyria are located. The central area is ringed by a circular waterway (the Persian Gulf) labeled as the "Salt Sea." Other more remote regions surround the sea's outer edge. Each region is indicated by a triangle jutting out of the ocean, which is labeled "Region" or "Island," and marked with some indication of the distance in between. (Scholars guess that the regions are depicted as triangles because that was how each would have appeared in the distance as it was approached by boat.) Each region also has a caption describing it in mythological terms. The continent on the map contains various geometric shapes representing places and topographic features. These places include the countries of Assyria (north-east of Babylon), Urartu (Armenia, north of Assyria), the land of Habban (South Yemen, south-west of Babylon), and the city of Babylon. The few topographic features include a mountain, a swamp, and a channel.

The map's main purpose appears to be to show the four regions at the edge of the world in relationship to Babylonia. Indeed, it is clear that the map was not intended to literally and completely depict the geography that was known at the time it was drawn. But rather, it was intended to embody that geography according to the Babylonian cosmos. A note inscribed on the tablet indicates that it is a copy of an original, indicating that the map enjoyed some significance over time. Today it is one of the most prized exhibits in the British Museum.

OPPOSITE: This ancient Mesopotamian artifact is the first known diagrammatic and labeled international map. The map presents a bird's-eye view of a flat, round world with Babylon at its center.

(c. 600–100 BC)
Classical Orders of Architecture

Three styles of architecture from ancient Greece—the Doric, Ionic, and Corinthian—established the Classical Orders that were later described by Vitruvius and adopted by the ancient Romans in the first century BC.

The ancient Greeks invented three classic styles of architecture, each of which was distinguishable by its proportions and other characteristics, particularly its columns. Two of the styles, the Doric and Ionic, appear to have developed around the same time; the Corinthian came later. Little is known about how the ancient Greeks may have compiled their magnificent architectural diagrams, but architectural historians ever since have sought to recreate and reconstruct their astounding creations based on study of the ruins and other clues.

The Doric was the simplest style, and characterized by heavy fluted columns with plain, saucer-shaped capitals and no base. With a height that is only four to eight times its diameter, the columns are the most squat of all classical orders. The shaft of the Doric is channeled with 20 flutes. The Temple of Hera in Olympia (c. 600 BC) is the oldest well-preserved temple of Doric architecture; the epitome of the order is the Parthenon in Athens (447–438 BC), which remains the world's most studied design.

The Ionic order is distinguished by slender, fluted pillars with a large base and two opposed volutes in the capital. The Temple of Athena Nike in Athens is one of the most famous Ionic buildings in the world. It is located on the Acropolis.

The Corinthian is the most ornate of the Greek orders, characterized by a slender fluted column having an ornate capital decorated with two rows of acanthus leaves and four scrolls. Many consider it most elegant of the three orders. The shaft of the Corinthian order has 24 flutes. The column is commonly 10 diameters high. The oldest known Corinthian example is found in the temple of Apollo at Bassae (c. 420 BC); it is the order that was later most widely adopted by the Romans.

Besides the existing remnants of some of the great Greek structures, the leading source of information about the Classical Order is the multi-volume work *De Architectura* (*On Architecture*), the only architectural writing that has survived from antiquity. Its author was the great Roman engineer and architectural authority Marcus Vitruvius Pollio, who died around 15 BC. Although the original illustrations accompanying Vitruvius's book had been lost, the text of his classic treatise containing many detailed descriptions was rediscovered in 1414 and translated into Latin; its publication profoundly influenced many Renaissance architects including Leon Battista Alberti (1402–72) and Michelangelo (1475–1564). Leonardo da Vinci's Vitruvian Man (see page 74) was inspired by Vitruvius's theories of beauty and proportion.

By introducing the Classical Orders, Vitruvius defined the essential column styles and entablature designs used in Classical architecture (later reproduced in so many representative diagrams), and also supplied his own judgments and tastes about what made the plans so distinctive and beautiful. The Orders and their accompanying diagrams widely influenced art and architecture and are a hallmark of the era.

OPPOSITE: An illustration of the Classical Orders from the 28-volume "Encyclopedia of Sciences, Arts, and Crafts" (1751–72) edited by Denis Diderot and Jean-Baptiste le Rond d'Alembert. Top: Doric; middle: Ionic; bottom: Corinthian.

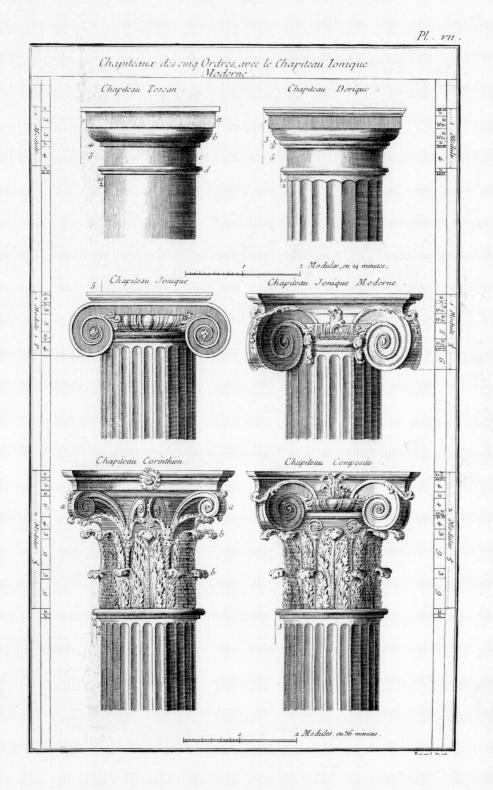

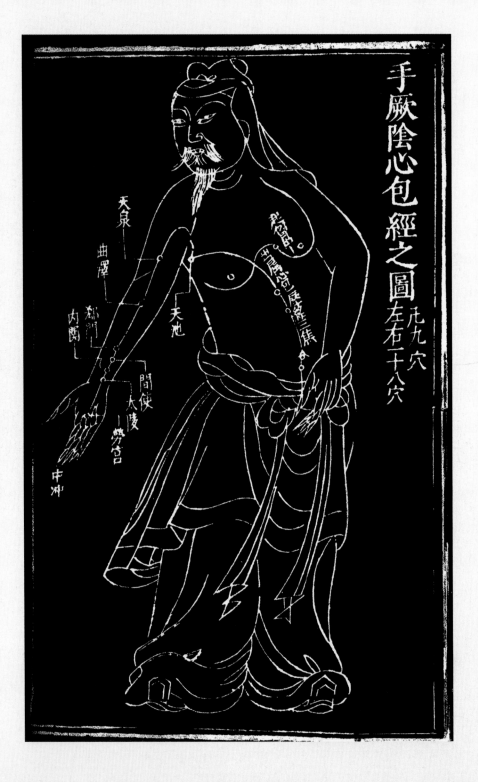

Acupuncture Points

The earliest written record of the ancient Chinese medical practice of acupuncture—the insertion of thin needles into specific points of the body to cure ailments and relieve pain—is found in the second book of *Huangdi Neijing* (*The Yellow Emperor's Inner Canon*). By the 1340s, some published editions of the work included diagrams of the body showing points of measurement.

The first written record of the medical use of acupuncture appears as part of the two-part *Huangdi Neijing* (also known as *The Medical Classic of the Yellow Emperor, The Inner Canon of Huangdi, or The Yellow Emperor's Inner Canon*), the great ancient Chinese text covering philosophy, military strategy, mathematics, astronomy, meteorology, ecology, and medicine, dated approximately 305–204 BC. The oldest surviving version dates to 1155.

The first and best-known part, the *Suwen*, covers the theoretical foundation of Chinese Medicine and its diagnostic methods. The second, the *Lingshu* (also known as *Spiritual Pivot, Divine Pivot, or Numinous Pivot*) covers acupuncture in great detail. Prior to that time, Chinese acupuncturists apparently relied on crudely sharpened stones (called *brian shi*) or bones, and sometimes carried out their practice in combination with moxibustion (the burning of moxa or mugwort directly on a pressure point).

According to Chinese medicine, acupuncture is used to restore the balance of life force energy (called *qi*), which flows across meridians of the body to organs designated as *yin* or *yang*. The *Lingshu* appears to include the first recorded reference to the use of unseen meridians for diagnosis and treatment in acupuncture. Some versions of the work contained diagrammatic maps of the body with names of the bones, which were included to aid measurement in placement of the needles. At the time it was written there were over 600 recognized acupuncture points, compared to about 400 today. Such diagrams helped to guide acupuncturists for hundreds of years and provided a visible and practical means of instruction for healers and patients alike.

Some scholars believe that the origins of acupuncture may extend back more than five thousand years, possibly even to other cultures besides ancient China. The famous 5,200-year-old "Ice Man" corpse discovered in a glacier in the Alpine Oetz valley between Austria and Italy in 1991 shows 15 groups of tattoos on his back and legs that match sites in the body used in acupuncture needle insertion. But so far the acupuncture connection has not been proved.

OPPOSITE: A 14th-century woodcut illustration of acupuncture points on the arm. Diagrams like this helped guide acupuncturists and provided a visual and practical reference for healers and patients.

Elements of Geometry

Euclid

Euclid of Alexandria compiled his great mathematical treatise that became one of the most influential books of all time. A fragment of papyrus dating from AD 75–125 shows the oldest and most complete example of one of his diagrams.

Practically nothing is known about Euclid, the ancient Greek mathematician who lived in Alexandria in the heyday of the Hellenistic period. But his great treatise, *Elements* (c. 300 BC), consisted of 13 books with 465 propositions dealing with plane and solid geometry and number theory, which the master scholar had compiled as a concise encyclopedia of geometry definitions, axioms (or "common notions"), postulates and other essential mathematical knowledge, and also absolutely confirmed through his own rigorous proofs. The work is divided into books on triangles, rectangles, circles, polygons, proportion, similarity, number theory, solid geometry, pyramids, and platonic solids. While the Egyptians and the Babylonians had used geometry to solve specific problems, Euclid took the study further to thinking in terms of general rules and overarching ideas that could provide mathematical guidelines.

With the exception of Autolycus of Pitane's fully preserved work, *On the Moving Sphere*, Euclid's *Elements* is one of the oldest extant Greek mathematical treatises and the oldest extant axiomatic deductive treatment of mathematics—a foundational work in logic and modern science. The first printed edition, based on Campanus of Novara's 1260 Latin translation, appeared in 1482, shortly after the introduction of the printing press. Its logical axiomatic approach and flawless proofs have made it the cornerstone of mathematics.

In 1896–97 a papyrus fragment of the ancient Greek version was found by B.P. Grenfell and A.S. Hunt in rubbish piles at Oxyrhynchus in upper Egypt, who subsequently dated it to AD 75–125. The fragment contains the statement, in Greek, of Proposition 5 from Book II of Euclid's *Elements* with the accompanying diagram. At the very top of the fragment is a small trace of what seems to be the statement of Proposition II.4. No part of the proof of either Proposition is present. According to Grenfell and Hunt, the text reads: "If a straight line be cut into equal and unequal segments, the rectangle contained by the unequal segments of the whole together with the square on the straight line between the points of section is equal to the square on the half."

The fragment is now housed at the University of Pennsylvania.

OPPOSITE: This fragile fragment of papyrus is the oldest example of a diagram from Euclid's great treatise Elements. *For 23 centuries Euclid's work was the primary textbook of mathematics.*

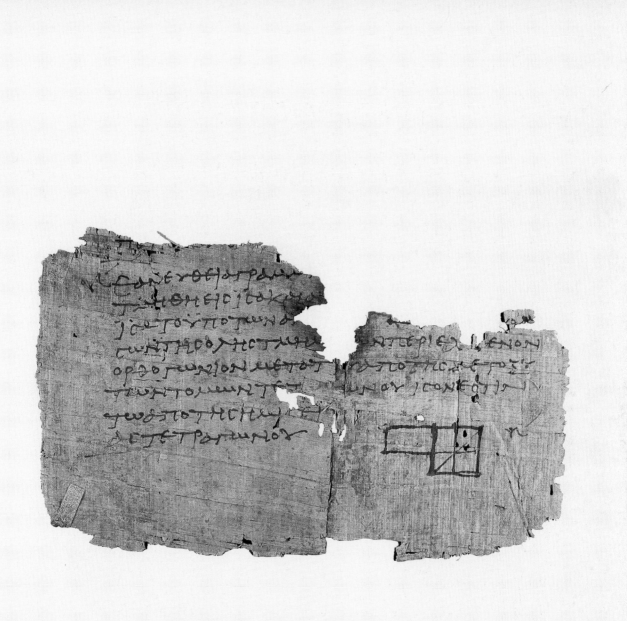

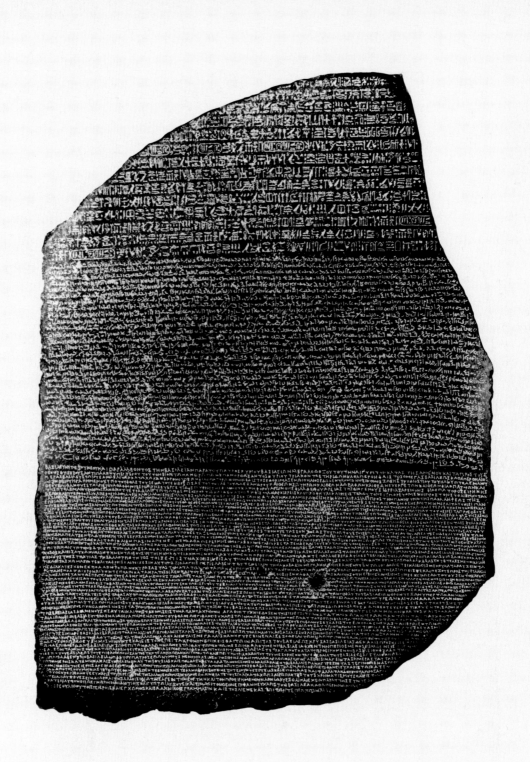

Rosetta Stone

After foreign invaders uncovered a strange stone covered with three types of ancient writing on a wall in the Nile Delta, a succession of scholars spent decades deciphering the text. The Rosetta Stone held the key to unlock the lost history of ancient Egyptian civilization and its name came to exemplify an essential clue to an important body of knowledge.

In 1799, French soldiers who were demolishing an ancient wall in the Egyptian town of Rosetta stumbled upon an unusual stone bearing hundreds of lines of extremely dense text, meticulously inscribed in different scripts. Measuring 3 ft 9 in (114 cm) high, 2 ft 4.5 in (72 cm) wide and 11 in (28 cm) thick, the damaged slab weighed just under a ton (762 kg) and was missing a large portion of the upper left-hand corner and a smaller part of its lower right corner, so some of the carved text had gone. Nevertheless, linguists quickly determined that the message was cast in three different scripts, one of which was clearly ancient Greek. The French made impressions of the stone's surface and circulated the facsimiles among various scholars to get their opinion. Translation of the ancient Greek writing revealed the stone to be part of a stele containing a decree issued at Memphis on behalf of King Ptolemy V in 196 BC. But nobody could identify the other two scripts. One text was determined to be hieroglyphics, the mysterious code that adorned the walls of so many extraordinary ancient Egyptian temples and monuments. The second was later found to be demotic, a cursive language that evolved from hieroglyphs around 643 BC. The problem was that hieroglyphics and its offshoot were dead languages that had been eradicated

under Christian rule because their markings were thought to have sacred (pagan) meaning, so Egypt's ancient written history had been lost. Before Napoleon's minions could try to learn more from the stone, it landed in the hands of the British, who deposited it in the British Museum.

The Rosetta Stone aroused intense international interest. In the early 19th century a succession of scholars from several nations labored over the stone in an effort to crack the mysterious codes. Two of the most prominent investigators, England's Thomas Young and Jean-François Champollion of France, eventually discovered that all three scripts contained the same message. Different carvers, each speaking a different language, must have been tasked to inscribe the important proclamation in order to ensure that everyone in the diverse population got the message. This revelation eventually enabled Champollion and others to decipher the two lost languages. Suddenly the wealth of symbols carved into other ancient stones and painted on papyri could be deciphered and part of Egypt's missing history was recovered. The decoding of hieroglyphics brought a rebirth in the study of ancient Egyptian civilization covering three thousand years.

OPPOSITE: *Discovered in 1799, this granite block containing a decree written in three languages allowed Egyptologists to interpret hieroglyphics for the first time—a language that had been out of use since the fourth century AD.*

The Ptolemaic System

Claudius Ptolemy

Ptolemy codified the ancient Greek view that the Earth is the center of the universe and that all other objects orbit around it. For more than a millennium, European and Islamic astronomers accepted Ptolemy's system as the correct cosmological model, making it one of the longest lasting celestial theories in history.

Claudius Ptolemy (c. AD 85–165) of Alexandria was a renowned mathematician, geographer, and astronomer who codified the geocentric view of the universe and rationalized the apparent motions of the planets as they were known in the second century. His most influential major work was a treatise in 13 books called the *Almagest* (*The Mathematical Compilation*). In it he used mathematics to prove the long-held belief in the immobility and the centrality of the Earth in the universe, also presenting in detail his complex mathematical model of the motions of the Sun, Moon, and planets. Ptolemy believed that Earth was the center of the universe and that the Sun and planets orbited Earth (with the planets moving in smaller circles called epicycles).

The Ptolemaic system looked like a complex interaction of overlapping circles. Diagrams of the Ptolemaic order of spheres from the center (Earth) showed in order of their proximity: Moon (Lvnae), Mercury (Mercvrii), Venus (Venens), Sun (Solis), Mars (Martis), Jupiter (Iovis), Saturn (Saturni), and the Fixed Stars. Ptolemy's argument that the Earth was at the center of the universe was based in part on the longstanding observation of the stars. His theory used geometry to posit that each planet is moved by a system of two or more spheres: its deferent and its epicycles. The deferent is a circle whose center point exists halfway between the equant (the point around which the epicycle moves) and the Earth, whereas another sphere (or epicycle) is embedded inside of the deferent. A given planet then moves along the epicycle at the same time the epicycle moves along the path marked by the deferent. These combined movements cause the given planet to move closer to and further away from the Earth at different points in its orbit.

This geocentric model fit in with a number of observations the geometry-loving Greeks had made, including their belief that things fall toward Earth, and that Venus stays roughly the same distance away from the Earth. Later on, Christian church doctrine also supported Ptolemy's model and further contributed to its long and firmly held rule. The astronomical predictions of Ptolemy's geocentric model were used to prepare astrological charts for over 1,500 years. The geocentric model held sway into the early modern age, but was gradually replaced from the late 16th century onward by the heliocentric model of Copernicus (see page 86), Galileo, and Kepler. Today, intricate and colorful diagrams of Ptolemy's elaborate system are consigned to museums.

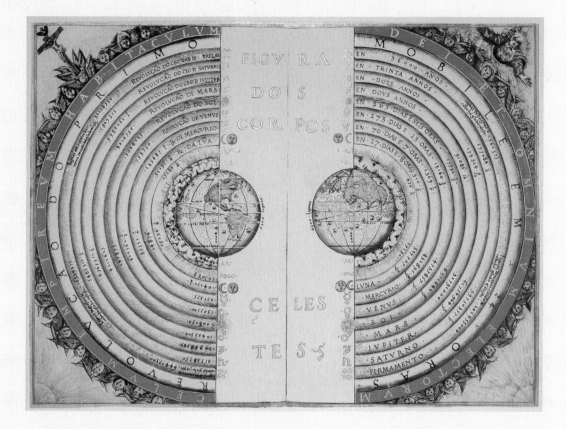

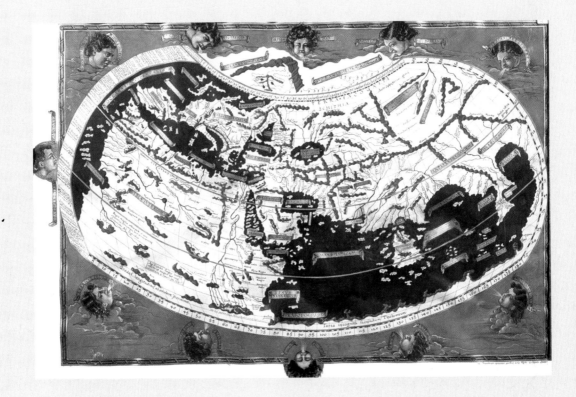

Ptolemy's World Map

Claudius Ptolemy

The mathematician Claudius Ptolemy was also a great cartographer whose classic work *Geographica* is credited with introducing latitudinal and longitudinal lines and other innovations in the Roman Empire of the second century.

Ptolemy collected, analyzed, and presented geographical knowledge so that it could be preserved and perfected by future generations. Although no original Ptolemaic world map has been found, his descriptions in his seven-volume compilation *Geographica* contained instructions for drawing maps of the entire *oikoumene* (inhabited world), prompting many scholars to call it the first atlas. Many versions were later drawn based on his surviving descriptions. This geographical work contained thousands of references to various parts of the known world, with coordinates for most, which seem to have influenced many early Islamic maps.

After centuries of being lost, Ptolemy's geographical writings resurfaced during the Renaissance. After an ancient Greek manuscript was translated into Latin around 1300, European cartographers were better able to reconstruct Ptolemy's world view for a new audience. The book was a sensation, as it challenged the very basis of medieval mapmaking. Before then, mapmakers had based their depiction of countries not on mathematical calculations, but on the perceived importance of different places. Ptolemy also instructed cartographers how to make better maps. He offered three different methods for projecting the Earth's surface on a map (an equal area projection, a stereographic projection, and a conic projection), presented the calculation of coordinate locations for some eight thousand places on the Earth, and developed concepts of geographical latitude and longitude. Although his "world map" only depicted the Old World from about 60°N to 30°S latitudes, showing only the continents of Europe, Asia and Africa, his work also described 26 regional maps and 67 maps of smaller areas. Ptolemy standardized the orientation of maps, with north at the top.

Ptolemy introduced mathematics and the idea of accurate measurement to cartography, which changed the nature of mapmaking forever. (Many of his calculations proved incorrect, however; his longitudes were grossly inaccurate and his estimate of the Earth's circumference turned out to be short by 7,102 miles.)

In the 1480s, Ptolemy's geographical work was also translated into various languages and widely printed with woodcut maps, which had tremendous influence in the age of discovery. One of its users was Christopher Columbus. Copies and reprints of Ptolemy's world maps made up the majority of navigation and factual maps for centuries to come, providing the base information for early European explorers.

OPPOSITE: *In this 15th-century example of the Ptolemaic world map, the Indian Ocean is enclosed and there is no sea route around the Cape. The "inhabited" (Old) World is massively inflated.*

Porphyrian Tree

Porphyry of Tyre

A third-century Syrian philosopher developed a hierarchical approach to the organization of thought, using a diagram based on the form of a tree to display levels of knowledge. The middlemost part, like the trunk, contains the series of genus and species, while the offshoots, resembling the branches, contain the differences.

Porphyry of Tyre (c. 234–305) was a third-century Neoplatonic philosopher, grammarian, and rhetorician born in the ancient Phoenician city of Tyre (Lebanon) and author of many classic works of logic. He is best known for his introduction to Aristotle's *Categories,* which provides an introduction to the study of logic, comprising the theories of predication, definition, and proof. *The Introduction* describes how qualities attributed to things may be classified, famously breaking down the philosophical concept of substance into the five components of genus, species, difference, property, and accident. (Genus stands for a class of objects divided into subordinate species having certain common attributes; species means a division subordinate to a genus; difference stands for a variation within the species; property is a character which belongs to the whole of a species, and to nothing else, but not to the essence or definition; and accident means a circumstance or attribute that is not essential to the nature of something, such as a white crow).

In the eighth century *The Introduction* was translated into Arabic and long remained the standard introductory logic text in the Muslim world, influencing the study of theology, philosophy, grammar, and jurisprudence. The Latin translation (*Introductio Praedicamenta*) became a standard medieval textbook in European schools and universities, which set the stage for medieval philosophical-theological developments of logic and the problem of universals. To this day, Porphyry's essay continues to be used as a standard introductory reading in college philosophy and logic, and his taxonomy for classifying living organisms continues to be extremely influential in biology. Porphyry's *Arbor porphriana* (Porphyrian Tree) graphically illustrated his logical classification of substance. A Porphyrian tree is a hierarchical construction consisting of three interconnected rows or columns of words that resemble the form of a tree (or a chain). The middle row, like the trunk, contains the series of genus and species; the extremities, containing the differences, are analogous to the tree's branches. This taxonomy diagrams the relations between unities (universals) on top and the particulars on the bottom.

Porphyry wrote the biography of Pythagoras. He was also an avowed anti-Christian who subscribed to paganism, and a famous diagram of a monk chopping at the Porphyrian tree illustrated his view that Christians were attacking the basic order of Nature.

OPPOSITE: *This medieval depiction of Porphyry's Tree shows the order of nature and the structure of knowledge under attack by Christianity (represented as an axe-wielding monk).*

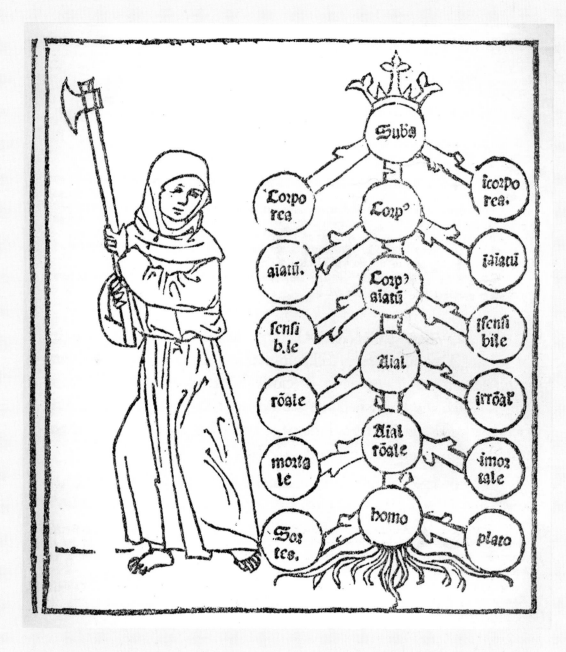

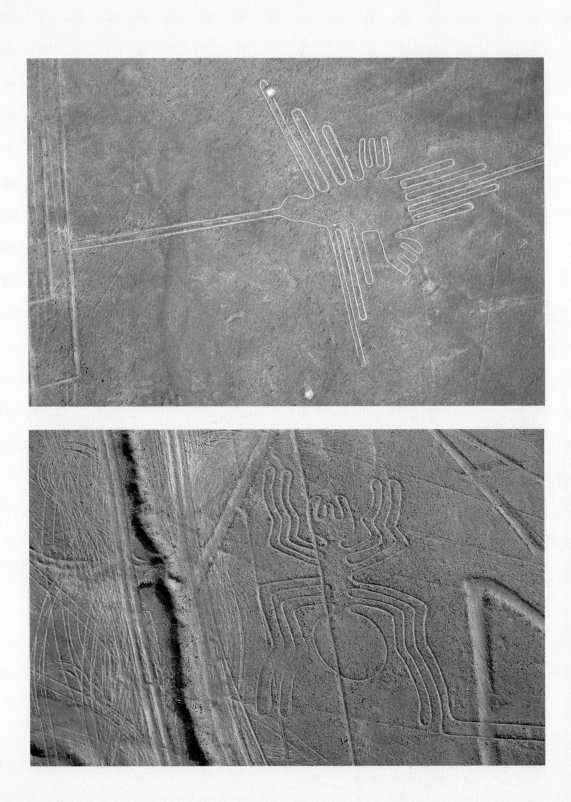

Nazca Lines

Nobody knows for sure why or how the ancient Nazca people carved a vast series of huge diagrams into the Peruvian Desert, but the drawings' presence has prompted many theories.

While pausing during his hike atop a foothill about 200 miles south of Lima, the Peruvian archaeologist Toribio Mejía Xesspe made an astonishing discovery in 1927. Gazing at the barren reddish hillsides and desert plain, he spotted an assortment of perfectly straight lines in grand geometric forms resembling insects, birds, animals, and plants that appeared to have been left by some long-lost civilization. Since then, closer examination of the area has revealed no less than 900 immense geoglyphs (an art form of geometric shapes drawn on the ground).

Archaeologists reckon that some of the markings may have been constructed as long ago as 200 BC by members of the now-vanished Paracas culture who populated the Andes from 750 to 100 BC. But they think most of the carvings, particularly the geoglyphs, date back to the period between about AD 400 and 650; their creation is attributed to the now-extinct Nazca, who later inhabited that region for at least five centuries until about the year 500.

Today the mysterious area is sheathed with reddish-brown iron oxide-coated pebbles that cover the desert's weathered surface. Beneath the top layer is a stratum of white colored sand, yet the desert's extremely dry, windless and constant climate has kept erosion there to a minimum. Such conditions have helped preserve the ancient carvings, which remain formed by a shallow trench with a depth of between 3.9 in (10 cm) and 5.9 in (15 cm). The size and precision of the geoglyphs seem to indicate the use of some sort of unique technology. Perhaps someone made a smaller drawing of the symbol and used a grid system to divide it up; then a group of trained persons could have recreated the drawing on the grid on a larger scale, using established methods. This is just one of the more plausible theories that have been offered to explain the mysterious drawings. (A few writers have suggested far-out explanations for the carvings, including the theory that they were made by visitors from another planet.)

In recent years, scholars have determined that the Nazca practiced human sacrifice and head-hunting. Their culture relied on fishing in the ocean (just 15 miles away) and in what were then many local fresh-water streams. They also enjoyed thriving agriculture that gradually shifted from maize to cotton growing. For much of their time of settlement, the region abounded in fertile farmland amid an eco-system that was dominated by the huarango tree. But the Nazca cleared the vital trees so much that in around AD 400, they had begun to deplete the local soil. Then in AD 500 a massive El Niño built up in the Pacific, dumping huge volumes of rain in the nearby Andes. The Nazca suffered a catastrophic collapse, leaving behind an uninhabited desert full of gigantic carvings—a wasteland of ancient diagrams.

OPPOSITE: A hummingbird and a spider—just two of the Nazca motifs, each executed in a single continuous line. These aerial photos give an impression of the scale—the hummingbird is 310 ft (93 m) long; the spider is 150 ft (47 m).

Dunhuang Star Map

More than 1,300 years ago, an unidentified Chinese scholar produced with mathematical precision the world's first known portable star chart, thereby demonstrating the surprisingly advanced nature of that civilization's early astronomy. The achievements of China's ancient astronomers are only lately being recognized in the West.

In the early 1900s, a wandering Taoist monk named Wang Yuan Lu made an incredible discovery within the massive Buddhist Mogao cave complex near the city of Dunhuang in Gansu province. Sealed inside was a hidden walled-off chamber containing a huge trove of Buddhist art and ancient manuscripts, some of them dating from AD 406 to 1002. Although concealed there for eight hundred years, many of the items had been extremely well preserved.

Some of the objects ended up in the British Library where they gradually came under close study. One diagrammed manuscript in particular emerged as extremely important. Known as the Dunhuang Star map, it was first thought to have dated from the 10th century but more recent examination has placed its origin in the seventh century, making it the oldest star map in the world and one of the most precious objects in the whole history of astronomy. The colored fine paper scroll, measuring 82 x 10 in (210 x 25 cm), shows 12 sections of the night sky as seen from the Northern Hemisphere. It displays

1,345 stars grouped in 257 non-constellation patterns—a level of detail that would remain unmatched until the introduction of the telescope several centuries later. The map also represents the sky as a sphere projected on a cylinder, which again was a technique not adopted in Europe until the 15th century.

Scholars from the Paris Observatory recently concluded that the map was composed in around AD 649–684—possibly by Li Chunfeng (602–670), the gifted mathematician who served as Imperial Astronomer. One member of the French team, Dr Françoise Praderie, concluded that the origin of the star chart's manufacture and the story of its real use remain unknown. "One can conjecture," he said, "that it was used for military and travelers' needs and probably also for uranomancy—divination by consulting the heavens—as suggested by the cloud divination texts preceding the charts." Praderie and other experts have marveled at the star catalogue's amazing accuracy. Such findings have changed the world's appreciation for early Chinese science.

> OPPOSITE: *The Dunhuang star map has proved to be surprisingly accurate. The lower half of this chart of the north polar region shows the Big Dipper (or Plough), part of the constellation now known as Ursa Major.*

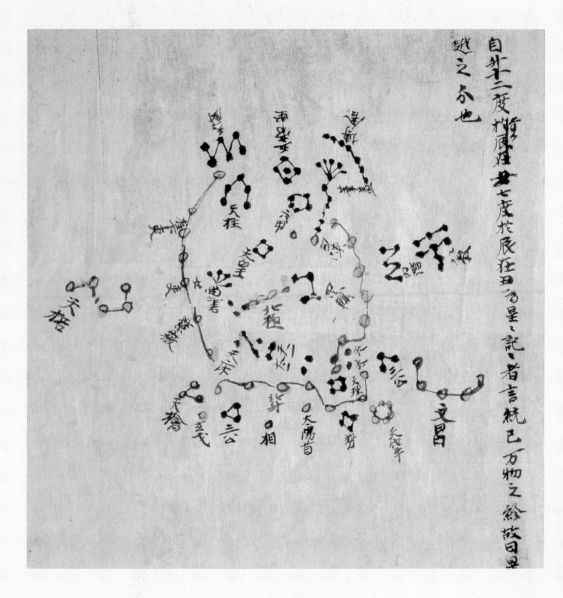

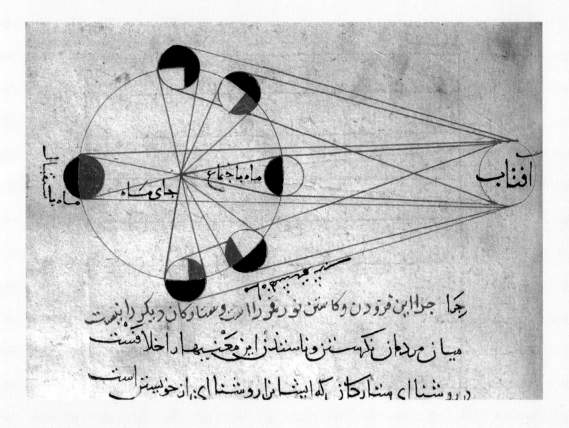

Lunar Eclipse

Abu Rayhan al-Biruni

As one of Islam's great scientific figures of the Middle Ages, al-Biruni made many important new astronomical observations, some of which he recorded in historic trigonometric diagrams.

Abu al-Rayhan Muhammad ibn Ahmad al-Biruni, known in English as al-Biruni (AD 973–1048) was an Iranian Muslim astronomer, mathematician, astrologist, biologist, cartographer, chemist, geographer, geologist, anthropologist, chronologist and historian, who was one of the great polymaths of his day. Born near Kath in Khwarezm (now a part of Uzbekistan), he was an exceptional scholar who was well versed in ancient Greek, Persian, and many other traditions. While in Rayy, at about age 18, he discussed with the astronomer al-Khujandi the latter's observations with a mural sextant and later wrote a treatise on this instrument. While in Kath in 997, al-Biruni observed a lunar eclipse that Abu al-Wafa had also observed in Baghdad; on the basis of the time difference the pair later determined the longitudinal difference between the two cities, marking the first time that anyone had applied this method. He made many serious studies of the world's configuration and the nature of stars, describing the Milky Way as a collection of countless fragments of the nature of nebulous stars; he also wrote that the speed of light is immense as compared with the speed of sound.

The origin of some of his celestial writings can be precisely dated and located based on their astronomical significance. For example, he wrote his own observation of the solar eclipse of April 8, 1019 at Lamghan, a valley surrounded by mountains between the towns of Qandahar and Kabul. In another famous instance, while at Ghazna shortly after midnight on September 17, 1019, he also described and drew a diagram explaining the lunar eclipse. He said he measured the time "When the cut at the edge of the full Moon had become visible" by determining the altitudes of four stars. The stars and their altitudes, all above the eastern horizon, were Capella at slightly less than 66 degrees, Sirius at 17 degrees, Procyon at 22 degrees, and Aldebaran at 63 degrees. He also drew diagrams to estimate the radius and circumference of the Earth.

An early critic of Aristotle's geocentric theory of the universe, al-Biruni famously described the Earth's gravitation as "the attraction of all things towards the center of the Earth." Al-Biruni devoted his life to his studies and writings, penning 146 books, most of which were devoted to the study of astronomy.

OPPOSITE: *An illustration showing the different phases of the moon from al-Biruni's manuscript copy of his Kitab al-Tafhim (Book of Instruction on the Principles of the Art of Astrology).*

Heraldry

On the occasion of his knighting his 15-year-old son-in-law in 1127, King Henry I of England bestowed a distinctive shield emblazoned with a special design, which became part of the family's hereditary armory, marking the first recorded example of a coat of arms and the seeds of heraldic structure.

In 1127 King Henry I (c. 1068/69–1135) had received such good reports about the military exploits of young Geoffrey V (1113–51) that he arranged for him to marry his daughter, Matilda, and opted to knight his new son-in-law as Count of Anjou and Maine. The marriage was intended to seal the peace between England, Normandy and Anjou, and to herald the event, the King had his court design a distinctive azure shield painted with four gold lions to hang around Geoffrey's neck. The knighting ceremony was conducted in Rouen.

Geoffrey went on to incorporate the design into his personal identification and his family's hereditary armory. Geoffrey died in 1151, but various paintings and artifacts indicate that the same shield was later displayed in the tomb effigy of his grandson, William Longespée, third Earl of Salisbury.

Henry's idea caught on all across Europe, so that by the middle of the 12th century, coats of arms were being inherited by the children of armigers (persons entitled to use a coat of arms) in several nations. As the heraldic convention became more established, its components became more elaborate and regulated. Because heraldry functioned as a system of identification, complex rules apply to the physical and artistic form of new creations of arms, the most important of which is the rule of tincture. Heraldry distinguishes only seven basic colors and makes no fine distinctions in the precise size or placement of emblems (known as charges) on the background (known as the field).

Under heraldry's set diagrammatic requirements, the blazon includes a description of the armorials contained within the escutcheon (shield), the crest, supporters (where present), motto, and other insignia. Coats of arms (or family seals) are described in a concise jargon known as blazon. Each coat of arms consists of several standard parts: the shield, the mantling, the helm, the wreath, charges, and the crest (although not all arms have crests). The identifiable coats of arms were to be used in wax seals, flown on family banners, and inscribed on family tombs.

ABOVE: *The British Royal Coat of Arms, supported by a crowned English lion and a Scottish unicorn.*

OPPOSITE: *This enamel plaque of Geoffrey V, Count of Anjou (1113–51) adorned his tomb in Le Mans Cathedral (it is now in the Musée de Tessé). This is one of the earliest pictorial examples of the use of heraldic devices.*

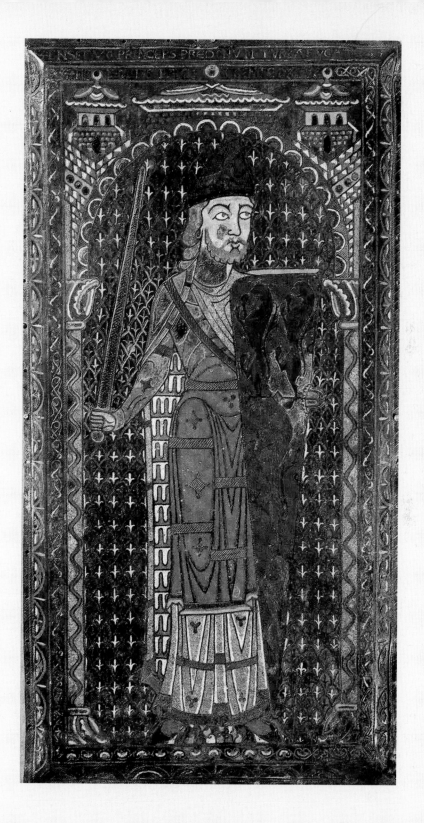

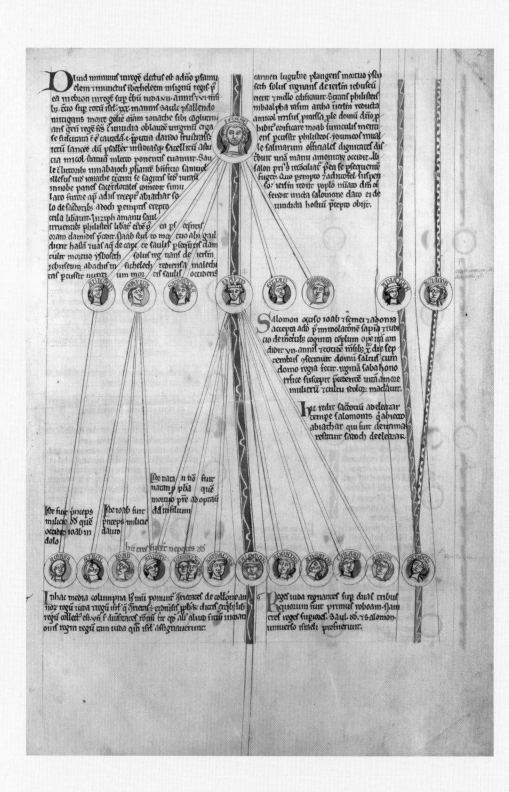

Compendium of the Genealogy of Christ

Peter of Poitiers

Peter of Poitiers compiled an elaborate genealogical tree of Jesus Christ intertwined with Bible stories, all finely illustrated with line drawings and diagrams for use as a teaching aid.

Peter of Poitiers, chancellor at the University of Paris from 1193 to 1205, compiled his manuscript of *The Compendium Historiale in Genealogia Christi (The Compendium of History through the Genealogy of Christ)* as a visual tool for teaching Bible studies. The vellum scroll was organized as a genealogical tree of Christ linked to biblical history, and illustrated with extensive line drawings and diagrams that achieved a powerful interplay between text and image.

Starting with the creation of Adam and ending at the birth of Jesus, Poitiers' history of the world is organized into six ages, each introduced in the manuscript with a line drawing. The lineage is shown through a stemma (a system of lines and framed circles that runs down the center of the scroll's length), with noteworthy ancestors and stories pictured at regular intervals along the stemma and other branches diverging along the sides that also contain well-known stories with illustrations showing ancient rulers of the Near East, Greece, and Rome. Diagrams represent such stories from the Bible as the Mansions in the Desert (the 42 places the Israelites stopped over a period of three years during the Exodus), the Twelve Tribes of Israel, the City of Jerusalem, and other memorable contextual mileposts.

The artist also used different motifs and color of ink to distinguish the characters (women's names appear inside circles surrounded by green, and men's in circles surrounded by red) and the characters' social class is also color-coded (with red and ochre being used for monarchs, and blue for prophets). Similarly, each of the ages from Adam and Eve to the crucifixion is shown in a distinctive color: the first age is ochre, the second red, the third green, the fourth red, the fifth blue and the sixth golden yellow.

Poitiers' intention was to assist clergy who were unable to pay for books to teach their students. By pinning the parchment to the classroom wall, the teachers were able to use it as a visual aid to guide their instruction. His approach proved successful and they were widely used. At least 50 copies from the 13th to the 15th century have survived.

OPPOSITE: *Peter of Poitiers' vividly colored visual history of the Old Testament was primarily designed as a teaching aid. This c. 1230 copy uses lines, circles and colored frames to help explain lineage while distinguishing between the status of each character.*

Carta Pisana (Chart of Pisa)

The most famous portolan chart, the Carta Pisana, is widely considered as the oldest surviving nautical map, designed to show accurate navigational directions that would aid mariners. Its new approach helped pave the way for the age of discovery.

Mariners in 12th- and 13th-century coastal Italy devised and constantly refined a new kind of practical map that, unlike its predecessors, was not based on theological beliefs, but devised for sea navigation. These so-called portolano charts sought to incorporate accurate information on ports, coves, seas, and sailing distances, without trying to show the topography or toponymy of the inland areas.

The best-known and perhaps the oldest surviving nautical chart is the Carta Pisana, so named because it was found in Pisa, though most experts believe it originated in Genoa in about 1275–1300. Measuring 411 x 198 in (1,045 x 502 cm) in size, the chart was hand-drawn on sheepskin by an unknown but experienced cartographer using different colored inks. Today it is housed in the Bibliotheque Nationale de France in Paris.

While the map's sources are unclear, the Chart of Pisa appears to be a compilation from many earlier charts that had been refined over time to reflect the results of various voyages. The writing on the chart appears in several different languages, which may further indicate that its information came from multiple regional sources. The area covered includes the entire Mediterranean Sea and the Black Sea as well as a part of the Atlantic coast from the north of present-day Morocco to present-day Holland. The area closest to Genoa turns out to be quite accurate, but the Atlantic coast beyond Gibraltar is schematic. Great Britain—the irregular shaped rectangle top left— shows a barely recognizable English southern coast with *Civitate Londra* (London) in the middle. There are only 11 place names listed and the toponyms are written where space is sufficient from the coastline to right

The map has many noteworthy features that help to distinguish it from other portolan charts. The map is oriented with north on the upperside compared to earlier charts showing east on top. The map encompasses almost all of the Mediterranean inside two circles, one for the western Mediterranean, one for the eastern part. These circles are divided into sixteen parts, providing the map with a dense network of "rhumbs" (corresponding wind directions) that are represented in different colors. The chart also features a grid that sailors could use to make calculations with the compass, as well as a scale bar that proved useful in understanding the distances between different points on the coastline. It also displays information about 32 named winds, each of which is represented by color.

Subsequent portolan charts were more refined and more accurate. Improved versions aided Magellan, Columbus, and other great explorers.

OPPOSITE: The complete map (above) shows the Mediterranean Sea, the Black Sea and part of the Atlantic coast. In the detail (below) Great Britain can be seen top left, barely recognizable as an irregular rectangle with London in the middle.

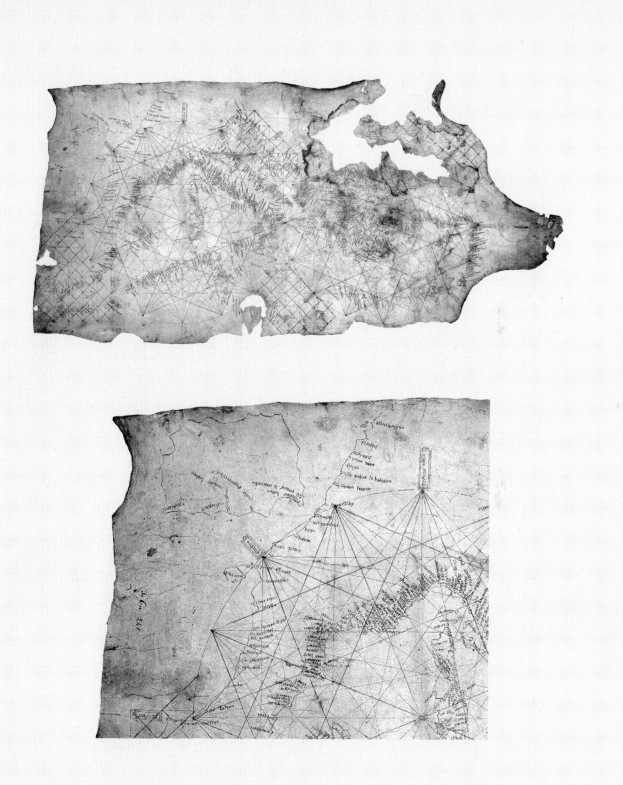

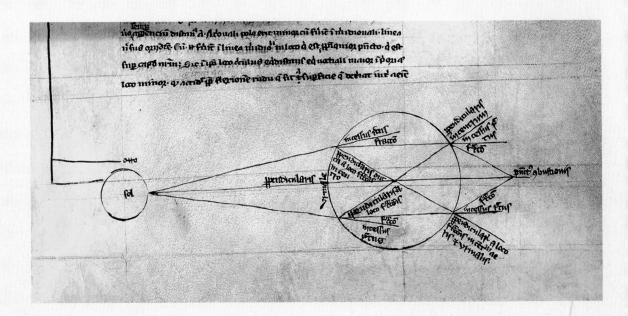

Optics

Roger Bacon

The medieval scientist's insistence on systematic observation and experimental study, particularly his work on lenses and magnification, led to his being called "the English father of optics" and a key forerunner in the use of modern scientific methods.

The Oxford-educated Franciscan friar Roger Bacon (c. 1214–94) studied a wide array of subjects, leading some historians of science to regard him as perhaps the most important scholar of the Middle Ages. Although Bacon's activities were restricted by a Franciscan statute forbidding friars from publishing books or pamphlets, he sometimes managed to circumvent this control. *Opus Maius, minus, tertium*, the related foundational work in *Philosophy of Nature, De multiplicatione specierum*, and another work on burning mirrors, *De speculis comburentibus*, along with an optical lens, were sent to Pope Clement IV in about 1267–68, in response to a papal mandate. Many of these writings by Bacon were about his study of optics, the branch of physical science that deals with the properties and phenomena of both visible and invisible light and with vision.

Opus Maius served as a compendium for much of Bacon's scientific writing, including his scientific exploration into the physiology of eyesight, the anatomy of the eye and the brain, direct vision, reflected vision and refraction, and mirrors and lenses. His scholarship extended beyond ancient Greek and Roman sources to medieval Islamic writers as well. After reading a translation from Arabic to Latin of Alhazen's *Book of Optics*, he carried out his own scientific experimentation on the subject before becoming the first person in the West to fully describe the properties of glass lenses for magnification to aid natural vision. This led to the creation of eyeglasses in Italy around 1286.

Being primarily a theoretical scientist, Bacon also offered his own theories of light, color, vision, and a variety of peripheral topics. Some of his most important optical works included drawings, such as a diagram showing sunlight being refracted by a spherical glass container full of water (in *De multiplicatione specierum*). *Perspectiva* (the fifth part of *Opus Maius*) also included circular diagrams relating to the scientific study of optics.

Bacon was primarily interested in what could be observed and discerned by the eyes. His scientific method emphasized the importance of using mathematics and exact measurement to study the natural world. His ideas had a profound effect on subsequent scientific thought. Sometime between 1277 and 1279, he was imprisoned or placed under house arrest for some reason that may or may not have been related to his writings. He then returned to the Franciscan House at Oxford, where he continued his studies until his death in 1294.

Dante's Divine Comedy

Dante Alighieri

Dante constructed his immortal poem with mathematical and numerological patterns printed throughout the work, thereby enabling subsequent artists over the ensuing centuries to graphically depict his intricate vision of Hell (*Inferno*), Purgatory (*Purgatorio*), and Heaven (*Paradiso*).

The Florentine poet Dante Alighieri (1265–1321) is said to have spent 17 to 18 years writing his epic allegorical poem, *The Comedy*, describing his imaginary travels through the after-world. None of his original manuscripts survived and the oldest extant version is dated to the 1330s. The most precious ones are the three full copies made by his friend, Giovanni Boccaccio (author of *The Decameron*) in the 1360s. It was Boccaccio who renamed it *Divine Comedy*. The first printed version of *Divine Comedy* was published in Italy on April 11, 1472. Since then, hundreds more have appeared, along with thousands of elaborate illustrations.

Written in Tuscan Italian in the first person, the poem is narrated by Dante and covers the period of the night before Good Friday until after Easter in the spring of 1300. Dante recounts his journey through the three realms of the dead, giving detailed descriptions filled with real and imagined characters. The Roman poet Virgil guides him through Hell and Purgatory; and Beatrice (based on young Dante's actual unrequited love from childhood, Beatrice Portinari), guides him through Heaven.

In the poem, Hell is depicted as nine concentric circles of suffering located within the Earth and representing a gradual increase in wickedness as one proceeds lower. These levels include: First Circle (Limbo), Second Circle (Lust), Third Circle (Gluttony), Fourth Circle (Greed), Fifth Circle (Anger), Sixth Circle (Heresy), Seventh Circle (Violence), Eighth Circle (Fraud), and Ninth Circle (Treachery). Dante's complex cosmology is constantly being depicted in countless diagrams and paintings, printed texts, music, dramas and films.

Allegorically, the *Divine Comedy* represents the journey of the Christian soul towards God, with the *Inferno* describing the recognition and rejection of sin. The three types of sin—the self-indulgent, the violent, and the malicious—also determine the three main divisions of Dante's Hell: Upper Hell (the first five circles) for the self-indulgent sins; circles six and seven for the violent sins; and circles eight and nine for the malicious sins. *Divine Comedy* helped establish the Italian language and is regarded as one of the greatest achievements in the history of literature.

Many of Dante's fantastic visual images had been formed by his study of medieval art and architecture all around him. His vivid poem offered an extraordinarily evocative blueprint by which others could imagine and even graphically represent this detailed vision. Other artists' graphic renditions of Dante's conception of Inferno, Purgatory and Paradise, have probably come to form the dominant iconography of the hereafter in the Christian mind.

OPPOSITE: A 19th-century interpretation of Dante's map of Hell. The level of suffering and wickedness increases on the downward journey through the inferno's nine layers. No original copies of Dante's manuscript survive.

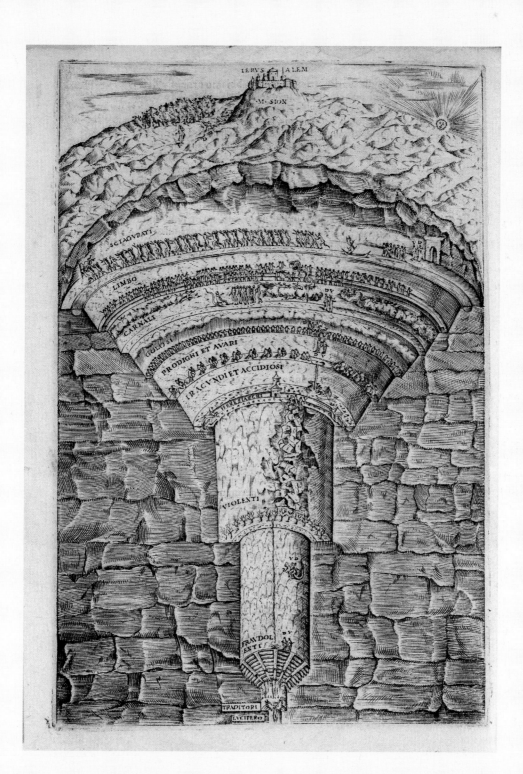

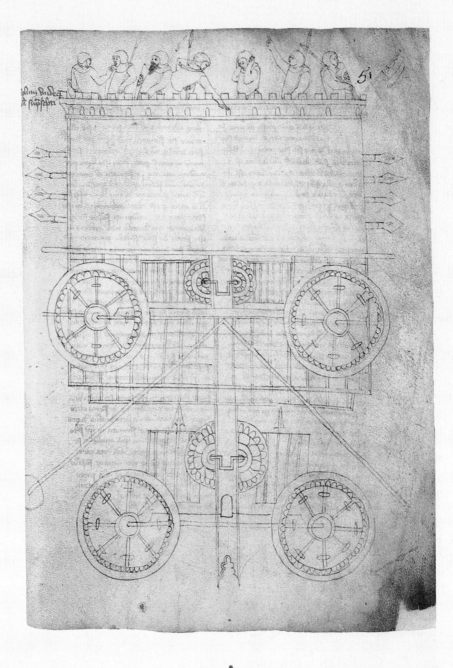

ABOVE: *Although his "wind wagon," or "windmill on wheels," was never tested,*
Guido da Vigevano's fantastical vehicle is seen as a forerunner of the car.

Windmill-Powered "Car" / Submarine

Guido da Vigevano

A medieval Italian inventor came up with several amazing technological ideas that were far ahead of his time—a wind-propelled automobile and a submarine, to name a few. His work would later inspire some great Renaissance thinkers, including Leonardo da Vinci.

Guido da Vigevano (1280–1349/50) was an Italian physician and engineer who served the French court as personal physician of Emperor Henry VII until that ruler's death in 1313; he was later close to King Philip VI, and from 1335 until 1349 he was the personal physician of Queen Jeanne de Bourgogne. He wrote several notable books about medicine, anatomy, hygiene, and "the art of war."

In 1328, when King Philip VI of France was planning a new crusade in the Holy Land, Vigevano hatched some bold ideas to aid the war effort, which he put together as a book for the king. Entitled *Texaurus Regis Francie Aquisitionis Terre Sancte de ultra Mare*, it included 14 folios offering new military technology. The second part contained text and drawings describing several advanced weapons that Vigevano had invented. The diagrams covered a wide range of innovations, such as a pontoon bridge (suggested due to the lack of wood in the Holy Land), a siege tower with liftable platform, a paddle boat, two battle wagons, and a submarine.

One of the most unusual designs was for a large, 25-ft-long (7.62 m), fully enclosed, wind-driven chariot. Its sturdy wooden wheels measured 7 ft 10.5 in (2.40 m) in diameter and could be propelled by a windmill through a chain of gear wheels, or by a hand crank that could be used if the wind was lacking. Big enough to hold several soldiers in its turret, the windmill-on-wheels was intended to cause fear and panic among the enemy. Besides giving instructions for its use, Vigevano wrote that he thought his drawings would be comprehensible to a master millwright

who could build the machine. Another diagram depicted his idea for an almond-shaped underwater attack boat—a submarine.

King Philip never left for the Holy Land, so Vigevano's extraordinary machinery was never built or tested. Although his flat sketches lacked perspective—a technique that had not yet been invented—his drawings later inspired a number of Renaissance engineers and artists including Leonardo da Vinci and Taccola. Today many historians consider his wind-powered car the earliest prototype for the chariot (or the armored troop carrier), and an environment-friendly version at that; his plans for the underwater boat has been called one of the world's first submarine designs.

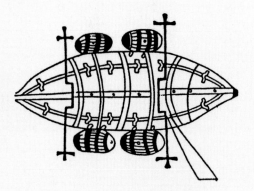

ABOVE: *Vigevano's "submarine" drawing predates Leonardo da Vinci's by almost 200 years.*

Astrarium

Giovanni de'Dondi

A Paduan clockmaker's incomparable design for an elaborate astronomical clock and planetarium captured the movement of the universe according to Ptolemaic standards. It was also a work of timeless beauty.

The earliest known use of a mechanical device (known as an *astrarium* or *planetarium*) to predict the movement of the sun, the moon and the planets dates back to ancient Greece and Rome. However, the greatest *astrarium* clock that would also keep track of time was designed and built in the late Middle Ages. Its creator, Giovanni de'Dondi (1318–89) was a physician, and teacher of astronomy at University of Padua. He had been trained in clock making by his father, Jacopo, who in 1344 had designed the astronomical clock in the Piazzi dei Signori, Padua—one of the first such devices of its type ever constructed. Giovanni spent 16 years designing and constructing his mechanism using brass and other expensive materials. From the moment it was unveiled, his spectacular achievement was considered one of the wonders of Italy, and 25 years later a local observer wrote: "So great is the marvel that solemn astronomers come from distant countries to visit Master Giovanni and to marvel at his work." In its day, his creation was considered remarkably accurate and convenient—the clock required winding only once a day, which was better than other timepieces—and it was beautiful.

Although his original *astrarium* was later lost, de'Dondi had left detailed diagrams which survived, thereby enabling others to later reconstruct his masterpiece. These plans show his device measures 4 ft (1.2 m) high and 32 in (81 cm) in diameter. Its highly complicated astronomical mechanisms are driven by mechanical clocks. In de'Dondi's era there were five known planets—Venus, Mars, Saturn, Mercury and Jupiter—and to show the position of the sun, moon, and the planets as they traveled through the zodiac, the clock uses 107 epicyclic gear wheels and skew gears. (His were the first known example of such gears).

The mechanism displays the mean time, sidereal (or star) time and the motions of the sun, moon and the planets. The clock's dials move a wheel (turning once a day), which moves another wheel that moves pointers representing the star's positions. The movements of the heavens are displayed on seven planetary dials around the top of the astrarium. Below the dial of the sun is a 24-hour time dial flanked by tables giving the times of sunrise and sunset throughout the year. Also in the same level is a dial of the moon and an ingenious chain mechanism carrying the movable feasts of the Church year.

Replicas of de'Dondi's *astrarium* reside in the National Time Museum in Chicago and the Smithsonian. The oldest original manuscripts are in the Biblioteca Marciana in Venice and the Biblioteca Capitolare, Padua.

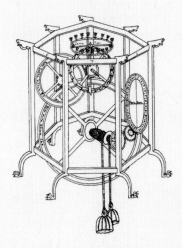

ABOVE: *A tracing of de'Dondi's drawing showing the astrarium's weights, escapement, and gear train.*

ABOVE: One of de'Dondi's illustrations from his magnum opus, Tractatus Astrarii. His book contained detailed plans and technical drawings of his clockwork planetarium.

The Voynich Manuscript

An elaborately illustrated hand-written manuscript that appears to have been composed in an unknown language or code in the 15th century has emerged as one of the world's most mysterious texts.

In 1912 an antiquarian book collector named Wilfrid M. Voynich purchased an unusual medieval manuscript that had been discovered in storage at a Jesuit villa in Frascati, Italy. Today it resides in Yale University's Beinecke Library, where it is known as the Voynich Manuscript.

Measuring 9.3 x 6.4 x 2 in (23.5 x 16.2 x 5 cm), the work consists of hundreds of vellum pages collected into 20 quires. Some of the pages have unusual fold-out shapes, so depending how the fold-outs are counted, there are approximately 240 total pages. The top right-hand corner of each right-hand page has been numbered from 1 to 116, probably by one of the manuscript's later owners. Experts suspect that the manuscript at one time included at least 272 pages. They also wonder if the order of some of the pages may have been changed at some point before they were numbered.

Analysis reveals that the text and drawings were made by a quill pen, with iron gall ink and colored paint also applied to some of the figures. Almost every page contains at least one illustration, with some featuring fold-outs with larger diagrams.

Investigators believe that the complete book was organized by subject into six sections, which some experts have roughly identified as herbal, astronomical, biological, cosmological, pharmaceutical, and recipes. The astronomical section has circular diagrams showing suns, moons, stars, and conventional symbols for the zodiacal constellations. The cosmological part contains circular diagrams or other diagrams indicating an island, a castle, and other features.

Recent scientific tests have dated the manuscript's origin at between 1404 and 1438. The fastidiously drawn script is clear and legible. However all attempts to decipher the unknown language or code have failed, leaving many analysts to ponder the meaning of some of the diagrams. Even the top military code-breakers have come up empty. Enormous effort has also gone into trying to establish who compiled the manuscript. One popular theory is that the author was Roger Bacon (see page 58), the legendary English Franciscan friar and polymath who lived from 1214 to 1294. But there are as many theories about its provenance as there are surviving pages. Was it the product of some forgotten great mind, another Leonardo da Vinci? We may never know.

The Voynich Manuscript remains a cause célèbre of historical cryptology and it has prompted several new forensic approaches across several fields. Like the riddle of hieroglyphics before that language was understood, the work's mysterious nature continues to confound and perplex some of the world's most inquisitive minds.

OPPOSITE: One of the many colorful yet enigmatic illustrations from the Voynich Manuscript. This diagram relates to the sun, the moon and a number of named stars, but its true meaning is yet to be decoded.

The Castle of Perseverance

The 15th-century manuscript of an early English morality play includes one of the earliest diagrams of a stage and set design for "theater in the round."

The *Castle of Perseverance* is a medieval morality play written by an unknown author that probably premiered sometime between 1405 and 1425, making it the earliest full-length vernacular play manuscript still in existence. A 3,700-line handwritten copy from the 15th century is currently part of the Cox Macro Manuscript (named after its previous owner, Reverend Macro Cox [1683–1767]), housed in the Folger Shakespeare Library in Washington, D.C. The medieval English dialect in which it is written has been traced to East Anglia or Essex, where there was also a tradition of playmaking at that time. As morality plays go, it is rather typical in terms of its structure or themes. Like others of its genre, the play shows through allegory mankind's progression from birth to death, based on a sequence of temptation, fall, and redemption. It carries the message that people in this world are continually tempted by sin and can be saved only by virtues—that is, by perseverance.

What makes the surviving manuscript even more unusual is that it is the only English medieval play that features a diagram containing stage directions and an accompanying plan for constructing a set in the open air. No other English medieval play manuscript contains a stage plan. It appears as a diagram, along with brief descriptive captions, that was written above the text of the play.

In the neatly sketched design, south (Flesh) is at the top of the circle, north (Belial scaffold) is at the bottom, east (God's scaffold) is on the left, and west (World scaffold) is on the right. Two concentric circles surround the main playing area. In the center of the innermost circle—the playing area—stands the Castle with a bed located inside. "This is the Castle of Perseverance that

stands in the midst of the place," the note above the castle reads, adding that nobody should sit there for they would obstruct the view. Beneath the outermost circle on the left side are instructions for the cast's wardrobe. The characters include Mankind, Belial, World, Good Angel, Bad Angel, Seven Deadly Sins, Virtues, Death, God the Father, and Others.

From the set design and the accompanying text, the modern reader can get a rare glimpse of the staging of a drama in the Middle Ages, more than a century and a half before Shakespeare. Without it, we would know very little about the once-flourishing genre of English morality plays and the dawn of English drama in pre-Elizabethan times. The diagram provides the oldest surviving visual representation of theatre in the round.

> OPPOSITE: *The Castle of Perseverance is the only surviving medieval manuscript to include a diagram with stage directions and a plan for constructing the set in the open air. In the center of the set is the castle itself with a bed located inside it.*

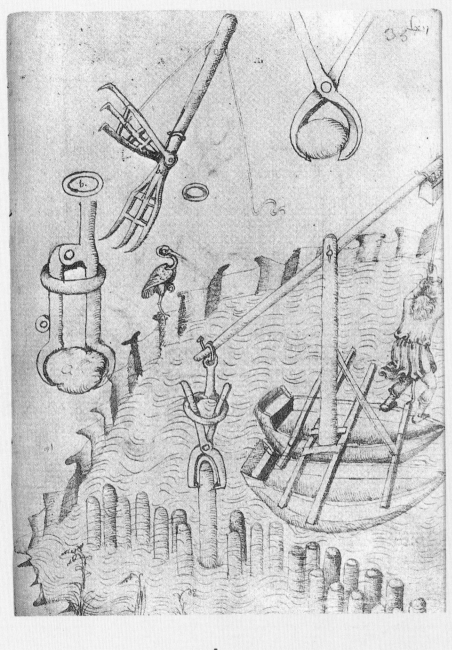

ABOVE: Mariano Taccola shows his post-pulling device from several angles. By providing the visual tools to help aid invention, Taccola is seen as a key figure in Europe's technological transformation during the Renaissance.

Exploded-View Diagram

Mariano Taccola

A new type of technical drawing, showing the structure and relationship of an object's components, can be traced back to the 15th-century diagrams of Mariano Taccola, whose work was later expanded upon and refined by Francesco di Giorgio and Leonardo da Vinci. The method—known today as exploded view—changed the practice of technical drawing and aided progress in many fields, including architecture, patents, and engineering.

Mariano di Jacopo detto il Taccola (1382–1453) was a Sienese artist, hydraulic engineer and superintendent of roads in the early Italian Renaissance. He is best known as the author of two influential technological treatises, *De ingeneis* and *De machinis*, which featured a new type of annotated drawings of various innovative machines and devices, many of which Taccola had invented. His interest in technological matters was reflected in his ability to capture in pen and ink illustrations the construction and inner workings of a wide range of devices, machines, and structures. These drawings showed the various parts and how they fit together. By providing new visual tools to aid the development of inventions in many fields, Taccola proved to be an important figure in Europe's technological transformation during the Renaissance.

Taccola's new style of technical drawing was perpetuated and refined by another Sienese artist and engineer, Francesco di Giorgio (1439–1502), who was a more skilled draughtsman and who was also interested in anatomical representation and perspective. He also added more details to his drawings. The diagrams of Taccola and di Giorgio together also influenced Leonardo da Vinci (1452–1519) of Florence, who carefully studied their mechanical drawings and took their approach to new heights. One of da Vinci's early exploded-view drawings was his design of a reciprocating motion machine; many other examples of his use of the technique appear in his

notebooks, and he adopted the approach for all sorts of subjects. One of the most famous is his great symmetrical drawing of Vitruvian Man (see page 74), which actually consists of an image taken from di Giorgio (which had also been redrawn by da Vinci's close friend, the architect Giacomo Andrea da Ferrara). However, da Vinci drew the image with incomparable skill; he also improved upon di Giorgio's sketch of a parachute and many other subjects.

The exploded-view technique went on to become a common feature of patent designs, blueprints, product assembly instructions, and many other forms of modern graphic design.

ABOVE: Leonardo da Vinci perfected the exploded view, as shown in this c. 1485 diagram of a geared device.

Aztec Calendar

In 1790 laborers doing repairs to Mexico City Cathedral unearthed a massive stone bearing an elaborate collection of exquisitely carved ancient symbols—a representation of the remarkable Aztec calendar.

When the Spanish conquistadors sacked the great Aztec capital of Tenochtitlan in 1521, they removed a brightly colored sacred stone from atop the Indians' main temple and buried it at the spot, which later became the site of great Mexico City's cathedral. After the heavy stone was accidentally uncovered in the 1790s, the Spaniards embedded it in a wall, where it stayed for several decades. In 1855, the Mexican government removed the artifact from that spot to Museo Nacional de Antropologia, where it has since undergone intense study. Known as the Cuauhxicalli Eagle Bowl, or the Aztec Calendar stone, it is considered one of the great astronomical and mathematical achievements of Mesoamerican culture.

The circular stone is 12 ft (3.6 m) in diameter and weighs about 23 metric tons. Fashioned from basalt (a solidified lava), small traces of paint reveal that it would have been painted a vibrant red, blue, yellow and white. Its carving took 52 years to complete, from 1427 to 1479, making it 103 years older than the Gregorian calendar and the best-known calendar of the Aztec civilization of Pre-Columbian Mexico. Its pictures represent how the Aztecs measured days, months and cosmic cycles (suns). The calendar—actually a number of calendars in one—includes a 365-day calendar cycle called *xiuhpohualli*, considered an agricultural calendar since it is based on the sun. There is also a 260-day ritual cycle known as *tonalpohualli* (day count), which is the Aztec's sacred calendar. These two cycles together form a 52-year calendar round, or their equivalent of a century. The Aztec year begins with the first appearance of the Pleiades asterism in the east immediately before the dawn light. There are 18 months, each 20 days long, or four (five-day) weeks. To bring the year up to 365 days, the Aztecs added five "unlucky" days. Every month has its name, which corresponds to the symbol for snake, house, wind, crocodile, flower, rain, flint, movement, vulture, eagle, jaguar, cane, herb, monkey, hairless dog, water, rabbit, deer, and skull. The days of the month are numbered from one to 20. The days of the last month, *nemontemi*, are numbered from one to five and represented as dots inside a circle. The calendar also contains eight equally spaced holes where sticks are put to serve as a sundial.

The calendar must have been the product of several centuries of ancient Aztec study of the heavens. Its incredible precision represents a brilliant combination of many fields of knowledge expressed in extraordinary artistic geometry.

OPPOSITE: This ornately carved stone is an impressive 12 ft (3.6 m) in diameter. Traces of paint reveal that it would have been colored in vibrant shades of red, blue, yellow, and white. It offers a unique insight into the ancient Aztecs' study of the heavens.

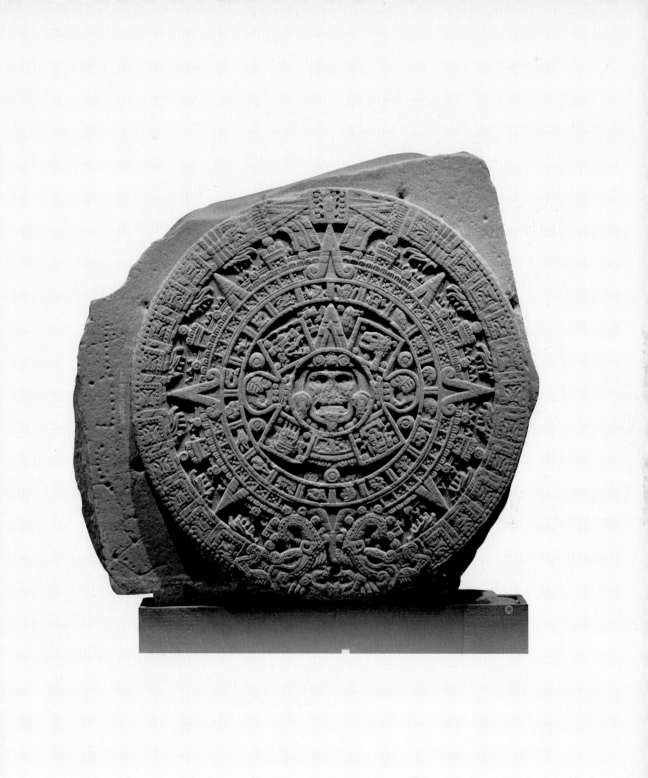

Vitruvian Man

Leonardo da Vinci

Leonardo da Vinci's drawing of Vitruvian Man is one of the most widely reproduced artistic images. This iconic work was inspired by the theories of the first century Roman architect Vitruvius, who believed that the body's proportions could be used as a model of natural proportional perfection. Vitruvius's ideas, as presented by da Vinci, formed the basis of Renaissance theories of proportion in art and architecture.

Often referred to as the Canon of Proportion or Proportions of Man, da Vinci's original Vitruvian Man drawing is now kept at the Gallerie dell' Accademia in Venice. Found in one of the artist's notebooks, da Vinci's drawing was inspired by the Roman architect and engineer, Marcus Vitruvius Pollio (c. 75–25 BC).

In his book *De architectura*, Vitruvius proposed a concept that architecture should imitate nature in the construction of housing by using natural materials that are beautiful, durable, and useful. He asserted that the invention of the Greek classical architectural orders, Doric, Ionic, and Corinthian (see page 32), were developed to give the architecture of man a sense of proportion. He compared this concept of proportion to the proportions of the human body, nature's greatest work. Taking his inspiration from the writings of Vitruvius, da Vinci's Vitruvian Man superbly illustrates Leonardo's interest in human proportion—Vitruvian theory transferred to art on paper. Various artists and architects

had illustrated Vitruvius's theory prior to Leonardo, but da Vinci's drawing differs from the previous works in that the male figure adopts two different positions within the same image. He is simultaneously within the circle and the square, while an additional sense of movement is suggested by the figure's active arms and legs. Da Vinci's Vitruvian Man is actually a more accurate representation of the human body than the description offered by Vitruvius. Leonardo's figure appears as a living being with unruly hair, distinct facial features and a strong build. However, despite the figure's lifelike appearance, Leonardo's aim was to represent the body as a building, illustrating Renaissance theories that linked the proportions of the human body with architectural planning.

The notes surrounding Vitruvian Man were written in da Vinci's "mirror writing" technique. The text paraphrases Vitruvius's theory. It is apparent that da Vinci wrote the text after creating the drawing, as the words are tailored to the contours of the circle and the square.

{
OPPOSITE: *This sketch, and the notes that go with it, show how da Vinci understood the proportions of the human body. The head measured from the forehead to the chin was exactly one tenth of the total height, and the outstretched arms were always as wide as the body was tall.*
}

Helicopter and Flying Machine

Leonardo da Vinci

More than just a great painter, da Vinci was one of the most inventive minds in history. His genius produced some of the earliest and most influential designs for manned flight, as evidenced by his diagrams of a helicopter and a flying machine.

Part engineer, da Vinci created an endless number of inventions of all kinds, some of which he actually constructed but most of which were simply recorded on paper and never realized. His interests covered an endless range of subjects, but one of his greatest fascinations was reserved for flight. His Codex on the Flight of Birds (c. 1505) reflected years of careful study of bird behavior, which had inspired his own ideas for man-made flying devices, including his extraordinary plans for a helicopter and a flying machine. On January 3, 1496 he recorded in one of his notebooks that he had tried to get one of his inventions to take flight from a hill near Florence, but failed. Nevertheless, his ingenious prototypes would ultimately influence aviation design more than four centuries later.

For his flying machine (the ornihopter), shown here in his pen and ink drawings from his Codex Atlanticus notebooks, da Vinci envisioned having the aviator lie prone on the craft and flap his arms and legs like a bird's wings. Leonardo also tried to fashion its wings like those of an eagle, so that "the great bird will take its flight." But the contraption proved unflappable.

His "Helical Air Screw" (or simply the "airscrew") was based on Archimedes' design of a helix or corkscrew. "If this instrument made with a screw be well made," da Vinci reasoned, "that is to say, made of linen of which the pores are stopped up with starch and be turned swiftly, the said screw will make its spiral in the air and it will rise high." Da Vinci's helicopter measured more than 15 ft (4.6 m) in diameter and was made from light materials such as reed, linen and wire. It was supposed to be powered by four men who stood on a central platform turning cranks to rotate the shaft. Da Vinci (mistakenly) believed that with enough rotation, the contraption would lift off the ground. Although his machine failed to work, it was nevertheless designed to achieve flight by means of compressing air—similar to the concept behind the helicopter that was finally realized nearly 450 years later. Instead of da Vinci's corkscrew-shaped propeller, the modern-day whirlybird substituted some large blades for the corkscrew-shaped propeller. And up it went.

OPPOSITE: *Da Vinci's "helicopter" or "airscrew" (above) was based on Archimedes' design of a helix or corkscrew. His flying machine (below) imagined the aviator lying prone on the craft and flapping his arms and legs to make it airborne.*

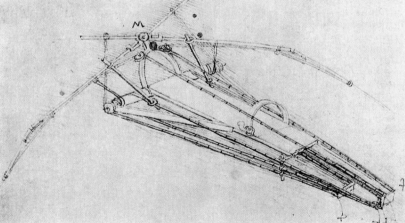

Foetus in the Womb

Leonardo da Vinci

Da Vinci became the first person to accurately depict a human foetus within the womb, based on his study of a dissection—thereby strengthening his standing as one of the founders of anatomical illustration.

Leonardo da Vinci (1457–1519) was a decidedly hands-on artist. His formal training in human anatomy began with his apprenticeship to the great Florentine sculptor Andrea del Verrocchio, and it continued decades later in Milan when he participated in human dissections under the guidance of anatomist Marcantonio della Torre. "To obtain a true and perfect knowledge of the vascular system," da Vinci wrote, "I have dissected more than 10 human bodies, destroying all the other members, and removing the very minutest particles of the flesh by which these veins are surrounded." Due to the lack of refrigeration or other means to preserve the corpses, "it was necessary to proceed with several bodies by degrees, until I came to an end and had a complete knowledge; this I repeated twice, to learn the differences."

Some of da Vinci's most famous anatomical contributions were his embryological drawings of a seven-month foetus in the womb with accompanying observational annotations, drawn with black and red chalk with some pen and ink wash on paper. The series included drawings from various angles. They survived among 13,000 pages of notes and drawings he compiled in the third volume of his private notebooks. "This work must commence with the conception of man," he wrote, "and must describe the nature of the womb, and how a baby lives in it, and in what degree it resides there, and the way it is enlivened and nourished, and its growth, and what interval there will be between one degree of growth and the next, and what it is which pushes it out of the mother and for what reason it sometimes comes out of its mother's womb before due time."

Based on da Vinci's own first-hand and up-close observation of the surgery and its aftermath, his masterful drawings captured the embryo as it actually appeared in the womb. He was the first person in history to correctly depict the human foetus in its proper position within the womb and the first to expertly draw the uterine artery and the vascular system of the cervix and vagina. His drawing of the uterus with only one chamber contradicted prevailing theories of the day that the uterus was comprised of multiple chambers. His sketches show the dissected uterus, the vascular system of the cervix and vagina, the umbilical cord and placenta with absolute precision and reflecting a more advanced understanding of the human reproductive system than others of his day had achieved. Consistent with his multi-view approach, Leonardo used a method of cross-sectional representation for his graphic depictions of veins, arteries, and nerves in order to show the layouts from different angles. The notebook pages are alive with other drawings and notations that capture the sight in extraordinary detail.

OPPOSITE: Da Vinci was the first person to correctly depict the human foetus in its proper position. The precision of his drawings demonstrate a more advanced understanding of the human reproductive system than any of his contemporaries had shown.

Triangulation

Regnier Gemma Frisius

The Dutch mathematician Frisius drew a diagram introducing the idea of triangulation as a method of accurately locating places; his scientific method is still used by surveyors today.

Regnier Gemma Frisius (1508–55) was a Flemish mathematician, astronomer, cartographer, instrument maker, and physician. In 1529 he published his first work, a corrected version of Apianus's *Cosmographia*, and a year later he brought out the book *De Principiis Astronomiae Cosmographicae* to accompany a combined terrestrial and celestial globe he had made. In 1533, Friar achieved great commercial success with his publication of an enlarged version of *Cosmographia*. That same year, his pamphlet *Libellus de locurum describendorum ratione* presented the first proposal to use triangulation as a method of accurately locating places. His technique utilizes the properties of the triangle to determine distances. Applying the theory of trigonometry to surveying, the surveyor first measures a certain length exactly to provide a base line. From each end of this line he then measures the angle to a distant point, thereby forming a triangle in which he knows the length of one side and the two adjacent angles. Thus, by simple trigonometry he can work out the lengths of the other two sides. In his pamphlet, Frisius included a diagram along with the following explanation:

He starts drawing a circle with a meridian (the diameter) on two different pieces of paper. Afterwards he climbs on the tower in Antwerp and puts one circle in the right position (the meridian north-south) using the compass needle. He draws the directions to the adjacent cities Middelburg, Ghent, Brussels, Leuven, Mechelen and Lier taking that tower in Antwerp as the center of the circle. With the circle on that other piece of paper he repeats the procedure looking out from a suitable tower spire in Brussels towards the other cities. Coming home he puts the two papers at an arbitrary distance from each other but keeping the two meridians parallel. Then prolongating the lines of the different directions (which he drew at the top of the towers) he gets the exact location of the cities at the points of intersection. In this example he writes that starting from the distance between Antwerp and Mechelen (four units), dividing this segment in four and comparing with the other segments, one can find all the distances between the different cities on the map.

Frisius's diagram became well known across Europe, making triangulation the standard method of surveying.

ABOVE: *Frisius showed that by establishing a baseline (between Brussels and Antwerp for example), the location of other cities (such as Middelburg) could be found by taking their compass direction at each end of the baseline and plotting where the two directions crossed.*

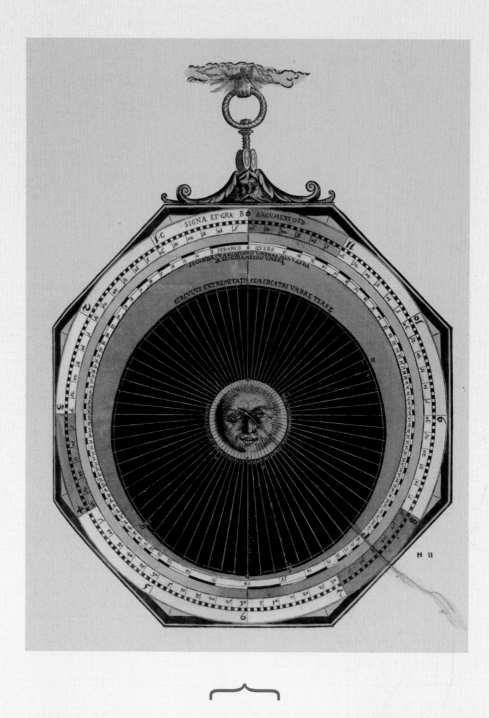

ABOVE: The use of ingenious mechanisms—revolving paper disks in layers and threads of colored silk with sliding pearl seeds—meant that the Astronomicum Caesareum could be used as a two-dimensional substitute for an astrolabe.

Astronomicum Caesareum

Petrus Apianus

One of the most sumptuous and unusual of all Renaissance instructive manuals laid out the mechanics of the universe according to the Ptolemaic system and provided instruments for calculating the altitude of stars, computing planetary positions, and obtaining other astronomical information.

Petrus Apianus (1495–1552), was a German humanist and mathematician who served as court astronomer to Emperor Charles V. In 1540, after eight years of study and labor, he produced *Astronomicum Caesareum* (*The Emperor's Astronomy*), one of the most notable achievements in the history of publishing—a lavish volume that exemplified both the best of 16th-century science and the pinnacle of the book-maker's art, and a work that was as much a scientific calculating instrument as a fine book. Its large, brilliantly hand-colored pages were filled with ingeniously contrived mechanisms, sometimes with five or six layers of volvelles (medieval instruments consisting of a series of little concentric revolving paper disks that were used to compute the phases of the Moon and its position relative to the Sun), which had all been expertly arranged to give precise planetary positions plus a variety of calendarial and astrological data. In addition to its 37 full-page diagrams, the work contained Latin text that summarized the current knowledge in astronomy.

Apianus was not the first person to introduce a mechanical device in a book, and paper dials had been used for at least two or three centuries as tools to illustrate complex principles. Yet his was considered the great masterpiece of the genre. Each copy was individually crafted. The great volume changed in the course of each new printing, eventually comprising 55 leaves, of which 21 contained moving parts and 12 more had index threads.

Among its beautiful pages with moving parts was a set of paper wheels for locating the planets within the zodiac. Embodying all the details of the geocentric Ptolemaic system, the volvelles and threaded charts gave a remarkably accurate graphical calculation of each planet's position. Apianus provided detailed directions throughout for the operation of the volvelles and other tools, as well as instructions for how to calculate eclipses. He advocated the use of solar eclipses to determine longitude. He also was the first to point out the fact that comet tails point away from the sun. One of the comets he described was the one later named as Halley's Comet.

Astronomicum Caesareum described the mechanics of a geocentric (earth-centered) universe with great lucidity. But within three years of its publication, the work was eclipsed by Nicolaus Copernicus's *De Revolutionibus* (see page 86), and flaws of Ptolemy's system (see page 40) were revealed. Today Apianus's achievement ranks as one of the most valuable rare books, all the more so because of its innovation in book design and function.

Human Body

Andreas Vesalius

By dissecting human corpses, Andreas Vesalius discovered startling facts about the body, which he captured in breathtakingly accurate drawings and text in *De Humani Corporis Fabrica* (*On the Structure of the Human Body*), a triumph in anatomy, art, and printing.

For more than 1,300 years, all Western professional knowledge about human anatomy had stemmed from the teachings of the Greek physician Galen (AD 129–216), and most physicians were never required to study the inside of a human body. So when the Flemish physician and anatomist Andreas Vesalius (1514–64) suddenly focused his attention on dissecting human corpses and describing what he found in meticulous detail, both his approach and its results shook up the medical field. Many considered it profane.

Vesalius crafted meticulous drawings of his findings, which he made available to his medical students in the form of large illustrated anatomical tables. The tables became so much in demand that in 1538 he published them in a book under the title *Tabulae Anatomicae Sex*. The next year a Paduan judge became so impressed by Vesalius's work that he made more bodies of executed criminals available for dissection. The young anatomist used some of the royalties from his book to create more sophisticated anatomical diagrams, some of which he had drawn by first-rate Renaissance artists. After publicly dissecting the body of a notorious felon from

Basel, Vesalius donated the skeleton to the local medical school, which won him more admirers. However, some critics questioned his departure from Galen's anatomical teachings, to which Vesalius responded that the great Greek healer Galen had actually based his work on dissections of animals, such as gorillas, not on human corpses; Vesalius also provided detailed empirical evidence proving several mistakes in Galen's anatomical precepts.

In 1543 Vesalius published his greatest work, the seven-volume *De Humani Corporis Fabrica* (*On the Structure of the Human Body*). *Fabrica* was lavishly illustrated with many finely detailed and expertly drawn views of the human body, its intricate muscular system, vascular and circulatory systems, and the brain, all of which he had recreated based on his own minute inspections of real human corpses. Some of his diagrams showed the naked and dissected bodies striking lifelike poses and frolicking about the countryside. The work revolutionized the field of anatomy and inspired many Renaissance artists; it is also regarded as one of the great achievements in the history of printing.

{ *OPPOSITE: Vesalius's revolutionary anatomical treatise, De Humani Corporis Fabrica, shows the dissected body in unusually animated poses. These detailed diagrams are perhaps the most famous illustrations in all of medical history.* }

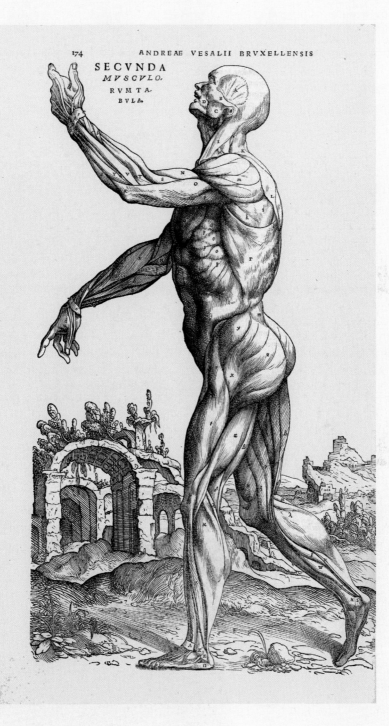

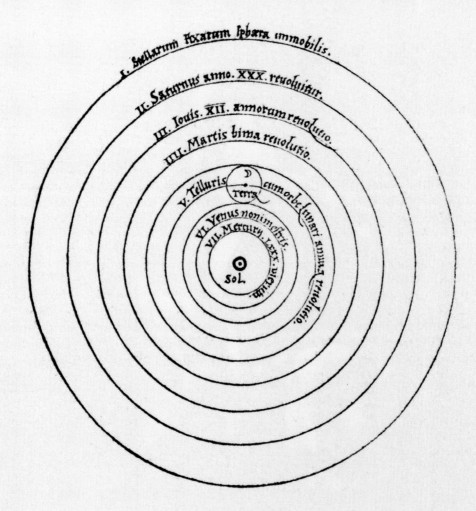

Heliocentric Universe

Nicolaus Copernicus

Copernicus's heliocentric model—which placed the Sun, not the Earth, at the center of the solar system—changed our view of the universe forever. His potentially heretical writings and drawings were brought together in his book On the Revolutions of the Celestial Spheres, which was published as he lay on his deathbed in 1543.

The 16th century finally saw what came to be a watershed in the development of cosmology. In 1543 Nicolas Copernicus's new view of the world was published—the heliocentric model. It is hard to underestimate the importance of this event: it challenged the age-long views of the way the universe worked and the preponderance of the Earth and, by extension, of human beings. The realization that we, our planet, and indeed our solar system (and even our galaxy) are quite common in the heavens and reproduced by myriads of planetary systems provided a sobering (though unsettling) view of the universe. All the reassurances of the cosmology of the Middle Ages were gone, and a new view of the world, less secure and comfortable, came into being.

Copernicus's model, a rediscovery of the one proposed by Aristarchus (310–230 BC), explained the observed motions of the planets more simply than Ptolemy's (see page 40) by assuming a central sun around which all planets rotated, with the slower planets having orbits farther from the sun. Superimposed on this motion, the planets rotate around their axes. Copernicus was aware that these ideas would inevitably create conflicts with the

Church, and they did. Though he informally discussed his ideas, he waited until he was about to die to publish his magnum opus (*On the Revolutions of the Celestial Spheres*), of which he only printed a few hundred copies. Nonetheless, this work was far from ignored and in fact was the first (and perhaps the strongest) blow to medieval cosmology.

The heliocentric model was eventually universally accepted by the scientific community, but it spread quite slowly. There were reasons for this: on the one hand, there certainly was a reticence to oppose the authority of the Church, but there was also the fact that the heliocentric model contradicted the prevailing view of the time—a view that had been held for the last 14 centuries.

From publication until about 1700, few astronomers were convinced by the Copernican system. Even 45 years after the publication of *Revolutions*, the astronomer Tycho Brahe went so far as to construct a cosmology precisely equivalent to that of Copernicus, but with the Earth held fixed in the center of the celestial sphere instead of the Sun. It was another generation before a community of practicing astronomers appeared who accepted Copernicus's heliocentric cosmology.

OPPOSITE: Copernicus's revolutionary view of the universe was crystallized in this simple yet disconcerting line drawing. His heliocentric model— which placed the Sun and not the Earth at the center of the universe— contradicted 14 centuries of belief.

Camera Obscura

Regnier Gemma Frisius

Frisius observed the solar eclipse of January 24, 1544, using a camera obscura; his drawing of the event was the first published diagram of a pinhole camera obscura and centuries later the image would help lead to the development of the camera used in photography.

A camera obscura (from the Latin meaning darkened chamber/room) is an optical device that projects an image of its surroundings on a screen. The device consists of a room or box with a pinhole in one side facing the light. Light from an external scene passes through the hole and strikes a surface inside where it is reproduced, upside-down, but with color and perspective preserved. The image can be projected onto paper, and can then be traced to produce a highly accurate representation. Some aspects of this phenomenon were noted in China as far back as the fifth century BC, and Aristotle (384–322 BC) described it as well. But it was only in the Renaissance, with the development of optical science and technology and the demand for accuracy in visual representation, that the phenomenon became the subject of more systematic investigations and was adapted as a drawing aid by painters. "Who would believe that so small a space could contain the image of all the universe?" da Vinci wrote in his journal in 1490. "Here the figures, here the colors, here all the images of every part of the universe are contracted to a point. O what a point is so marvelous!"

Nevertheless, the best-known illustration and explanation of the camera obscura did not occur until 1544. That was when the Flemish mathematician, physician, philosopher, cartographer, and instrument maker Regnier Gemma Frisius (1508–55) published an account about using a pinhole in his darkened room to observe "an eclipse of the sun at Louvain in 1544." (This device enabled astronomers to make solar observations without damaging their eyes.) Frisius drew a diagram showing how he had utilized the phenomenon to follow the event. This illustration from *De Radio Astronomico et Geometrico* was widely circulated and used as the basis for many more refined versions over the ensuing centuries.

The actual term "camera obscura" was first used by the German astronomer Johannes Kepler in 1604. Portable models of the camera obscura were later adapted by Nicéphore Niépce, Louis Daguerre, William Fox Talbot and other pioneers of photography, making it the "father" of the photographic camera, thereby further ensuring the place of Frisius's diagram in history.

Solis deliquium Anno Christi
1544. Die 24: Januarÿ
Louanÿ

{
*ABOVE: This is the first known
illustration of a camera obscura.
Gemma Frisius used it to observe a
solar eclipse on January 24, 1544.
The diagram was published the
following year in his treatise De Radio
Astronomico et Geometrico.*
}

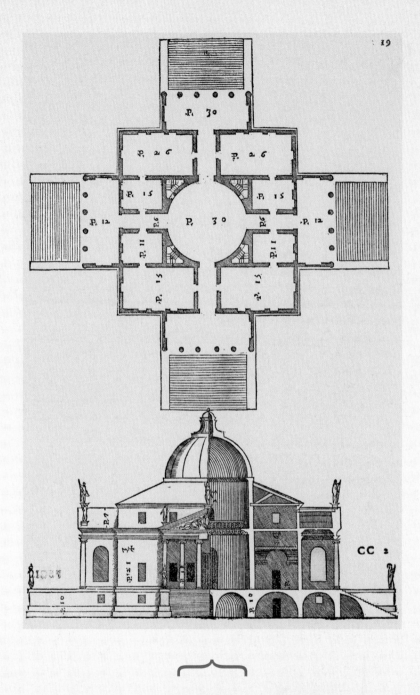

ABOVE: *Palladio's country villas, urban palazzos, and churches combined modern features with classical Roman principles. His designs were hailed as "the quintessence of High Renaissance calm and harmony."*

The Four Books of Architecture

Andrea Palladio

In addition to designing some of the finest structures of the Renaissance, Andrea Palladio (1508–80) published a great treatise filled with diagrams of classical architectural designs from ancient Greece and Rome, which has made him perhaps the most influential individual in the history of Western architecture.

Around 1540 Andrea di Pietro della Gondola was working as a stonecutter in Venice when a wealthy humanist and writer, Count Gian Giorgio Trissino, recognized his creative talents and encouraged him to study the arts and classical architecture. Trissino renamed him Palladio as an allusion to the Greek goddess of wisdom. The young man threw himself into studying more about the masters of Greek and Roman architecture, especially Marcus Vitruvius. Soon, with the patronage of many more powerful figures in Venice, he began to create his own designs. While adhering to classical Roman principles, Palladio eventually developed his own style. For Palladio, this meant being in harmony with his culture in Renaissance Italy. Among his specialties were the design of many serene country villas, urban palazzos, and churches—all of them with features that were at once new yet in keeping with the finest classical tradition, as well as in complete harmony with their surroundings.

Late in life he presented his teachings in a great architectural treatise, *I Quattro Libri dell'Architettura* (*The Four Books of Architecture*), published in 1570. The four volumes were a showcase for his art and the ancient structures that inspired him. The First Book is devoted to building materials and techniques and the five orders of architecture. In it he offers the most important practical method for the applying proportion in architecture, complete with clear-cut rules. The Second Book deals with private houses and mansions, almost all of Palladio's own design. The Third Book is concerned with streets, bridges, piazzas, and basilicas. In the Fourth Book, he reproduces the designs of several magnificent ancient Roman temples and plans and architectural sketches of the Pantheon. In all, the text is illustrated by more than two hundred exquisitely drawn and magnificently engraved plates, showing edifices that he has either designed or reconstructed from classical ruins and contemporary accounts. These classical diagrams are some of the finest architectural drawings of all time.

ABOVE: **The title page of Palladio's Four Books of Architecture, published in 1570.**

Flush Toilet

John Harington

Queen Elizabeth I's "saucy godson" John Harington invented one of the most practical and sanitary devices of modern living—the flush toilet—however his dream would not become a household reality for another 300 years.

John Harington (1561–1612) was an English poet whom Queen Elizabeth called her "saucy godson." Known for his risqué sense of humor, Harington is often cited for his famous epigram, "Treason doth never prosper: what's the reason? Why, if it prosper, none dare call it treason." But he is best remembered as the inventor of the Ajax—what we know today as the flush toilet.

Harington introduced his invention in 1596 in a political allegory entitled, *A New Discourse of a Stale Subject, called the Metamorphosis of Ajax*, which he published under the pen name of Misacmos. The work began with an exchange of letters between Philostilpnos (a lover of cleanliness) and his cousin Misacmos (a hater of filth). In the opening letter, Philostilpnos exhorts Misacmos to make his invention, a "jakes" (privy) with a water flushing mechanism, public. Philostilpnos lists some of its benefits, not only for the great houses of the nobility and the Queen but also for "townes and Cities."

The third section describes the suggested new privy design in text and pictorially, purporting to show "by pen, plot, and precept, how unsaverie places may be made sweet, noysome places made wholesome, filthie places made cleanly."

Harington's two diagrams show the contraption with several parts: a cistern to hold wash water; an oval-shaped vessel of brick, stone, or lead that sits under the stool seat; a brass sluice on the bottom of the vessel; and a screw to open the sluice. The sluice is normally in the closed position and the vessel filled with a half foot of clean water to prevent smells from entering back through the pipe. Although the drawing includes a fish in the tank and other tongue-in-cheek touches, his appeal was intended to be taken seriously. The text provides a list of the current market prices for each of the parts required in the design, indicating that he was trying to facilitate its practical implementation.

Harington's invention gained notoriety but had little practical effect. The powers-that-be did not embrace his proposal. Flushing privies (known as water-closets) did not come into wider use until the mid-1800s and it took several years to work out the problems before such a system was able to operate in a sanitary manner.

{ OPPOSITE: *The text accompanying Harington's diagram identified A as the "Cesterne," D as the "seate boord," H as the "stoole pot," and L as the "sluce." If used correctly, "your worst privie may be as sweet as your best chamber."* }

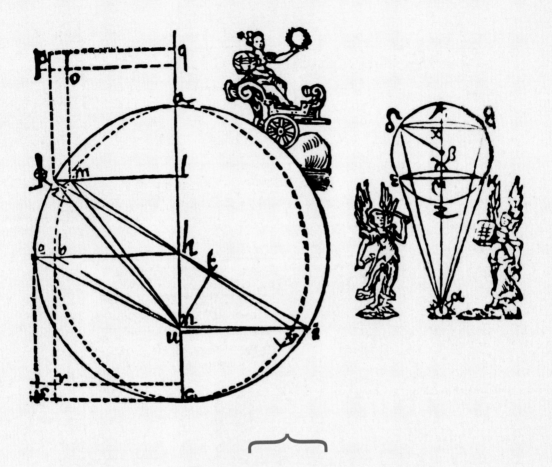

ABOVE: *This illustration from Astronomia Nova showed that the orbit of Mars is elliptical. Unlike the perfect circles of Copernicus's heliocentric model, Kepler deduced that the planets followed an elliptical orbit around the Sun.*

Kepler's Law of Planetary Motion

Johannes Kepler

The German astronomer's 10-year-long geometrical reconstruction of the motion of Mars unwittingly discovered that planets orbit the sun in an ellipse, not in a circle as Copernicus thought.

In 1601 the German mathematician, astronomer, and astrologer Johannes Kepler (1571–1630) succeeded Tycho Brahe as Imperial Mathematician in Prague, the most prestigious appointment in mathematics in Europe. Like Brahe, his work followed in the footsteps of the great solar theorists. Claudius Ptolemy's theory held that the Earth is at the center of the universe with the Sun, Moon, planets, and stars revolving about it in circular orbits (see page 40). Nicolaus Copernicus proposed in 1543 that the Earth and other planets orbit the Sun (see page 86). And indeed, Brahe's "Tychonic system" had combined what he saw as the mathematical benefits of the Copernican system of the solar system with the philosophical and "physical" benefits of the geocentric Ptolemaic system.

Kepler hoped to improve upon the Copernican model and strengthen the case for the Tychonic system, in part by redoing some of the calculations done by Claudius Ptolemy, and introducing physics into the heavens. As he was doing this, however, Kepler found an error in Ptolemy's placing of the Sun, which he corrected. But the result revealed an error in the predicted position of Mars. Kepler spent 10 years grappling with this problem. Finally, he realized that the orbits of the planets were not the circles demanded by Aristotle and assumed implicitly by Copernicus, but rather they were "flattened circles" or ellipses. As a master mathematician, Kepler knew about the properties of ellipses. An ellipse has two points (foci) such that the sum of the distances to the foci from any point on the ellipse is a constant. He also knew about the nature and amount of their flattening ("eccentricity").

Utilizing the voluminous and precise data that had been compiled by his predecessor Brahe, Kepler was eventually able to prove that the orbits of the planets were ellipses to formulate his three laws of planetary motion.

In 1609 Kepler prepared a diagram showing what he had found—that planets move in elliptical orbits with the Sun at one focus of the ellipse. His diagram was published in his book, *Astronomia Nova (New Astronomy)* as Kepler's first law of planetary motion. *Astronomia Nova* gave valuable insight into planetary movement and bolstered the arguments for heliocentrism. Historians consider it one of the most important works of the Scientific Revolution.

*ABOVE: **The title page of Kepler's Astronomia Nova published in 1609.***

Telescope

Galileo Galilei

Galileo was not the first to come up with the idea of a telescope, but he quickly designed and manufactured the most superior model, then explained to others how he had done it. His spyglass would turn out to be one of the central tools of the Scientific Revolution.

In October 1608 a Flemish spectacles-maker named Hans Lippershey applied for a patent in Holland to make an instrument with a magnifying lens that would make distant visible objects look nearer. Although the patent was denied and Lippershey was given money to make three more such instruments for the government without disclosing to others what he was doing with the device, word of the invention quickly leaked out in diplomatic and scientific circles. Galileo Galilei (1564–1642), then a little-known Florentine mathematician and astronomer, got wind of Lippershey's device in July 1609 while visiting Venice. He immediately set out to determine how he too might invent such an instrument.

Shortly thereafter, Galileo tried his own method, which was based on the theory of refraction. "First I prepared a tube of lead," he later wrote, "at the ends of which I fitted two glass lenses, both plane on one side while on the other side one was spherically concave and the other was convex." His early sketch showed a long narrow tube. Then he diagrammed the optical path of his telescope, showing light entering the tube's far end passes through a convex lens, which bends the light rays until they come into focus at the focal point. The eyepiece then spreads out (magnifies) the light so that it covers a large portion of the viewer's retina and thus makes the image appear larger. Then, using his mathematical skills, Galileo determined the mathematical relationship that governed the instrument's ability to magnify. By following this formula and grinding his own lenses, he had created a spyglass that could enlarge an image by 20 times—by far the greatest magnification ever achieved to that point.

A few months later Galileo published an account entitled *Sidereus Nuncius (The Starry Messenger)*, which told the story of his discovery (called the *perspicullum*) and included the diagram showing how it worked. He presented the first copy to the Grand Duke Cosimo II de' Medici along with the very object he had recently invented and described—the amazing telescope—a tool that would change the world.

ABOVE: Galileo's simple diagram outlined the optical principles for the telescope.

ABOVE: The title page of Sidereus Nuncius. Galileo's short booklet was the first publication to describe his telescopic findings. At the time of its publication, Kepler was still speaking in derogatory terms about the "two-lensed tube."

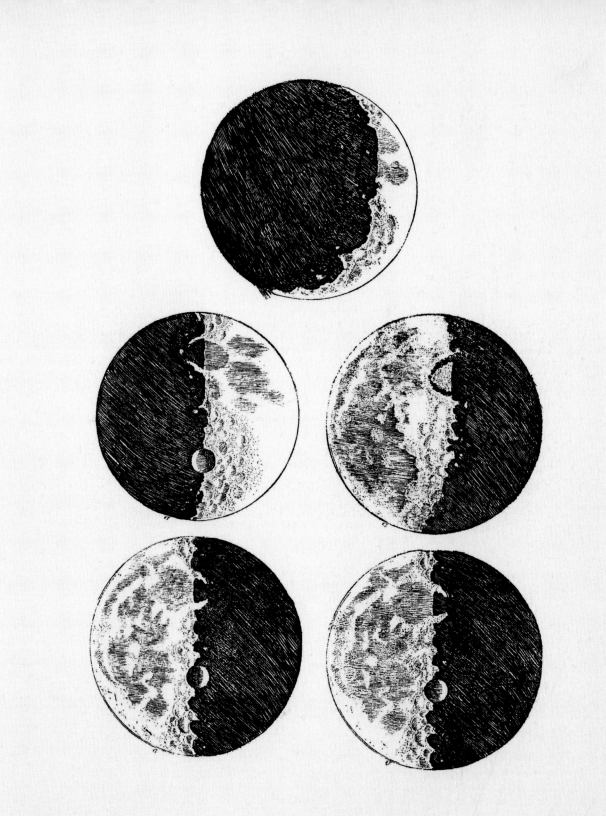

Moon Drawings

Galileo Galilei

In Sidereus Nuncius (The Starry Messenger), Galileo told how he used his newly invented spyglass to conduct the first telescopic observations of the Moon, and he included his stunning drawings showing what he had discovered—all of which had sweeping implications for scientific theory.

Galileo's remarkable illustrated account of his telescope (see page 96) included his observations of the heavens made with it on December 1 and 4, 1609. This included his report of what he had learned about the Moon and his discovery of four satellites around Jupiter. At the time, these achievements would bring him as much fame as his invention of the telescope, catapulting him to stardom in the scientific world.

Galileo put his artist's training, including his study of chiaroscuro, to work in drafting a series of pen-and-ink drawings and watercolors of what he had spied through his revolutionary instrument. These skills, together with his scientific background, enabled him to understand that the patterns of light and shadow now visible through his telescope were in fact topological markers on the Moon's surface. He realized that his diagrams showed the Moon's surface was not smooth and perfectly spherical, as commonly assumed, but was mountainous and pitted with craters. (Indeed, one crater he shows in accurate detail is Albategnius.) The terminator between lunar day and night is clearly seen down the center of his drawing.

His observations of Jupiter over successive nights revealed four star-like objects in a line with it. The objects moved from night to night, sometimes disappearing behind or in front of the planet. Galileo correctly inferred that these objects were moons of Jupiter, which orbited it just as the Earth's Moon orbits Earth. Using his telescope, he also was able to make out many fixed stars that had never been visible to the naked eye.

Galileo's findings had enormous ramifications. For the first time, objects had been observed orbiting another planet, thus weakening the hold of the Ptolemaic model. In short, the Earth was not the only center of rotation in the universe. His graphic depictions also undercut Aristotle's geocentric world view, which held that everything above the Earth was perfect and incorruptible; the work also upheld Copernicus's theory of the Heliocentric Universe since the circulation of four stars around Jupiter showed that the heavenly bodies could indeed revolve around centers other than the Earth.

Sidereus Nuncius initially came under intense criticism from the Catholic Church. But as his observations quickly received confirmation from other scientists, it made Galileo famous, eventually establishing his reputation as the "father of modern observational astronomy" and the "father of modern science."

> *OPPOSITE: Aided by his telescope, Galileo's drawings of the moon were a revelation. Until these illustrations were published, the moon was thought to be perfectly smooth and round. Galileo's sketches revealed it to be mountainous and pitted with craters.*

Movement of Objects

René Descartes

In his master work *Principles of Philosophy*, Descartes set forth the principle that in the absence of external forces, an object's motion will be uniform and in a straight line. Forty years later, Isaac Newton would later borrow this principle from Descartes to form his First Law of Motion.

Although the French writer René Descartes (1596–1650) is best known as the "father of modern philosophy," ("I think, therefore I am") he also made important contributions to physics and mathematics. In *Principles of Philosophy* (first published in Latin in 1644 and in French in 1647) Descartes sets forth the three laws of nature (physics) which essentially are laws of motion, which he defines as "the transfer of one piece of matter or of one body, from the neighborhood of those bodies immediately contiguous to it and considered at rest, into the neighborhood of others." The first law states "that each thing, as far as is in its power, always remains in the same state; and that consequently, when it is once moved, it always continues to move." The second holds that "every motion of itself is rectilinear; and hence what is moved circularly tends always to recede from the center of the circle it describes…The third law: that a body, upon coming in contact with a stronger one, loses none of its motion; but that, upon coming in contact with

a weaker one, it loses as much as it transfers to that weaker body." The work presented the most extensive discussion of motion that had occurred in science to that point.

Descartes used numerous analytic geometric diagrams to illustrate his theories. One sketch showed that a stone being whirled around in a sling in a circle and then released at a given point, A, will continue on a line tangential to the circle at A (toward point C) rather than continuing in a circular motion (toward B); even if the stone is not released at A, it "strives" toward C. "For if the stone were to leave the sling at the moment in time when, coming from L, it arrived at point A, certainly it would go from A toward C, not toward B; and although the sling may prevent this effect, it does not prevent the striving."

Forty years after Descartes' *Principles of Philosophy* was published, Isaac Newton would model his first law of motion on this Cartesian breakthrough. Yet Descartes' contributions to physics would not be fully credited until the mid-20th century.

{
OPPOSITE: *By using the example of an object being swung in a sling, Descartes stated that everything that is moved is "determined to continue its motion toward some direction along a straight line, and never along any curved line."*
}

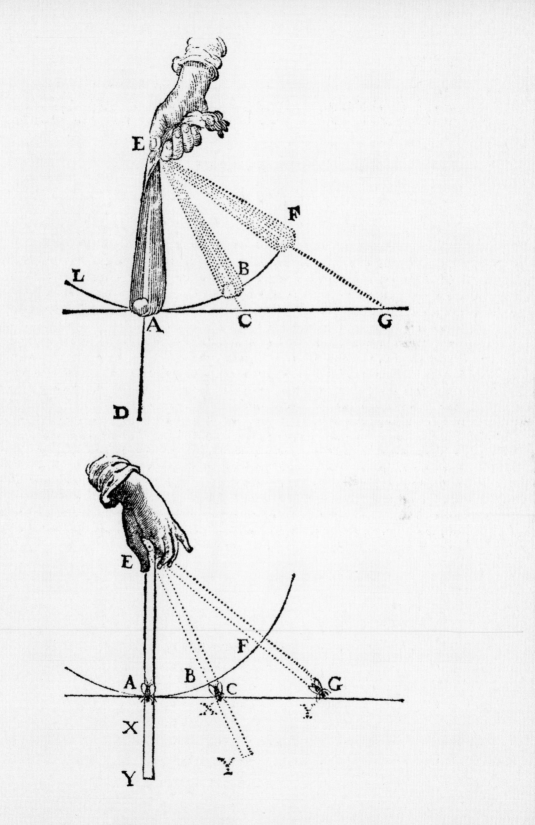

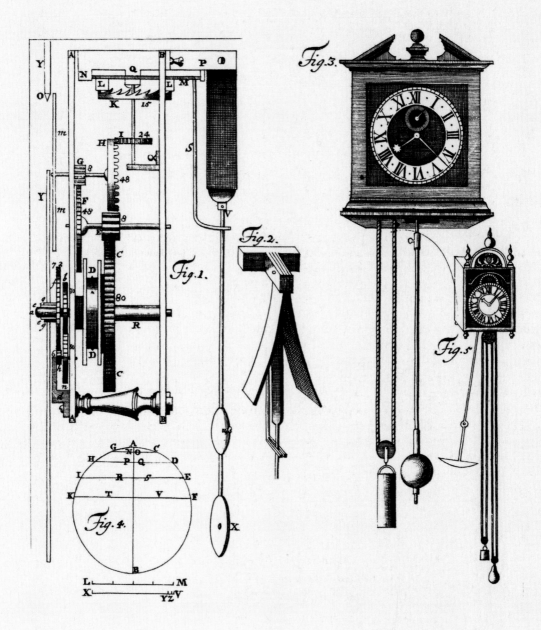

Pendulum Clock

Christiaan Huygens

A Dutch mathematician refined Galileo's idea to design the first successful pendulum clock, which represented a breakthrough in timekeeping and held sway as the most accurate type of clock for nearly 300 years.

Christiaan Huygens (1629–95) was a prominent Dutch mathematician, astronomer, and physicist who acted as a scientific explorer. His specialty was horology (the science of measuring time). In the mid-17th century astronomers, navigators, and other path-breakers felt the pressing need for a better clock that would be accurate to within a few seconds during a 24-hour period, not off by 15 minutes or more per day as with the existing and erratic "verge and foliot" timepieces that had been used since 1285.

Huygens had studied and admired the work of his great Italian predecessor, Galileo Galilei (c. 1564–1642), who had spent many years dealing with the clock problem until his blindness had stopped his work. Huygens knew that Galileo had discovered a key property of pendulums that might supply the answer—isochronism, meaning that the period of a pendulum's swing remains approximately the same even for different sized swings so that the time interval between swings stays the same. Therefore, Huygens worked on finishing Galileo's designs.

Huygens' diagrams called for his pendulum, consisting of a metal ball suspended by silk threads, to swing in a wide arc of about 30°. To minimize the effects of air and gear friction, he designed a thin rod for the pendulum and he enclosed the pendulum to shield it from drafts that would disrupt its movements. He also concentrated the mass at the bottom of the pendulum.

Huygens refined and completed Galileo's designs, and then contracted with the renowned instrument maker Salomon Coster (1620–59) in The Hague to build his first model of a pendulum clock. It was completed on Christmas 1656. Although the first working model used the older style of the verge escapement, the new clock was accurate to within one minute a day. Huygens' invention was patented in 1657.

Coster continued to be the authorized maker of pendulum clocks until his death in 1659. Soon the pendulum clock became the preferred type of timepiece in the Western world and it would remain so for nearly three hundred years.

{ OPPOSITE: *Huygens' patent for "a mechanical system of a clock driven by weights and pendulum." Huygens' invention was a breakthrough in accurate timekeeping. Most pendulum clocks that followed were constructed along the lines of his 1657 patent.* }

Micrographia

Robert Hooke

Published by the Royal Society, Hooke's prodigious and exquisitely illustrated book became one of the most important works in the history of science, showing readers what scores of tiny objects looked like under a microscope, and introducing the biological term "cell."

On his way to becoming the great experimental scientist of the 17th century, the multi-talented Robert Hooke (1635–1703) was still in his twenties when he produced his most famous work, *Micrographia*. A painstakingly accurate and supremely detailed record of his observations through one of the best illuminated microscopes of his time, Hooke's massive volume was full of astonishing text and magnificent drawings of organisms as diverse as spiders, mosquitoes, bryozoans, foraminifera, fungi, and peacock feathers—all blown up to gargantuan size to reveal incredible, never-before-seen features.

By the mid-17th century, crude microscopes had been around for hundreds of years, but advanced magnification was undergoing major improvement. Hooke's greatly enlarged images revealed a miniature world that most readers had never imagined: presented on oversized fold-out pages, the flea measured 18 in (45.7 cm) across and the scene of a louse gripping a human hair was nearly 2 ft (62 cm) wide. Extraordinary sights that previously had been invisible to the naked eye were now exposed as the spectacular "Head of a Fly," or "the Beard of a wild Oat."

Some of his Hooke's word descriptions were just as amazing. In his microscopic examination of cork tissue, he famously uncovered what appeared to be pores or "cells" that reminded him of tiny rooms in a monastery. He also presented groundbreaking ideas about distant planetary bodies, the wave theory of light, the organic origin of fossils, and countless other philosophical and scientific discoveries.

Readers were electrified. The illustrious diarist Samuel Pepys called *Micrographia* "the most ingenious book that ever I read in my life." Hooke's opus literally opened up a whole new world to scientific investigation. His work offered ordinary readers the chance to actually see what objects looked like beneath the surface. The instrument of the microscope could tell them things they hadn't known before—if only they would look.

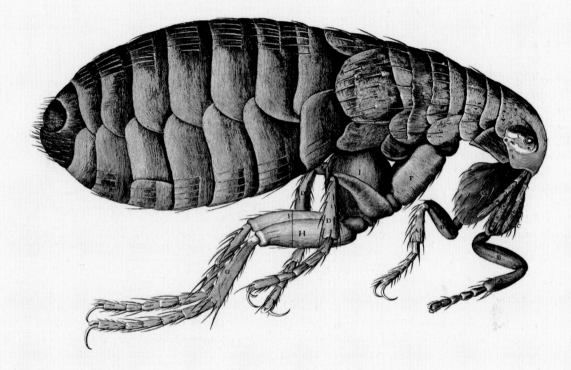

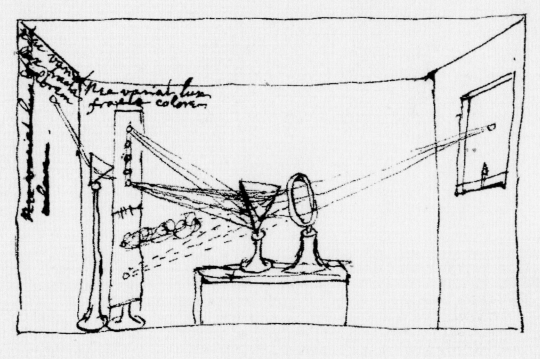

ABOVE: The notes that accompanied Newton's drawing explained that colors of the spectrum cannot themselves be individually modified, but are "Original and connate properties."

ABOVE: "Diagrams of optical phenomena, including the rainbow, the double Icelandic spar, and prism refraction" published in Newton's Opticks (1704).

Prism
"Crucial Experiment"

Isaac Newton

Using a pair of prisms he had bought at a country fair, a brilliant Cambridge mathematician conducted what he called "the Crucial Experiment," which solved the age-old mystery of light itself, demonstrating that white light is not pure, but made up of a number of different colors. Then he drew a crude but effective diagram that proved his point.

In the late 1660s, most educated people continued to believe that color was a mixture of light and darkness, and that prisms colored light. But Isaac Newton (1642–1727) suspected otherwise. Using two common prisms he had purchased, he conducted a long series of experiments to study the dispersion of white light by a single glass prism. Newton's most famous experiment, the "*experimentum crucis*," demonstrated his theory of the composition of light.

In a dark room, Newton allowed a narrow beam of sunlight to pass from a small hole in a window shutter through a prism, thus breaking the white light into an oblong spectrum on a board. Then, through a small aperture in the board, Newton selected a given color to pass through yet another aperture to a second prism, through which it was refracted onto a second board. What began as ordinary white light was thus dispersed through two prisms.

Newton believed that his "crucial experiment" demonstrated that a selected color leaving the first prism could not be separated further by the second prism. Thus he concluded that white light is a "eterogeneous mixture of differently refrangible Rays" and that colors of the spectrum cannot themselves be individually modified, but are "original and connate properties."

To prove his point, he drew a diagram in his notebook showing the results of his prism experiments. The sketch shows a sunbeam streaming through a hole in the window shutter on the right and falling on a prism. A spectrum appears on a screen in the middle of the room. The screen has a small slit in it that allows only the red portion of the spectrum to pass through. This red light then falls on a second prism positioned to the left of the screen. Only red light is seen emerging from the second prism.

"I concluded that the true cause of the length of the Spectrum is none other than that Light consists of Rays that are each refracted by a different amount," Newton wrote. "Light is not simple or homogeneous, but consists of different Rays, some of which are refracted more than others. This is not because of any force exerted by the glass or any other cause, but from every particular Ray's natural tendency to experience a particular amount of Refraction."

Bacteria

Antony van Leeuwenhoek

Van Leeuwenhoek was the first to observe and draw microscopic organisms he called "animalcules," which Christian Gottfried Ehrenberg in 1828 labelled as "bacterium."

Antony van Leeuwenhoek (1632–1723) was a Dutch lens grinder who was so inspired by reading Robert Hooke's *Micrographia* (see page 104) that he began manufacturing some of the highest-quality microscopes of his day—devices that magnified objects over 200 times, with clearer and brighter images that enabled him to see more than others had ever dreamed.

While not a scholar, Leeuwenhoek in 1673 wrote his first letter to the newly formed Royal Society of London, describing what he had just microscopically observed about the stings of bees. It would prove the beginning of a 50-year correspondence, and at least 200 of his letters, written in Nether-Dutch, were translated into English or Latin and printed in the *Philosophical Transactions of the Royal Society*. Although the subjects seemed randomly chosen and his down-to-earth style did not conform to scientific conventions, Leeuwenhoek's letters represented the first time that anyone had tried to describe the microscopic world of red blood cells, spermatozoa, and other common microorganisms.

On September 17, 1683, in what would become his most famous letter, Leeuwenhoek told how he took from between his teeth "a little white matter, which is as thick as if 'twere batter" (plaque). Having always prided himself on keeping very clean teeth, he was amazed when he examined the material under his microscope. "I then most always saw," he wrote, "with great wonder, that in the said matter there were many very little living animalcules, very prettily a-moving. The biggest sort ... had a very strong and swift motion, and shot through the water (or spittle) like a pike does through the water. The second sort ... oft-times spun round like a top ... and these were far more in number." Then the curious observer looked at matter taken from the mouths of two respectable ladies

and two old men who had never cleaned their teeth. From the mouth of one of the old men, the microscopist found "an unbelievably great company of living animalcules, a-swimming more nimbly than any I had ever seen up to this time. The biggest sort. . . bent their body into curves in going forwards. . . Moreover, the other animalcules were in such enormous numbers, that all the water. . . seemed to be alive."

Leeuwenhoek was so impressed that he included with his letter a diagram showing exactly what he had discovered under the microscope. Not only were his the first recorded observations of living bacteria—he had also described and illustrated five different kinds of bacteria present in his own mouth: what today is readily identified as a motile bacillus, Selenomonas sputigena, a micrococcus, Leptothrix buccalis, and a spirochete—which was quite a mouthful.

*ABOVE: **Leeuwenhoek's single-lens microscope was capable of magnifying objects over 200 times.***

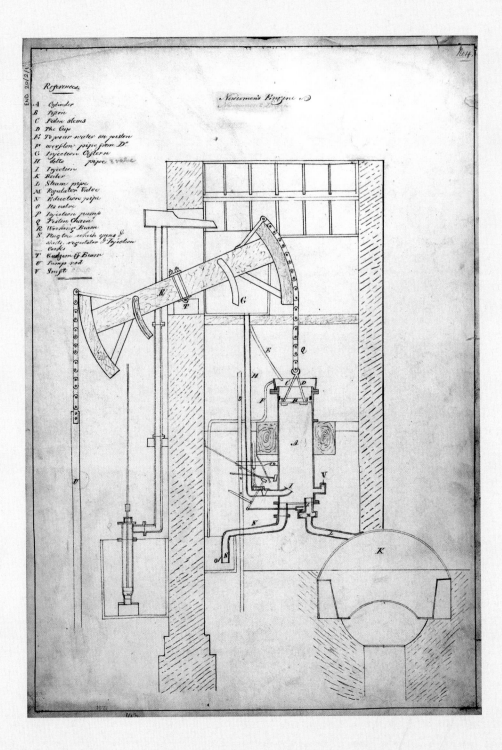

Steam Engine

Thomas Newcomen

Newcomen made a significant contribution to the Industrial Revolution with his "atmospheric engine." The English ironmonger's device paved the way for James Watt's steam engine of 1769, which helped make Britain the first industrial nation.

Scotsman James Watt might be forever viewed as the pioneer of steam power, but it was Englishman Thomas Newcomen, an ironmonger from Dartmouth in Devon, who devised the first practicable Atmospheric Steam Pumping Engine around 1710. Newcomen not only sold iron goods but fabricated parts himself, bringing him into contact with the many lucrative tin mines in neighboring Cornwall. Flooding in the mines was a constant hazard and it was a costly business pumping them out. The problem had partly been solved by English military engineer Thomas Savery whose 1698 patent for "raising water and imparting motion to all sorts of mill-work by the impellant force of fire" relied upon vacuum and atmospheric pressure to raise water from below, driven upwards by high-pressure steam directed down to the flooded area. Newcomen's design was a far more ingenious use of the "impellant force of fire" that employed low-pressure steam and atmospheric pressure to provide motive power. His invention was a real engine and was not limited by the pressure of the steam as it was with Savery's design.

Newcomen started his steam engine by opening a valve and letting steam at low atmospheric pressure pass from a boiler into a large cylinder fitted with a sliding piston. The action of the engine was transmitted through a rocking beam, the fulcrum of which rested on the solid end-gable wall of the engine house with the pump side projecting out of the building. A counterweight attached to a rocking beam was then able to raise the piston. Once the piston reached the top of the cylinder, the operator sprayed cold water into the cylinder, rapidly condensing the steam inside it. The resulting partial vacuum allowed the pressure of the surrounding atmosphere to push down on the upper surface of the piston. The powerful downward stroke of the piston worked the rocking beam, which was in turn used to drive a pump or other machinery.

The location of his first successful working engine is lost to history but records show that one was operated by Newcomen and his partner John Calley at the Conygree Coalworks near Dudley in 1712 and also nearby in Wolverhampton. The flaw in Newcomen's design was its 1% efficiency and voracious appetite for coal. The prodigious consumption of fuel limited its use to coal mines, where there was a massive supply of cheap low-grade coal and industries that could justify the expense of bunkering huge amounts of solid fuel. However Newcomen's design paved the way for James Watt's steam engine of 1769, which crucially added a condenser, reducing the amount of coal needed to run the engine and allowing many more industries to embark on steam mechanization, ultimately allowing Britain to become the first industrial nation.

OPPOSITE PAGE: While earlier engines had used condensed steam to make a vacuum, Newcomen created his vacuum inside a cylinder and used it to pull down a piston. It took another 60 years before his invention found a technological rival.

Machine Gun

James Puckle

In an age of cumbersome one-shot firearms, an English lawyer invented the first machine gun—a tripod-mounted, single-barrelled flintlock weapon fitted with a multi-shot revolving cylinder—which worked quite well, but did not catch on because it was ahead of its time.

Since the 14th century, there had been many attempts to produce a small caliber, rapid-fire weapon. Leonardo da Vinci was among those who designed one. However, the first workable ancestor of the machine gun was introduced in the early 18th century. In 1717 James Puckle (1667–1724), a London solicitor and writer, designed and demonstrated his portable Defence Gun. Intended for shipboard use to prevent boarding, the so-called Puckle gun resembled a large flintlock revolver with a multi-shot revolving cylinder that was mounted on a tripod and capable of firing up to nine rounds per minute. But the military brass rejected his invention.

Nevertheless, Puckle kept trying. He obtained a patent on May 15 , 1718 and established a company to manufacture and market the gun. According to his diagram, the loaded cylinder was lined up with the barrel and locked in place, thrusting the chamber mouth into the rear end of the barrel to seal the joint against gas leaks. A manually operated crank movement brought the chambers one by one to the breech of the gun's single barrel. Then a lever was tripped to release the cock of a flintlock mechanism, which ignited the charge in the chamber. After the first shot, the cylinder was unclamped,

adjusted to align the next loaded chamber with the barrel, reclamped, and fired again. Once the cylinder was empty, the operator could loosen the crank, allowing it to be taken off and a fresh one loaded.

In one amazing demonstration on March 22, 1722, Puckle fired 63 shots in seven minutes in a driving rainstorm on the London Artillery Ground. Every musket ball landed with great force, which was quite a feat at a time when the standard soldier's musket could at best be loaded and fired no more than three times per minute. John Montagu, Second Duke of Montagu and Master-General of the Ordnance, was so impressed that he purchased several of the guns for his foiled attack on St. Lucia and St. Vincent. But the Puckle Gun never achieved wide use because British gunsmiths at the time found the weapon's manufacturing requirements too challenging.

Re-emergence of the machine gun did not occur until the 1860s, when Richard Gatling's revolving Gatling guns were used in the American Civil War. Starting in the First World War, more advanced versions made the machine gun one of the most lethal weapons in modern warfare—200 years after Puckle's invention.

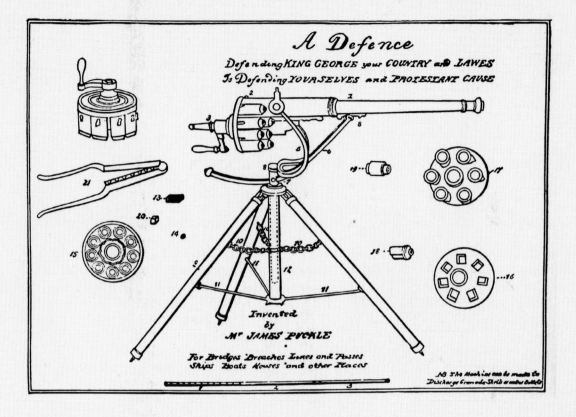

A Defence

Defending KING GEORGE your COUNTRY and LAWES
Is Defending YOURSELVES and PROTESTANT CAUSE

Invented
by
Mr JAMES PUCKLE

For Bridges Breaches Lines and Passes
Ships Boats Houses and other Places

NB The Machine can be made to
Discharge Granade Shells or other Bullets

ABOVE: The patent drawing for James Puckle's Defence Gun looks surprisingly modern. Mounted on a tripod, its multi-shot revolving cylinder was capable of firing nine shots per minute. Puckle's invention was the prototype machine gun.

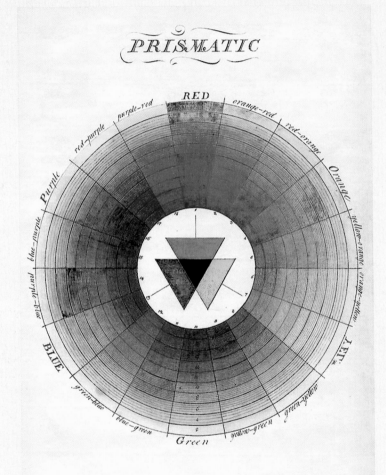

Color Wheel

Moses Harris

Sixty years after Isaac Newton separated white light through a prism and created color, an 18th-century engraver and entomologist devised the first known color wheel showing all primary and secondary colors. His exacting drawings of this precise classification system proved extremely useful to artists, printers, and dyemakers.

In *Opticks* (1704) Isaac Newton announced that his prism studies had determined there to be seven primary colors; he was also the first to arrange hues on a wheel based on their spectral tone. But persons seeking to obtain certain precise colors quickly found that Newton's scheme had several shortcomings, and others tried to come up with a better schematic.

Finally, Moses Harris (1731–85), an English entomologist and engraver, unveiled a new theory of color classification, which was published as *The Natural System of Colours* (London, 1766). Harris concluded that contrary to Newton's theory, there were instead three grand primary colors (red, yellow and blue), so that all hues could be reduced to mixtures of red, yellow and blue pigments; and there were also three compound principals (orange, green and violet). To illustrate his theory, Harris produced a Prismatic circle diagram consisting of 11 concentric circles. In the center, he drew the three pigment primaries (which he called "primitives") as overlapping colored

triangles. The resultant intermediate colors are taken as the basis for a second circle of mixed "compound" colors in two intermediate stages. This created a total of 18 colors: red, orange-red, red-orange, orange, yellow-orange, orange-yellow, yellow, green-yellow, yellow-green, green, blue-green, green-blue, blue, purple-blue, blue-purple, purple, red-purple, and purple-red. These 18 colors were numbered and graded into shades (darker values, which he created by optically mixing more closely placed black lines) and tints (lighter values, normally created by adding white, but he showed wider spacing between the black lines). At the center of his circle, Harris demonstrates that black will be formed through the superimposition of the three basic colors of red, yellow and blue.

Harris insisted that perfect colors such as those in his prismatic circle should be described by precise words that mean nothing but that color. His color wheel classification system enabled users to both identify more colors and to mix them to achieve the desired result.

> OPPOSITE: *Moses Harris's chart was the first full-color circle. The 18 colors of his wheel were derived from what he then called the three "primitive" colors: red, yellow, and blue. At the center of the wheel, Harris showed that black is formed by the superimposition of these colors.*

A New Chart of History

Joseph Priestley

Before he discovered oxygen, the British polymath gained fame for his charts of biography and history that introduced the timeline as a means of visualizing life spans and important historical events.

The Englishman Joseph Priestley (1733–1804) was a leading theologian, natural philosopher, chemist, physicist, educator, progressive political theorist, and dissenter, who first achieved fame and commercial success while serving as a lecturer at Warrington Academy. Priestley designed unusual charts to serve as visual study aides for his lectures in history. In an effort to better understand the relationship between historical figures, Priestley recorded their dates of birth and death on a time chart. As he explained, the charts proved useful in helping the reader quickly grasp how the persons fit into their historical period; for "as soon as you have found the names," he wrote, "you see at one glance, without the help of Arithmetic, or even of words, and in the most clear and perfect manner possible, the relation of these lives to one another." Known as the first timeline charts, Priestley's new graphic device used individual horizontal bars on a time grid to visualize life spans. He also invented the convention of using dots (...) to indicate uncertain birth and death dates. (In fact, he went so far

as to grade uncertainty into five levels using different numbers of dots.) The trustees were so impressed by his invention that they arranged for him to receive his doctor of law degree from the University of Edinburgh. For his book, *Chart of Biography* (London, 1765) Priestley prepared schematic diagrams showing the life spans of 2,000 famous persons in history, from 1200 BC to 1750. The work became a huge seller.

Four years later, Priestley published another masterful work containing more elaborate timelines to graphically depict important historical events. He believed that his charts would allow students to "trace out distinctly the dependence of events to distribute them into such periods and divisions as shall lay the whole claim of past transactions in a just and orderly manner." His book, *A New Chart of History* (London, 1769) was also a major success. Priestley's charts also utilized color, type size, type face, the density of the entries on the page, overlapping lines, and other visual features to convey as much information as possible about his subject.

OPPOSITE: *The regularized distribution of dates on Priestley's chart and its horizontal composition help to emphasize the continuous flow of time. This innovative, colorful timeline allowed students to survey the fates on 78 kingdoms in one chart.*

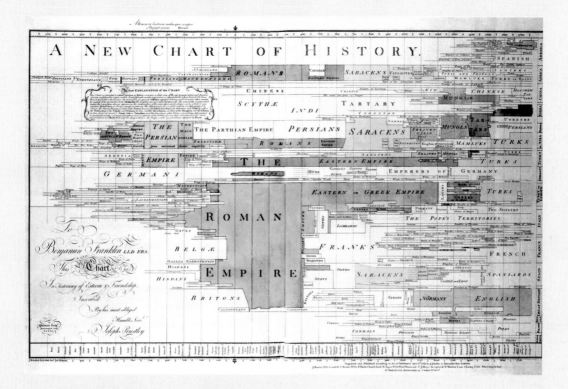

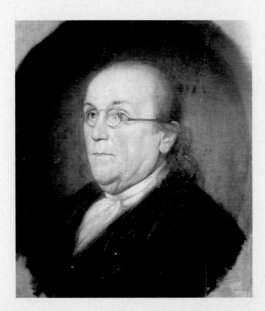

Bifocals

Benjamin Franklin

While a few historians still quibble over who invented bifocal eyeglasses, most credit Benjamin Franklin for the advance, based in part on his letter and diagram describing his handy "double spectacles."

By the end of the American Revolution, some type of visual instruments had been around for more than 18 centuries, dating back to the Romans. Seneca was said to have peered at his books through a glass globe of water and Nero held an emerald to his eye to watch the gladiators fight. Around AD 1000, presbyopic monks utilized an early magnifying glass, known as the reading stone, as a reading aid, and the glass-making Venetians later discovered how to construct lenses that could serve the same purpose. As the great English philosopher Roger Bacon had written in his *Opus Majus* in 1268: "If anyone examine letters or other minute objects through the medium of crystal or glass or other transparent substance, if it be shaped like the lesser segment of a sphere, with the convex side toward the eye, he will see the letters far better and they will seem larger to him. For this reason such an instrument is useful to all persons and to those with weak eyes for they can see any letter, however small, if magnified enough."

The learned and enterprising Benjamin Franklin (1706–90) was of course aware of all such advances, but as a (longsighted) hyperope he could not make out anything close by without his spectacles, which was a serious impediment for a man of letters. Spectacles were Franklin's trademark, as shown in all of his portraits and cartoons. A few of these appear to show that sometime in the 1760s that Franklin began wearing an unusual type of eyeglasses, which other accounts indicate he had custom-made to suit his specifications.

On August 21, 1784, while serving in France as the American envoy to the Court of Louis XVI, the 78-year-old polymath wrote a letter to his close friend George Whatley. "I cannot distinguish a letter even of large print," Franklin confided; "but am happy in the invention of double spectacles, which serving for distant objects as well as near ones, make my eyes as useful to me as ever they were: If all the other defects and infirmities were as easily and cheaply remedied, it would be worth while for friends to live a good deal longer." Along with his handwritten comments, the old man included a copy of his diagram showing a pair of spectacles in the style he favored. The lenses were bisected, and the ones on the bottom were labeled "most convex for reading," whereas he had described the lenses on the top half as being "least convex for distant objects."

Franklin recommended double spectacles to many of his friends and the style became popular. Later called bifocals, they became one of the best known and most useful of all his practical inventions.

OPPOSITE: Franklin's letter to his close friend George Whatley (above) contained the first diagram of his "double spectacles." He is shown wearing his invention in this 1787 portrait (below) by Charles Willson Peale. This was the last portrait made during Franklin's lifetime.

Bar Chart

William Playfair

A nonconformist Scotsman invented a number of revolutionary methods to graph statistics, including the simplest and most basic one for making numerical comparisons—the bar chart.

William Playfair (1759–1823) came from an illustrious family: his eldest brother John was Scotland's leading mathematician and his brother James was a prominent architect. William began to distinguish himself at a young age, as well. When he was 13 his father died and he was apprenticed to Andrew Meikle, the inventor of the threshing machine; by age 18 he was serving as personal assistant to the great mechanical engineer James Watt of steam engine fame, for whom he prepared expert engineering and patent drawings. Playfair's early career combined a high degree of mathematical and empirical science with practical engineering skills; he was also a skilled millwright, silversmith, engraver, accountant, and pamphleteer, although he encountered various financial difficulties and political scrapes, which kept him from gaining financial security.

Well schooled in geography and cartography, Playfair was an admirer of Joseph Priestley (see page 116). He had been inspired by Priestley's successful innovation of timeline charts that utilized individual bars to graphically depict persons' lifespans. In 1785, as Playfair prepared a manuscript on English trade, he advanced the novel idea, "The amount of mercantile transactions in money, and of profit or loss, are capable of being as easily represented in drawing, as any part of space, or as the face of a country."

His treatise was published in 1786 as *The Commercial and Political Atlas: Representing, by Means of Stained Copper-Plate Charts, the Progress of the Commerce, Revenues, Expenditure and Debts of England during the Whole of the Eighteenth Century,* becoming the first publication to contain statistical charts.

Among its extensive diagrams there was one that appeared in a different format from the others; it was also the only one that did not include the dimension of time, for which Playfair apologized, saying, "This Chart … does not comprehend any portion of time, and it is much inferior in utility to those that do." The chart was entitled, "Exports and imports of SCOTLAND to and from different ports for one Year from Christmas 1780 to Christmas 1781," and it featured an explanation at the bottom which stated: "The Upright divisions are Ten Thousand Pounds each The Black Lines are Exports the Ribbed-lines Imports." Playfair's simple diagram, called a bar chart or bar graph, established a new method of using rectangular bars with lengths proportional to their numerical values. The spare, easy-to-understand design enabled a reader to quickly grasp the numerical comparisons.

Although the value of Playfair's graphic work was not widely appreciated until the mid-19th century, the bar chart has become one of the most commonly used tools of presenting statistical comparisons.

![Exports and Imports of SCOTLAND to and from different parts for one Year from Christmas 1780 to Christmas 1781. A horizontal bar chart showing export and import values for various places, with a scale marked in tens of thousands of pounds from 10 to L300,000. Place names listed on the right include: Names of Places, Jersey &c., Ireland, Poland, Isle of Man, Greenland, Prussia, Portugal, Holland, Sweden, Guernsey, Germany, Denmark and Norway, Flanders, West Indies, America, Russia, Ireland. Note at bottom reads: The Upright divisions are Ten Thousand Pounds each. The Black Lines are Exports the Ribbed lines Imports.]

ABOVE: Playfair's black and white diagram showing Scottish imports and exports was published in his Commercial and Political Atlas (1786). This was the first bar chart to appear in print.

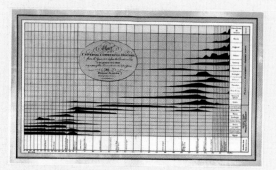

ABOVE: This colorful "Universal Commercial History" bar chart by Priestley was published in 1805.

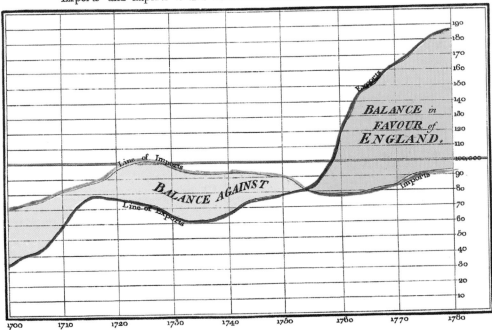

Exports and Imports to and from DENMARK & NORWAY from 1700 to 1780.

The Bottom line is divided into Years, the Right hand line into L10,000 each.

Published as the Act directs, 1st May 1786. by Wm. Playfair

Neele sculpt 352, Strand, London.

Line Graph

William Playfair

As the first person to depict socioeconomic data in line-graph format, Playfair appreciated that visual comparisons of size could be made more rapidly, and almost as accurately, by comparing the areas of similar figures than by comparing the numerical quantities themselves.

As its title indicated, William Playfair's *Commercial and Political Atlas* of 1786 was modeled on the familiar geographical atlas. Yet the volume contained no geographical maps. It was also unusual in format: the layout was landscape and the text was supplemented with numerous foldouts, many of them two to three times larger than the volume itself. But the book's most original feature became revealed when the reader opened the fold-outs. For the author had prepared a series of 34 copper-plate engravings about the import and export from different countries over the years, and each presentation differed from the traditional lists or tables of numerical data that one might find in other economic reports of the day. Instead, all but one, the bar chart (see page 120), took the form of clearly marked colored line graphs or surface charts together with instructions, such as a map key that explained to the reader the significance of the graphic lines. Playfair had invented the first line graphs.

His plates had several basic features: graduated and labeled axes; grid lines; a title; labels; lines indicating changes in the data over time; and color coding to categorize the different time series and accumulated quantities. Each line graph depicted actual, missing, and hypothetical data, differentiating the various forms by means of solid or broken lines as well as color coding and other graphic devices. Each had a brief descriptive title at the top, telling what the chart was about, such as "Exports and Imports to and from DENMARK & NORWAY from 1700 to 1780," along with brief indicators that labeled the axes. Most of the charts in the Atlas used the slopes of lines to indicate trends, such as increases or decreases in exports or imports during a specific period.

Playfair's statistical charts indicated that he understood that line graphs could prove extremely practical and useful in depicting numerical comparisons—provided they were simply constructed and easy to read. In most cases, a reader could quickly grasp what trend was being shown. The fluctuations were clear. And the implications could be pondered at will.

OPPOSITE: William Playfair was the first person to display demographic and economic data in graph form. His clearly drawn, color-coded line graphs show time on the horizontal axis and economic data or quantities on the vertical axis.

Brooks Slave Ship

Thomas Clarkson

The slave ship *Brooks* was first drawn and published by the Society for Effecting the Abolition of the Slave Trade in November 1788. It was published in Bristol the following year and would be redrawn and republished many times in Britain and America in the years that followed. It came to epitomize the cruelties of the trade in enslaved Africans of the 18th and 19th centuries and the struggle to abolish that trade.

In 1788 the abolitionist Thomas Clarkson commissioned two wooden models of the *Brooks* slave ship—one of which was given to William Wilberforce, Member of Parliament for Hull. Wilberforce showed the model to Members in the House of Commons during the campaign to abolish the slave trade, using it as a visual aid to highlight the brutality of a sea voyage. At the same time, a poster based on the deck plans was widely distributed among abolitionists up and down the country. The poster misspelled the ship's name as *Brookes*, by which it is now commonly known.

The many drawings that were published of the *Brooks* became a landmark in the understanding of visual propaganda. The diagrams managed to communicate, at a glance, an incontestable evil. The drawings carried their message into the minds of those who weren't willing or able to read the abolitionists' carefully mustered petitions and witness statements.

The drawing undermined all claims about the pleasant and commodious conditions enjoyed by those taken on the Middle Passage from Africa to the Americas. But the diagram wasn't, strictly speaking, a documentary record. It was a hypothetical projection. The Plymouth branch of the committee had discovered a plan of a loaded slave ship. In London, Clarkson and his colleagues applied its visual scheme to a ship that was in the news. A Privy Council inquiry into the slave trade had measured the internal dimensions of a number of vessels and published the results. The committee chose a Liverpool slaver, the *Brooks*, as an example: it was the first one on the inquiry's alphabetical list.

"This print seemed to make an instantaneous impression of horror upon all who saw it," Clarkson wrote. It became one of the first political posters. In April 1789 it was published in an initial run of 700 and was widely circulated. Other editions and other versions followed.

{ OPPOSITE: *One of the many reproductions of the drawing commissioned by Thomas Clarkson in 1788. The full title of the original poster is Stowage of the British Slave Ship Brookes under the Regulated Slave Trade Act of 1788.* }

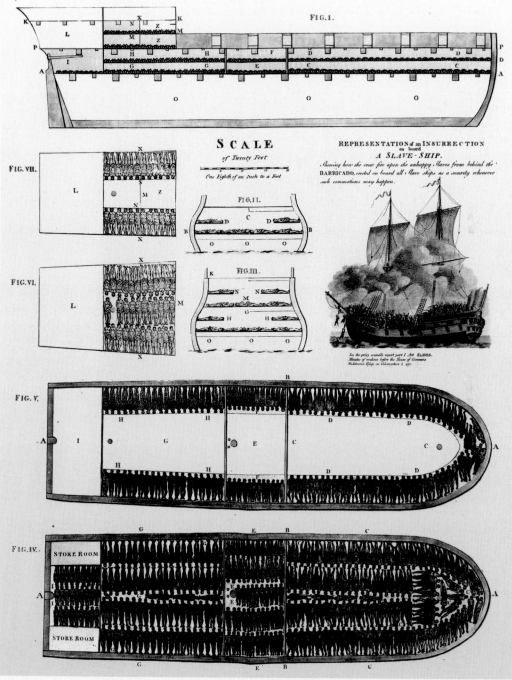

PLAN AND SECTIONS OF A SLAVE SHIP.

FIG.I.

FIG. VII.

SCALE
of Twenty Feet

One Eighth of an Inch to a Feet

FIG.II.

FIG.VI.

FIG.III.

REPRESENTATION of an INSURRECTION
on board
A SLAVE-SHIP.

Shewing how the crew fire upon the unhappy Slaves from behind the
BARRICADO, erected on board all Slave ships as a security whenever
such commotions may happen.

See the privy council's report part I. Art SLAVES.
Minutes of evidence before the House of Commons
Wadstroms Essay on Colonization & 1771.

FIG. V.

FIG.IV.

STORE ROOM

STORE ROOM

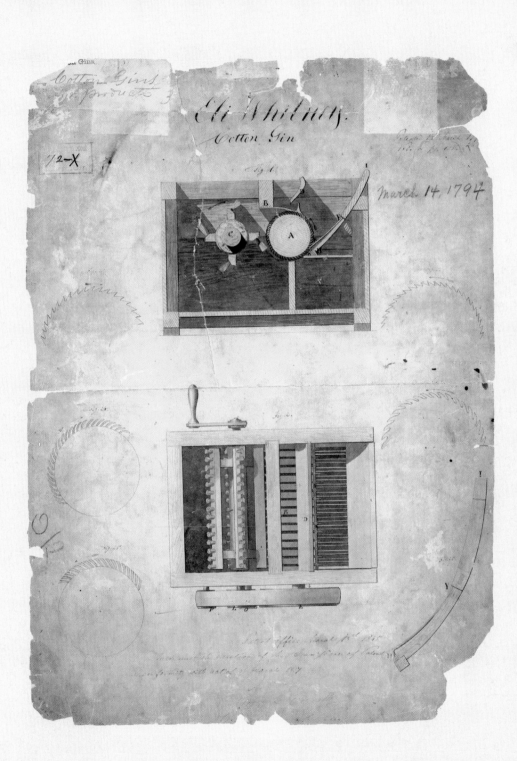

Cotton Gin

Eli Whitney

As one of the key inventions of the Industrial Revolution, a Connecticut Yankee's new machine made upland short-staple cotton into an immensely profitable crop, bolstering the economy of the American South and turning the US into a major exporter; in the process it also hardened the institution of slavery in the United States.

Prior to the late 18th century, the economy of the American South turned on tobacco, rice, indigo, and a few other staple crops, and the peculiar institution of slavery seemed destined for gradual extinction there, as had been happening in the North. As one French visitor (François-Jean de Chastellux) remarked, Southerners were "constantly talking of abolishing slavery, and contriving some other means of cultivating their estates." Cotton production in particular had proved too labor-intensive to be very profitable.

In 1793, however, a rambling Connecticut Yankee named Eli Whitney (1765–1825) hatched the bright idea of constructing an engine ("gin" for short) that would mechanically separate lint from the seeds of upland, short-staple cotton, thus greatly enhancing the material's commercial value. As a result, within a just a few decades, mass-produced cotton not only became king of the South's economy, but also America's leading export—the pillar of innumerable Southern plantations, Northern textile mills, shipping and Wall Street fortunes, and the impetus for more cheap labor to capitalize on the country's newfound bonanza. Legions of Negro slaves suddenly became Dixie's prized cotton pickers.

As shown in his patent diagrams, Whitney's simple design for the cotton gin used a combination of a wire screen and small wire hooks to pull the cotton through the machine, while brushes continuously removed the loose cotton lint to prevent jams. His introduction of "teeth" to comb out the cotton and separate the seeds, along with the advent of interchangeable spare parts, made the device a huge moneymaker for many planters and others.

Whitney and his partner, Phineas Miller, received a patent on March 14, 1794, but a decision protecting their invention was not rendered until 1807. In 1812, Congress denied the inventor's petition for a renewal of the patent, meaning Whitney himself was not able to cash in from his machine that was so simple to replicate.

Whitney's invention altered the course of the Industrial Revolution and furnished America's new formula for success. Under this new arrangement, Northern technological superiority and industrial enterprise would combine with Southern natural resources and slavery-based labor to make the United States a formidable economic power on the world market.

OPPOSITE: *Whitney received his patent in March 1794. His drawings reveal a simple design using a combination of a wire screen and small wire hooks to pull the cotton through the machine. His invention would alter the course of the Industrial Revolution in America.*

(1796)

Phrenology

Franz Joseph Gall

In the earliest and most primitive effort at brain mapping, a Viennese physician devised a visible means of measuring the human skull to identify a variety of behavioral traits based on localized brain function. Although this approach remained popular until the mid-19th century, phrenology was eventually dismissed as a pseudo-science—another mismeasure of man.

In the late 18th century, the Paris-trained Viennese anatomist and physician Franz Joseph Gall (1758–1828) focused on the study of the human brain, particularly on the function of its various components. At about age nine, Gall had noticed a classmate who had a superior memory but inferior verbal skills; he also observed that the boy had bulging eyes. Gall thought he noticed the same combination in another child and he began to posit the idea that bulging eyes were a mark of good memory. Many years later the eccentric Gall commenced a long-term study to explore his theory. He examined 300 crania of individuals who had been known as gifted writers, poets, statesmen, criminals, lunatics or some other designation; he also acquired casts of 120 familiar living persons. His goal was to systematically classify and study their skulls to determine if he could find signs that differences in their brains might account for their individual behavior. Gall thought he could correlate specific mental faculties to bumps and depressions on the surface of the skull, its exterior forms, or relative dimensions. Perhaps the most exciting product of his research was his creation of detailed topological maps of the brain showing the telltale signs. His fascinating diagrams elicited great interest on the lecture circuit.

Gall first began to sketch the basic lines of his "skull theory" in lectures held in Vienna in 1796. He later collaborated with J.G. Spurzheim (1776–1832) to author *Recherches sur le système nerveux en général, et sur celui du cerveau en particulier* (*Studies on the nervous system, with particular attention to the brain*), which was first published in Paris in 1809. Its four basic principles held that (1) human moral and intellectual faculties are innate; (2)

their function depends on organic structures (of which Gall identified 27); (3) the brain is the organ of "all faculties, of all tendencies, of all feelings"; and (4) "the brain is composed of as many organs as there are faculties, tendencies, and feelings."

Gall's science of "craniology" or "organology" later became known as phrenology. The first published phrenological diagrams were engravings showing skulls with 35 or more particular "organs" delineated and numbered. These organs were said to control an individual's capacity for language, parental love, mirth, sublimity, hope or other activities. They appeared in the *Philosophical Magazine* in 1802. While Gall is credited or blamed for inventing phrenology, it was his collaborator Spurzheim who publicized the image of a human head to illustrate the craniological map of the organs. This visible and easy-to-learn structure quickly captured the imagination of thousands of followers, but the practice fell out of fashion in the 1850s.

OPPOSITE: *A late 19th-century illustration based on Gall's research, showing the various traits supposedly detectable in a phrenological study of the human head. These easy-to learn, visual aids helped turn phrenology into an extremely popular science.*

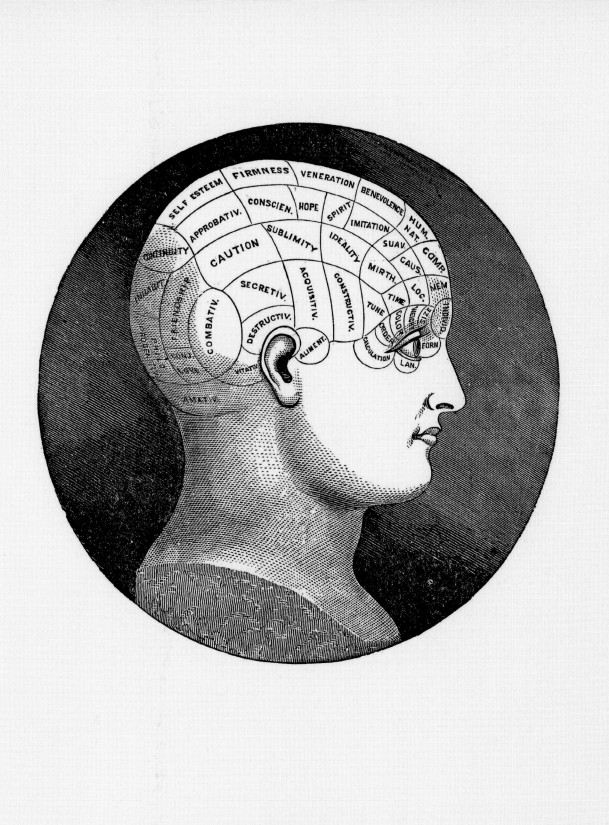

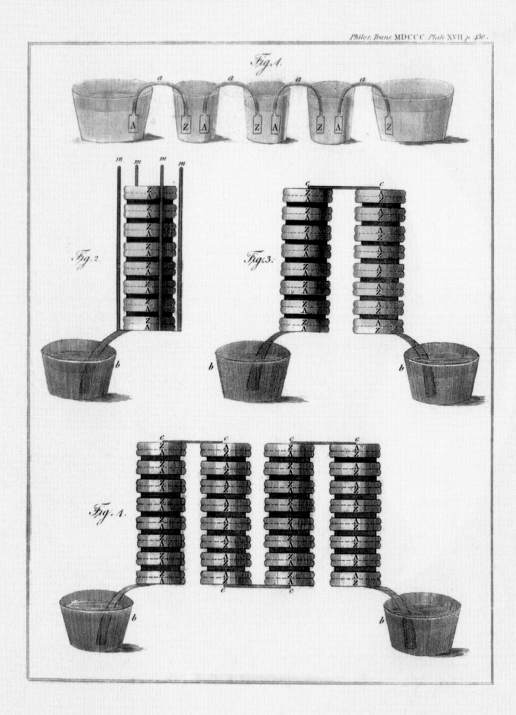

Electrical Circuit Diagram

Alessandro Volta

An Italian physicist's studies of static electricity led him to diagram and build a "voltaic pile"—the first electric battery capable of producing a steady, continuous flow of electricity.

At the end of the 18th century, Alessandro Giuseppe Antonio Anastasio Gerolamo Umberto Volta (1745–1827) was professor of experimental physics at the University of Pavia in Italy, where he had been conducting research on static electricity. Eventually he discovered that he could generate electricity himself by creating certain conditions.

Volta recorded his most successful study in a diagram. He had experimented with creating individual electric cells in series, each cell being a wine goblet filled with brine into which the two dissimilar electrodes were dipped. (Through trial-and-error he had determined that the most effective pair of dissimilar metals to produce electricity was zinc and silver.) Later he replaced the goblets with cardboard soaked in brine.

On March 20, 1800, Volta wrote a letter (in French) to Sir Joseph Banks, the president of the Royal Society of London. In it he reported how an electric apparatus could be assembled. He noted he had gathered silver and zinc discs and piled them up in a huge pile, one on top of the other, separating each pair with cardboard soaked in salt water. "In this manner," he wrote, "I continue coupling a plate of silver with one of zinc, and always in the same order, that is to say, the silver below and the zinc above it, or vice versa, according as I have begun, and interpose between each of those couples a moistened disk." When Volta touched the two ends of the pile, he felt a shock. The higher the pile, the greater the shock. He called his phenomenon the "voltaic pile."

A detailed sketch of this arrangement was published in Volta's paper in the September 1800 issue of the *Philosophical Transactions*, and shows his "chain of cups" apparatus (upper part), and the "columnar apparatus" (middle and lower parts), somewhat resembling a modern battery.

Volta's invention soon became a big success. Napoleon showered him with awards and named him Count Volt. His voltaic pile became the prototype for the modern electric battery.

OPPOSITE: *This diagram of the first battery was published in 1800. Volta's "pile" was a series of alternating zinc and copper discs separated by saline-soaked leather pads. When a wire connected the top and bottom discs, a current flowed through the wire.*

Steam Locomotive

George Stephenson

An English engineer pioneered improvements in steam locomotives and designed and built the world's first public railway line, revolutionizing transportation.

Others had been tinkering with the idea of a steam locomotive for several years before George Stephenson (1781–1848) came on the scene, but nobody would do more than he to develop it into the railway locomotive system. As a young civil engineer and mechanical engineer, he began drawing plans for his own steam locomotive and in 1813 he commenced the hard task of constructing it by hand, shaping each ponderous piece like a blacksmith forging gigantic horseshoes. He tested his iron horse, *Blücher* at Killingworth Colliery on July 25, 1814, hauling eight loaded coal wagons weighing 30 tons, at a speed of about 4 mph on an uphill track for 450 ft (137 m)—making his the first steam locomotive to run on a railroad.

Stephenson's new steam engine prototype was too heavy to run on wooden rails and iron rails were still not available, so he and an associate, William Losh, devised various improvements, including a "steam spring" to cushion the weight using steam pressure; a change from cast-iron to wrought-iron wheels; the introduction of numerous wheels to distribute the weight; a rail with a half-lap joint; and other features designed to create a smoother ride. With Ralph Dodds, he also patented a better method of driving the locomotive wheels using pins attached to the spokes to act as cranks. Their drawing showed direct drive and coupled wheels to ensure the cranks remained 90 degrees apart.

In 1820 Stephenson built an eight-mile railway from Hetton to Sunderland using a combination of gravity on downward inclines and locomotives for level and upward stretches. It helped him understand that railways should be kept as level as possible.

On September 27, 1825 he unveiled another improved steam engine, *Locomotion*, for the 25-mile-long Stockton and Darlington Railway, the world's first public steam railway. Driven by Stephenson, *Locomotion* carried an 80-ton load of coal and flour nine miles in two hours, reaching the amazing speed of 24 mph on one stretch. The engine was pulling the first purpose-built passenger car, *Experiment*, packed with excited dignitaries—also making the run the first time passenger traffic had been transported on a steam locomotive railway.

Over the rest of his illustrious career, Stephenson continued to rack up more achievements—including his competition-winning *Rocket* of 1829—that made the steam locomotive a key factor in the advance of the Industrial Revolution and established his title as the "father of railway transportation."

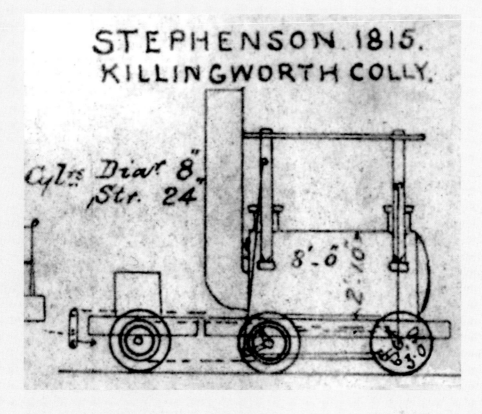

ABOVE: This drawings from 1815 shows an improved version of Stephenson's Blücher. By February 28, 1815 Stephenson had made enough improvements to file a patent with the overseer of Killingworth Colliery, Ralph Dodds.

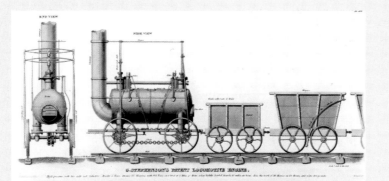

ABOVE: Rear and side view of Stephenson's 1825 Locomotive for the Stockton and Darlington Railway.

(1830)
Clifton Suspension Bridge

Isambard Kingdom Brunel

A young civil engineer's bold design for the world's longest suspension bridge over the dramatic Avon gorge in England captured the prize in an architectural competition in 1830, but the structure was not completed until five years after the designer's death in 1864.

In 1830 Isambard Kingdom Brunel (1806–59) was recuperating from injuries sustained in a construction accident when he heard of a competition to design an iron suspension bridge to cross the River Avon. The 24-year-old civil engineer entered four drawings in the

contest in hopes of winning the 100 guineas prize. Thomas Telford, the most famous bridge designer of his day, was called in as special consultant, but he was not supportive. He called Brunel's designs "pretty and ingenious," yet warned such a structure "would certainly tumble down

in a high wind," because the span over the gorge was too great for a suspension design; and he rejected the other submissions as well. Instead Telford proposed his own three-span design. However, after that design was publicly ridiculed, the competition was reopened.

Brunel ultimately convinced the 15 bickering judges to award the prize to him. His winning design drew its inspiration from ancient Egypt; he drew sphinxes on the pylons and hieroglyphic decorations on the towers (but these were abandoned).

Construction on the Clifton Suspension Bridge across the Avon began in 1831. But the bridge was not completed and opened for traffic until December 1864. By then Brunel was dead. Spanning over 700 ft (210 m), and nominally 245 ft (61 m) above the River Avon, the Clifton Suspension Bridge linking Clifton in Bristol with Leigh Woods in North Somerset had the longest span of any bridge in the world at the time of construction.

Today the bridge is considered one of England's iconic structures and Brunel is widely regarded as one of the most versatile and audacious engineers of the 19th-century with a legacy that includes many important tunnels, bridges, railway lines, pier and dock systems, and ships. More than four million vehicles cross the Clifton Suspension Bridge each year.

BELOW: A drawing from Brunel's winning proposal for a bridge to span the River Avon. Originally dismissed as "pretty and ingenious" Brunel's design, with its 700 ft (210 m) span, made it the longest bridge in the world at the time of its construction.

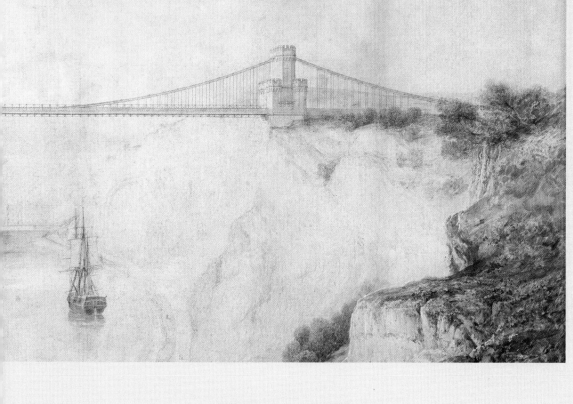

Evolutionary Tree

Charles Darwin

Darwin's simple diagram of an evolutionary tree, drawn in a field research notebook was the seed of the theory he would later express more fully in the most important biological book ever written, On the Origin of Species.

In mid-July of 1837 the British geologist and naturalist Charles Darwin (1809–82) had recently returned to England after a five-year survey expedition around the world on HMS *Beagle*, and he was still trying to process what he had learned. He began organizing his thoughts in a series of notebooks. In one group of notes labeled as "The Transmutation of Species," Darwin began to speculate that "one species does change into another," and it occurred to him that perhaps evolution could explain the similarities and differences between species in the same class or family.

On page 36 of his "B" notebook, Darwin made a little sketch that summed up some of his thinking to that point. On the top of the page he wrote, "I think." Beneath it he penned a diagram of an irregularly shaped tree. To the right of the tree he wrote, "Case must be that one generation then should be as many living as now. To do this & to have many species in same genus (as is) requires extinction." Beneath the sketch he wrote, "Thus between A & B immense gap of relation. C & B the finest gradation, B & D rather greater distinction. Thus genera would be formed. — bearing relation."

Darwin's early sketch of this phylogenetic or evolutionary tree showed the relationships of ancestry and descent among a group of species or populations. Later he would propose that this branching pattern of evolution resulted from a process that he called natural selection.

Darwin went on to explain this theory in his book *On the Origin of Species by Natural Selection*, which was first published on November 24, 1859. In it, he wrote:

> The affinities of all the beings of the same class have sometimes been represented by a great tree. I believe this simile largely speaks the truth. The green and budding twigs may represent existing species; and those produced during each former year may represent the long succession of extinct species . . . The limbs divided into great branches, and these into lesser and lesser branches, were themselves once, when the tree was small, budding twigs; and this connection of the former and present buds by ramifying branches may well represent the classification of all extinct and living species in groups subordinate to groups . . . From the first growth of the tree, many a limb and branch has decayed and dropped off, and these lost branches of various sizes may represent those whole orders, families, and genera which have now no living representatives, and which are known to us only from having been found in a fossil state . . . As buds give rise by growth to fresh buds, and these, if vigorous, branch out and overtop on all sides many a feebler branch, so by generation I believe it has been with the great Tree of Life, which fills with its dead and broken branches the crust of the earth, and covers the surface with its ever branching and beautiful ramifications.

S. F. B. MORSE.

Telegraph Signs.

No. 1,647.

Patented June 20, 1840

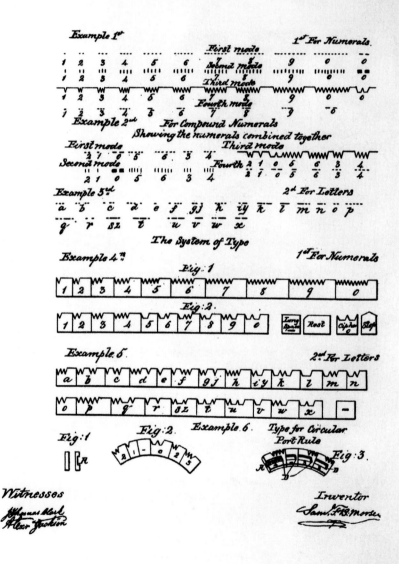

Morse Code

Samuel Morse

Samuel Morse's name is forever linked with his Morse Code and the invention of telegraph machinery, but he started off in life as a portrait painter. It took a family tragedy, however, to set him on a path to discover a means of sending messages quickly and a system of telegraph coding that remains in use today.

In 1825, Samuel Morse was commissioned to paint a portrait of the Marquis de Lafayette for $1,000. In the midst of painting, a horse messenger delivered a letter from his father that told him his wife was ill. Morse immediately left Washington for his home at New Haven. By the time he arrived home, she had already been buried. Morse was heartbroken in the knowledge that for days he was unaware of his wife's failing health and lonely death.

Beginning in 1836, he and the American physicist Joseph Henry, and Alfred Vail developed an electrical telegraph system. This system sent pulses of electric current along wires which controlled an electromagnet that was located at the receiving end of the telegraph system. Originally this produced indentations punched onto a paper tape.

The Morse code was devised so that operators could translate the different indentations marked on the paper tape into text messages. In his earliest code, Morse had planned to only transmit numerals, and use a dictionary to look up each word according to the number sent. However, Alfred Vail expanded the code to include letters and special characters so it could be used more generally. Vail determined the frequency of use of letters in the English language by counting the movable type he found in the type-cases of a local newspaper in Morristown. The shorter marks were called "dots," and the longer ones "dashes," and the letters most commonly used were assigned the shorter sequences of dots and dashes.

Having been unsuccessful in 1838, Morse made one last trip to Washington, D.C. in December 1842 to convince the US Congress of his invention's merits. He strung wires between two committee rooms in the Capitol, and sent messages back and forth to demonstrate his telegraph system. Congress agreed an experimental 38-mile telegraph line between Washington, D.C. and Baltimore. An impressive demonstration occurred on May 1, 1844, when news of the Whig Party's nomination of Henry Clay for US President was telegraphed from the party's convention in Baltimore to the Capitol Building in Washington. Morse had proved his system's worth.

OPPOSITE: Morse Code, or "Telegraph Signs" as it was submitted to the US patent office. Morse submitted a series of patents regarding electro-magnetic telegraph devices. In the early 1840s it was the same hotly contested area as today's cellphone technology.

Dinosaur (Megalosaurus)

Richard Owen

Based on a reconstruction from assembled bones, a succession of groundbreaking scientists were able to recreate what the prehistoric dinosaur Megalosaurus may have looked like when it roamed the Earth.

Although some scattered bones of huge and extinct animals had been discovered before the 19th century, it was not until 1815 that the English geologist William Buckland (1784–1856) inaugurated the careful scientific investigation of their remains. In 1824, he identified the jaw of one of them as deriving from a large, carnivorous fossil reptile, the genus of which he named as Megalosaurus. In 1842, another Englishman, Richard Owen (1804–92), a botanist, comparative anatomist, and paleontologist, classified the creature as part of an ancient line which he called "dinosaurian," from the Greek *deinos* (terrible, powerful, wondrous) and *sauros* (lizard). Owen noted that three prehistoric animals in particular had similar structures in their vertebrae and he decided that they should all belong to a new sub-order of the Saurian order. Among the first known dinosaurs he included were the carnivorous Megalosaurus, the herbivorous Iguanodon, and the armored Hylaeosaurus.

A few years later, Owen teamed with a talented sculptor, Benjamin Waterhouse Hawkins (1807–94), to attempt to recreate what the prehistoric creatures looked like, based on a reconstruction of their bones. Some miniature clay models were created for the Crystal Palace at the Great Exhibition of 1851. Following the exhibition in Hyde Park, the ornate glass palace was dismantled

and rebuilt in Sydenham. Thirty-three life-sized and jaw-dropping dinosaur recreations were put on display in the park in 1854. Owen provided detailed text and illustrations about of their concrete dinosaurs in his companion book, *Geology and Inhabitants of the Ancient World*. In it he asserted that he and Hawkins had "rigorously tested" their model

in regard to all its proportions with those exhibited by the bones and joints of the skeleton of the fossil animal … The next step was to make a copy in clay of the proof model, of the natural size of the extinct animal: the largest known fossil bone, or part, of such animal being taken as the standard according to which the proportions of the rest of the body were calculated agreeably with those of the best preserved and most perfect skeleton … a mould of it was prepared, and a cast taken from this mould, in the material of which the restorations, now exposed to view, are composed.

Although it may not look quite like the dinosaurs we've come to recognize, Owen's drawings of the Megalosaurus were the first well-known images of a dinosaur ever created, thereby providing a graphic glimpse into a lost world.

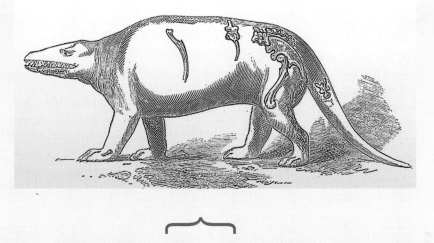

ABOVE: **This illustration of the Megalosaurus was published in Owen's *Geology and Inhabitants of the Ancient World* (1854). Owen's dinosaur was based on the handful of bones shown in his drawing.**

ABOVE: **This concrete sculpture of the Megalosaurus was built by Benjamin Waterhouse Hawkins. Based on Owen's research, Hawkins completed 33 dinosaurs for the opening of the newly relocated Crystal Palace in 1854. Although the palace is no longer there, the dinosaurs continue to surprise visitors to Crystal Palace Park in south London.**

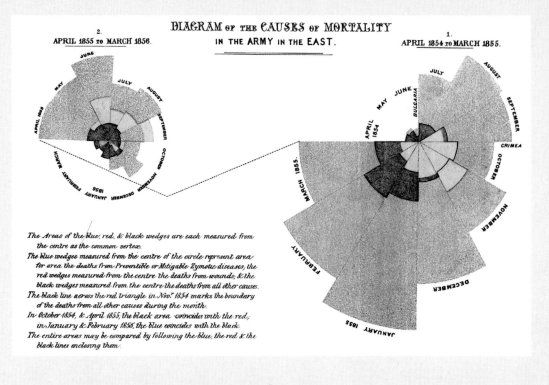

DIAGRAM of the CAUSES of MORTALITY

IN THE ARMY IN THE EAST.

2.
APRIL 1855 to MARCH 1856.

1.
APRIL 1854 to MARCH 1855.

The Areas of the blue, red, & black wedges are each measured from
the centre as the common vertex.

The blue wedges measured from the centre of the circle represent area
for area the deaths from Preventible or Mitigable Zymotic diseases, the
red wedges measured from the centre the deaths from wounds, & the
black wedges measured from the centre the deaths from all other causes.

The black line across the red triangle in Nov.ʳ 1854 marks the boundary
of the deaths from all other causes during the month.

In October 1854, & April 1855, the black area coincides with the red;
in January & February 1855, the blue coincides with the black.

The entire areas may be compared by following the blue, the red & the
black lines enclosing them.

ABOVE: Nightingale's diagram of causes of mortality in the Crimean War sent out the stark message that
hospitals can kill. Of the 18,000 deaths recorded, 16,000 were due to infectious diseases in hospitals.

ABOVE: This 1804 chart by William Playfair includes his invention
of the pie chart, a key influence on Nightingale's rose diagram.

Rose (or Polar Area) Diagram

Florence Nightingale

Nightingale, the celebrated "Lady of the Lamp," was also a gifted statistician who is credited with developing the polar area diagram (also called the coxcomb or Nightingale rose diagram), which is equivalent to a modern circular histogram.

Prior to becoming a nurse in the bloody Crimean War, Florence Nightingale (1820–1910) had studied mathematics and taken a particular interest in statistical graphics. One of the visual techniques for presenting data that she had followed was William Playfair's development of the pie chart in 1801. A pie chart (or a circle graph) is a circular chart that is divided into sectors (like pieces of pie) to illustrate proportion. The arc length of each piece is proportional to the quantity it represents.

After the war ended in 1856, Nightingale decided to write a report to Parliament to expose the awful effects of poor hospital sanitation in the conflict, and in order to dramatize her case she came up with a new method, modeled after the pie chart, for presenting the statistics in the most powerful way. She spent months reviewing all available reports about soldier mortality and the operation of military hospitals. With assistance from William Farr, an eminent British epidemiologist and statistician, she analyzed the data and sorted out its meaning. The most shocking statistics revealed that out of 18,000 deaths, 16,000 had been due to infectious diseases in hospital rather than battle wounds.

Realizing that a graphic presentation could have more impact than mere words or lists of numbers, Nightingale devised a new type of circular arrangement to pack as much data as possible into her "Diagram of the causes of mortality in the army in the East." Although the approach is similar to the pie chart, the segments in a polar diagram have equal angles and differ instead in how far each segment extends from the center of the circle. Nightingale color-coded the three most recurrent causes of death— blue for preventable diseases, red for wounds and black for those due to other causes—and prepared two circular diagrams, number of deaths in 1854–55 and number of deaths in 1855–56.

Nightingale's approach was credited with helping to convince the British government to improve the sanitation in its military hospitals, which saved many lives.

Her new graphic statistical method went on to become a common technique in modern statistical reporting, giving rise to still more offshoots such as the modern circular histogram.

Graded Sewing Patterns

Ebenezer Butterick

A New England tailor's invention of commercially produced graded home sewing patterns not only made clothes-making easier, it also extended fashion to the middle class.

Ebenezer Butterick (1826–1903) was an expert tailor in central Massachusetts at a time when clothing patterns came in only one cardboard size and it took the skill of an experienced seamstress or tailor to adjust the garment's size (a process called grading) to fit the individual customer. Many women tried to do the job themselves, but found it enormously time-consuming and frustrating, especially when attempting to make their children's clothes. The one-size-fits-all system was very unpopular.

In June of 1863, during the Civil War, Butterick hatched the novel idea of making his own standardized and graded patterns, which he could then market through the mail as a new business. Working at home on an extension table in the sitting room, he began to draw and cut his first graded patterns.

Butterick's first successful product was the "Butterick Shirt Pattern," followed by more patterns for boys and girls. But finding the usual heavy cardboard templates too unwieldy to fold and ship on order through the mail, he tried other materials until finally settling on tissue paper. He also expanded his repertoire to publish gentlemen's fashion plates, accompanied by the new idea of cut patterns, which did away with the traditional need to trace and cut out patterns from diagrams. These products proved immensely popular. Soon his burgeoning business was also manufacturing dress patterns for stylish women's clothing—something which previously had been available only to upper-class ladies. His invention helped make fashion style accessible to the masses.

Improvements in sewing, including the commercial success of Elias Howe's sewing machine, made for perfect timing of Butterick's system. His easy-to-use and economical patterns revolutionized home sewing and enabled many families to create their own tailored clothing. Over the decades, his operation grew to become a thriving business with its own publishing and fashion design platforms and branches throughout the country and beyond.

Today, the company remains "the world's first name in sewing patterns."

ABOVE: This advertisement from 1882 explains how to select the right Butterick pattern.

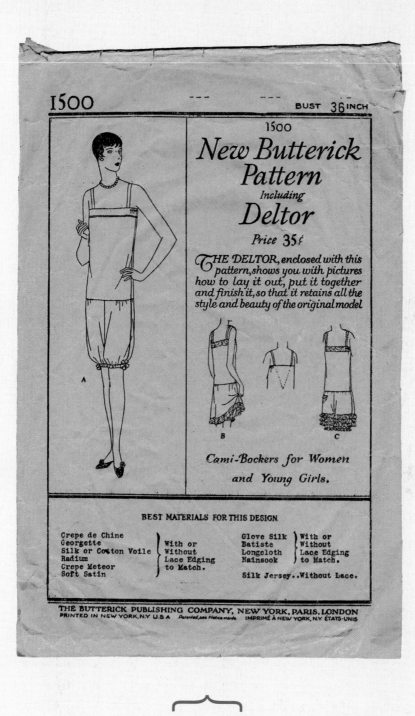

1500　　　　　　　　　　　　　　　BUST 36 INCH

1500

New Butterick Pattern

Including

Deltor

Price 35¢

THE DELTOR, enclosed with this pattern, shows you with pictures how to lay it out, put it together and finish it, so that it retains all the style and beauty of the original model

Cami-Bockers for Women and Young Girls.

BEST MATERIALS FOR THIS DESIGN.

| Crepe de Chine Georgette Silk or Cotton Voile Radium Crepe Meteor Soft Satin | With or Without Lace Edging to Match. | Glove Silk Batiste Longcloth Nainsook | With or Without Lace Edging to Match. |

Silk Jersey..Without Lace.

THE BUTTERICK PUBLISHING COMPANY, NEW YORK, PARIS, LONDON
PRINTED IN NEW YORK, N.Y. U.S.A Patented, see Notice made. IMPRIMÉ À NEW YORK, N.Y. ÉTATS-UNIS

ABOVE: This 1930s pattern for "Cami-Bockers" would have been available in several sizes. Butterick's graded sewing patterns made fashion accessible to the masses.

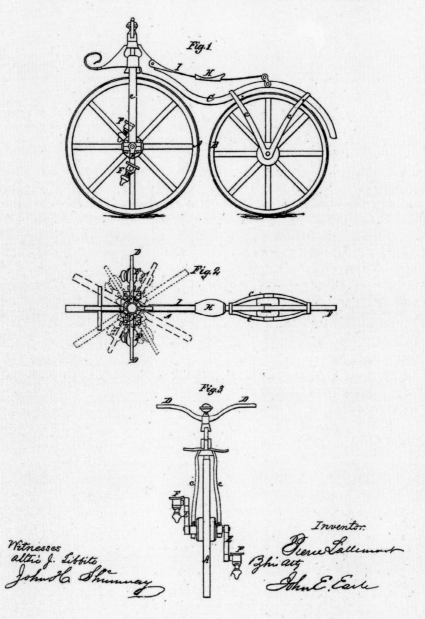

P. LALLEMENT.
VELOCIPEDE.

No. 59,915.

Patented Nov. 20, 1866.

Fig.1.

Fig.2

Fig.3

Witnesses
attic J. Libbits
John H. Shumway

Inventor
Pierre Lallement
By his atty
John E. Earle

Pedal Bicycle

Pierre Lallement

A French carriage maker designed the first pedal-driven bicycle for which he received the US patent in 1866, helping to launch a craze that spread throughout the world.

In 1862 Pierre Lallement (1843–91) was employed building baby carriages in Nancy, France when he saw someone riding a *draisienne* (dandy-horse) or velocipede, a two-wheeled vehicle that was powered by the rider's walking or running across the ground. The strange sight immediately fired his imagination to begin thinking up ways to improve the design. Although he was poor and lacked the money and materials needed to realize his dream, he stuck with it, scrimping and saving whatever scraps he could get. Somehow he managed to acquire a pair of small wooden wheels with iron tires. Later he and a fellow mechanic shaped a curved perch of wood into the form of a snake. Eventually, Lallement modified what he had seen by fashioning axles and bearings, braces from the rear axle to the perch, front forks and a transmission comprising a rotary-crank mechanism with foot pedals attached to the front-wheel hub, and wooden handle-bars. But he still had a way to go.

In July 1865, Lallement left France for the United States, settling in Ansonia, Connecticut in the hope of pedaling his new idea to a large market. But in order to get his diagrams to work, he had to learn how to ride it—a task that proved extremely difficult since nobody before him had ever succeeded. While trying to demonstrate its capabilities on Ansonia's sloped and bumpy roads, he took more than one nasty "header." At last, with financial backing from James Carroll of New Haven, Lallement built and demonstrated an improved version of his wondrous machine. On April 4, 1866 the excited Frenchman rode his newfangled vehicle all the way from New Haven to Ansonia (a journey of 12 miles) as a publicity stunt, attracting considerable interest along the way.

His application for a patent for his pedal-driven velocipede featured three diagrams showing the invention from different angles. Patent 59,915 was granted on November 20, 1866.

But after failing to convince manufacturers on both sides of the Atlantic to produce his machine, Lallement died penniless in Boston in 1891 at the age of 47. It was only after his death that many historians and cycling enthusiasts credited him with inventing the forerunner of the modern bicycle.

OPPOSITE: Lallement's patent for the velocipede was granted on November 20, 1866. However, Lallement failed to find a manufacturer for his invention and died penniless. It was only after his death that he was credited for inventing the pedal-driven bicycle.

Periodic Table

Dmitri Mendeleev

In 1869 the Russian chemist Mendeleev arranged the known elements (then numbering 63) into a Periodic Table based on atomic mass, and used the table to predict the properties of the elements not yet discovered. He is credited with devising the method of classifying the basic building blocks of matter, which has served as the cornerstone of modern chemistry and aided understanding of how our universe is put together.

Dmitri Ivanovich Mendeleev (1834–1907) was a Russian chemistry professor and inventor who transformed St. Petersburg into an internationally recognized center for chemistry research. When Mendeleev could find no suitable textbook for teaching his students general chemistry, he began writing his own, *Principles of Chemistry,* which turned out to be the definitive work in providing a framework for modern chemical and physical theory. During the course of its composition, the young scholar turned some attention to the need to classify the elements according to their chemical properties. (An element is a substance that cannot be broken down into simpler substances through ordinary chemistry—it is not destroyed by acids, for example, nor changed by electricity, light, or heat.) At the time, there were 63 known elements, and the number was still growing fast.

As Mendeleev diagrammed the elements and their properties, he began to notice some patterns among them. "I began to look about," he wrote, "and write down the elements with their atomic weights and typical properties, analogous elements and like atomic weights on separate cards, and this soon convinced me that the properties of elements are in periodic dependence upon their atomic weights."

On March 6, 1869, Mendeleev made a formal presentation to the Russian Chemical Society on the subject of "The Dependence between the Properties of the Atomic Weights of the Elements." In his paper he described his findings to his fellow chemists. He also noted that the elements which are the most widely diffused have small atomic weights, and that the magnitude of the atomic weight determines the character of the element, just as the magnitude of the molecule determines the character of a compound body.

Mendeleev's periodic table with many gaps and uncertainties was published shortly thereafter. He boldly stated that additional elements not yet discovered would be found to fill the blank places and he even predicted the properties of some of these missing elements. Mendeleev's actions were hailed for organizing the field of modern chemistry.

OPPOSITE: *Only 63 elements were known when Mendeleev drew up this periodic table (above) in 1869. He left gaps for new elements which were later discovered. Over 100 elements are listed in this colored perodic table (below) from 1949.*

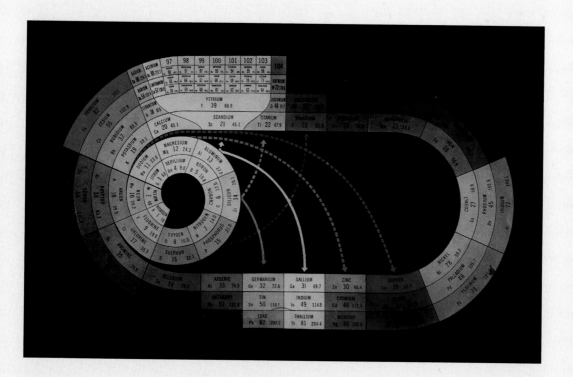

WEATHER CHART, MARCH 31, 1875.

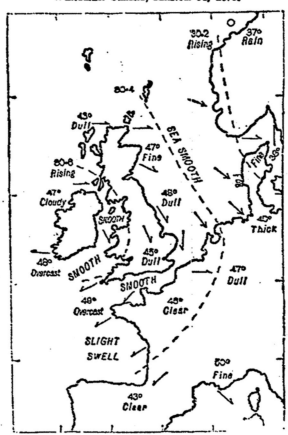

The dotted lines indicate the gradations of barometric pressure
The variations of the temperature are marked by figures, the state
of the sea and sky by descriptive words, and the direction of the wind
by arrows—barbed and feathered according to its force. ⊙ denotes
calm.

Weather Map

Francis Galton

In an age before computers, weather satellites, and rapid communications, a British polymath prepared the first weather map, which quickly became a standard feature in newspapers worldwide.

Francis Galton (1821–1911) was a half-cousin of Charles Darwin, a genius in his own right, and one of the great polymaths of his time. Explorer, author of non-fiction and fiction, inventor in modern statistical methods, developer of fingerprint identification, and a distinguished contributor to countless other fields, he was also a leading meteorologist whose book, *Meteorographica* (1863) was the first systematic attempt to gather, chart and interpret weather data on a continental scale, and one of the foundational works of modern scientific meteorology.

Galton contended that systematic charts of important meteorological observations needed to be gathered and printed pictorially and graphically, without sacrificing detail. He went about determining what measures should be included and what universal symbols should be used to represent such measures as rain, temperature, wind direction, changes in barometric pressure, and so on. He developed instruments and methods for observing various weather conditions and was the first to identify the anticyclone (a high pressure area) as opposed to the cyclone. Galton was also one of the moving forces behind the creation of a system of weather bureaus that produced weather charts for the greater part of Europe and shared the data via telegraph, thereby alerting meteorologists to approaching storms and other important weather conditions.

Known for his prolific writings in scientific journals, Galton collaborated with *The Times* to compile a weather chart for March 31, 1875, covering the British Isles and the English Channel. The first diagram used figures to record temperatures and barometric pressure, words to describe the state of the sea and sky, and different types of arrows to indicate wind conditions.

Published the next day, Galton's diagram became known as the first weather map and quickly became a standard feature in daily newspapers throughout the world. His system for recording and reporting weather conditions also helped to provide a more empirical basis for weather prediction.

OPPOSITE: *Galton's weather chart was published in The Times on March 31, 1875. It was the first ever weather map—a familiar form of diagram that has become a standard feature in daily newspapers throughout the world.*

Telephone

Alexander Graham Bell

A new immigrant to America built on his work with the deaf and his study of the existing telegraph system to develop one of the greatest inventions in the history of humankind—the telephone.

Born in Scotland to a deaf mother and a father who taught speech, Bell (1847–1922) grew up with a passion for communication and music. Despite her deficit, his mother had become an accomplished pianist, in part by feeling the vibrations. Alexander communicated with her via a special ear horn and endeavoured to learn more about acoustics. After moving to Boston in 1871, he attempted to amplify sound in ways that would enable the deaf to hear.

One of his goals soon became trying to create a "harmonic telegraph" that could transmit more than one message at a time, based on the principle that several notes could be sent simultaneously along the same wire if the notes or signals differed in pitch. While working with his assistant on June 2, 1875, Bell discovered that he could hear a distinct sound over a wire. The first sound he heard was that of a twanging clock spring which had been transmitted from a nearby room. Based on this experiment, he reasoned that it was possible to transmit the sound of a human voice over a wire.

In 1876 Bell sketched a crude diagram capturing his idea in three scribbled scenes. "As far as I can remember," he would later write, "these are the first drawings made of my telephone—or 'instrument for the transmission of vocal utterances by telegraph.'" The most important view, shows a person speaking into the wide end of a cone, just as Bell had done by talking into his mother's hearing horn. The cone sends and focuses the sound vibrations over a wire onto a diaphragm at the opposite end. When the sound waves vibrate the diaphragm, an armature also vibrates, inducing electrical signals via the electromagnet that is contained in a small box at the narrow end of the cone. These signals travel across the circuit to the electromagnet on the right and induce the armature on that side to copy the vibrations sent by the left armature,

and these vibrations, in turn, are mimicked by the diaphragm on the right. Thus the listener on the right hears a true reproduction of the original utterance.

Bell drew up a more refined version of the diagram and included it with his patent application, which was granted on March 7, 1876. On March 10, 1876, Bell and his assistant, Thomas A. Watson, demonstrated that the idea was successful. He recorded the breakthrough in his journal: "I then shouted into M [the mouthpiece] the following sentence: 'Mr. Watson, come here— I want to see you.' To my delight he came and declared that he had heard and understood what I said." Within a year, Bell founded his own telephone company. The telephone turned out to be the most lucrative patent ever granted—and arguably one of the greatest inventions of modern times.

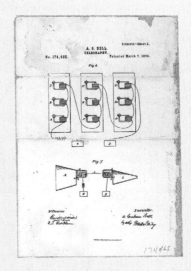

ABOVE: Bell's "Telegraphy" patent application was granted on March 7, 1876.

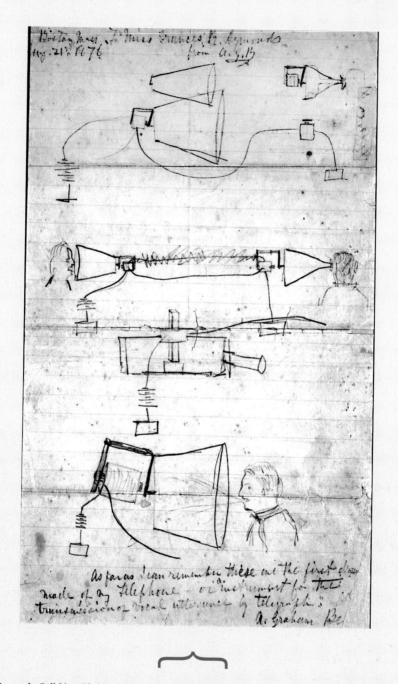

ABOVE: Drawn by Bell himself, this sketch from 1876 shows the essentials of his dramatic new invention. When Bell gave this sketch to his cousin, Miss Frances M. Symonds, he wrote, "As far as I can remember these are the first drawings made of my telephone—or 'instrument for the transmission of vocal utterances by telegraph.'"

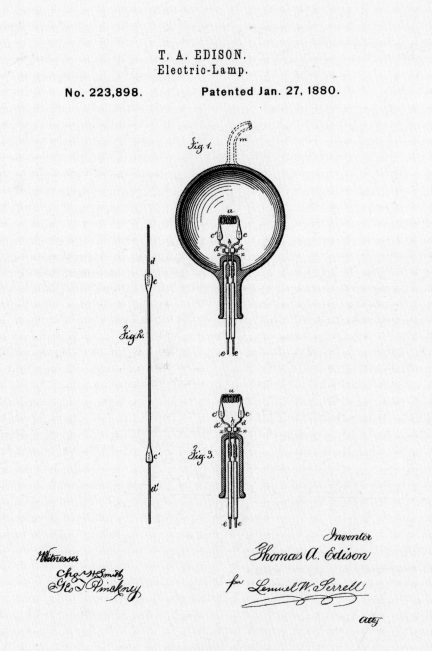

T. A. EDISON.
Electric-Lamp.

No. 223,898. Patented Jan. 27, 1880.

Fig. 1.

Fig. 2.

Fig. 3.

Witnesses *Inventor*
Chas H Smith Thomas A. Edison
Geo. T. Pinckney per Lemuel W. Serrell
 atty

THE NORRIS PETERS CO., PHOTO-LITHO., WASHINGTON, D. C.

Light Bulb

Thomas Edison

Thomas A. Edison is credited with having one of the brightest ideas of the electrical age. By creating the first incandescent light bulb with a long-lasting filament, he revolutionized the way we lit our homes.

Edison (1847–1931) grew up in Port Huron, Michigan, where he received little formal schooling but was encouraged by his mother to pursue his passion for studying chemistry and electronics. Trained as a telegrapher despite a serious hearing problem, the inquisitive youth quickly began inventing improvements, such as the automatic telegraph, the duplex telegraph, and the message printer. In 1876, he opened his own scientific laboratory in Menlo Park, New Jersey, aiming to develop an efficient incandescent lamp that would take the place of flickering candles and glimmering gaslights. The goal was to use electricity to heat a thin strip of material (called a filament) until it turned hot enough to glow, thereby generating light. Previous versions had proved too costly and short-lived. Edison's idea for a successful lamp would consist of the best possible filament housed in a glass vacuum bulb—a light bulb.

On November 4, 1879, Edison filed for US patent 223,898 (granted on January 27, 1880) for an electric lamp using "a carbon filament or strip coiled and connected to platina contact wires." The patent described several ways of creating the carbon filament, including "cotton and linen thread, wood splints, [and] papers coiled in various ways." His drawing includes three figures. Figure 1 shows the lamp sectionally: (a) is the carbon spiral or thread; (c,c') are the thickened ends of the spiral, formed of the plastic compound of lamp-black and tar; (d,d') are the plantina wires; (A,A) are the clamps, which serve to connect the plantina wires, cemented in the carbon, with the leading-wires (x,x) sealed in the glass vacuum-bulb; (e,e) the copper wires, connected just outside the tube to the wires (x,x); and (m) is the tube (shown by the dotted lines) leading to the vacuum-pump, which, after exhaustion, is hermetically sealed and the surplus removed. Figure 2 shows the plastic material before being wound into a spiral. Figure 3 shows the spiral after carbonization, ready to have a bulb blown over it.

Drafting the diagram proved easier than finding the right filament, and it took several months before Edison discovered his favorite—a carbonized bamboo filament that could last over 1,200 hours. Within a few years, electric lights were everywhere. By the time of his death in 1931, Edison had patented 1,093 inventions. Some of the best known included the microphone, telephone receiver, universal stock ticker, phonograph, motion picture camera, storage battery, electric pen, and mimeograph. Yet the one still most associated with his name is his light bulb.

OPPOSITE: Edison developed an efficient incandescent lamp that would take the place of flickering candles and glimmering gaslights. His "Electric-Lamp" patent was granted in January 1880.

Venn Diagrams

John Venn

A Cambridge logician devised a diagrammatic means of representing the differences and similarities in different overlapping sets. His visual way to picture sets, their unions and intersections, has become widely used in several areas of science.

So-called "Eulerian Circles" were a diagrammatic method invented by the Swiss mathematician Leonhard Euler (1707–83) in 1761 as a means of representing a logical proposition. To illustrate a syllogism, for example, Euler drew three circles. C was a separate circle, but A was a smaller circle inside the enveloping circle B. Euler then reasoned as follows: all A is B, no B is C, no C is B, and therefore no C is A.

The use of diagrams in logic was later studied and formalized by the British logician and philosopher John Venn (1834–1923), who first set out his ideas in a scientific paper entitled "On the Diagrammatic and Mechanical Representation of Propositions and Reasonings" that was published in the *Philosophical Magazine and Journal of Science* in 1880. Venn was keen to explore the visual representation of scientific classification using diagrams. Referring to the Eulerian circles, he wrote, "The weak point about these [circles] consists in the fact that they only illustrate in strictness the actual relations of classes to one another, rather than the imperfect knowledge of these relations which we may possess, or wish to convey, by means of the proposition."

Venn developed his own variation on Euler's circles in an effort to address this deficiency. His original diagram of this sort pictured three circles (sets) called R, S, and T as overlapping subsets of a larger set U. The diagram clearly divided the sets into eight distinct regions.

So-called Venn diagrams attempt to show all the possible logical relations between a finite collection of overlapping sets. They consist of interconnected curves, often drawn with circles, ovals, or polygons. The sizes or shapes of the curves are not important; what matters in the diagram is how they overlap. The spatial relationships between the regions bounded by each curve (overlap, containment or neither) corresponds to set-theoretic relationships (intersection, subset, and disjointedness). The simplest Venn diagram is one in which no more than two curves intersect at a common point; however, there can be many more complex forms.

The first person to use the term "Venn diagram" was Clarence Irving Lewis in 1918 in his book *A Survey of Symbolic Logic*. The technique has been incorporated into math and science teaching ever since.

OPPOSITE: *Pages taken from Venn's "Diagrammatic Representation" article of 1880. This was the first publication of what Venn then called his "Eulerian circles." His familiar circles were first referred to as Venn diagrams in 1918.*

then proceed to analyse the premises in order to see what classes are destroyed by them. The reader will readily see that the first premise annihilates all 'xy which is not z', or $xy\bar{z}$; the second destroys 'xyz which is not w', or $xyz\bar{w}$; and the third 'wx which is yz', or $wxyz$. Shade out these three classes, and we see the resultant figure at once, viz.

It is then evident that *all* xy has been thus made away with; that is, x and y must be mutually exclusive, or, as it would commonly be thrown into propositional form, 'No x is y.'

I will not say that it would be impossible to draw Eulerian circles (or rather closed figures of a more complicated kind, for circles would not do here) to represent all this, just as we draw them to represent the various moods of the syllogism; but it would certainly be an extremely intricate and perplexing task to do so. This is mainly owing to the fact already alluded to, viz. that we cannot break the process up conveniently into a series of easy steps, each of which shall be complete and accurate as far as it goes. But it should be understood that the failure of the older method is simply due to its attempted application to a somewhat more complicated set of data than those for which it was designed; although these data are really of the same kind as when we take the two propositions 'All x is y', 'All y is z', and draw the customary figure. When the problem, however, has been otherwise solved, it is easy enough to draw a figure of the

the relation of X to Z is readily detected; th... that troublesome interconnexion of a number... taneously with each other which gives rise... plexity in complicated problems. According... example as this is not a very good one fo... method now proposed; but, in order to ma... the figure to represent it is given, thus:

In this case the one particular relatio... of X to Z, it must be admitted, is not m... our plan than on the old one. The supe... an example must rather be sought in th... pictorial information in other respects... the intimation that, of the four kinds... had to be taken into consideration, on... the 'x that is y but is not z', is left... with the formal possibilities of y and... of these, as compared with the resulta... by the data, is detected at a glance.

As a more suitable example consi...

| All x is either y and z
| If any xy is z, then it
| No wx is yz;

and suppose we are asked to exhit... to each other. The problem is es... as the syllogistic one; but we certainly coul... figures in the off-hand way we did there. Since there are four terms, we sketch the appropriate 4-ellipse figure, and

we have then made our alte... and they alone, are either y o... Now if we tried to do th... should find at once that we... in which intricate matters... breaking them up into detai... making sure of each as we... have to be drawn so as to i... of the knowledge furnished... exceedingly simple cases... moods of the Syllogism,... when we come to hand... follow upon the combina... who have only looked... Hamilton, Thomson, and... of the Aristotelian Syllo... the intricate task whic... they tried, with such re... type that we must be p...

As the syllogistic f... familiar to ordinary re... though they are too... Take, for instance,

No Y is Z,
All X is Y,
∴ No X is Z.

This would commonly be exhibited thus:

It is easy enough to do this; for in drawing our circles we have only to attend to two terms at a time, and consequently

able you to bring suit. They always give a man such facilities gladly."

"But say she refuses to marry?"

"There is no precedent for a woman refusing to marry, in the law."

At this point Mr. Ryan left to get his dinner, and Mr. Burke indicated to the jailer his desire to take a lease of his cell (with privilege of renewal) and to fit it up on the installment plan.

The next day Mr. Ryan made application at one of the higher courts for a mandamus compelling the jailer to show cause why he should not release Fortunatus.

"I am going," said Ryan, "to make this a TEST CASE."

Burke said he was sorry to hear it.

The jailer got five days to file answer, then an extension of twenty, two postponements of ten days each, and three privileges to "amend" his reply, with three days along with each one. Meanwhile Mr. Burke languished in jail. Ryan came to see him, spoke hopefully, and said:

"We must move slowly but surely. I will make the jailer pay the costs. This is some satisfaction."

At the end of seven weeks the jailer filed his answer, which was:

"Demurrer to the complaint, as it is defective. Redress in equity is a suit against committing magistrate. I am only his agent."

Mr. Burke was cast for $413.75 costs.

Mr. Ryan, however, continued to make it a "test case." He carried it from one court to another; he took it from the general term to the special term; he wrote and filed 320 pages of manuscript; he furnished bonds to the amount of $20,000, the arts of a Choate in law, a Fox in eloquence, and a Macchiavelli in strategy, he employed unstintingly. At the end of a year and a half he got the case to the Court of Appeals, in Albany, and it was put "peremptorily" on the calendar for June 16th, 1886. With this cheering information he returned to poor Burke, who still languished in jail.

"Well," said B., "what has all this thing cost?"

"Nothing! I brought it in *forma pauperis*. Constructively, you are a tramp. That will appear on the record if you are discharged."

"If?" said Burke. "Is it not all settled?"

"A decision," said Ryan, will be handed down from the Bench in Albany within five years."

Mr. Burke said nothing. He arose from his bench, took off his coat, and inquired of Quirites what was the way he came in. Mr. Ryan told him.

"It is the shortest way for you out," said Fortunatus fiercely. "Jailer," he said, "take me before the judge."

Ryan retired discreetly, and Mr. Burke was led into court and placed before the bar.

HIS HONOR.—"What do you want?"

BURKE.—"I wish to plead guilty."

HIS HONOR.—"Of what offense?"

BURKE.—"Murder."

HIS HONOR.—"Murder!"

BURKE.—"Murder in the first degree."

HIS HONOR.—"What is your defence?"

BURKE.—"Insanity."

His Honor said:

"Burke, the point is well taken. A man charged with murder who pleads insanity is always acquitted. There is no use holding you. I discharge you. You are free."

BURKE.—"Don't you want bail?"

HIS HONOR.—"It is useless. There is not the faintest possibility of a murderer with such a defence being condemned. Why didn't you enter this plea before?"

Mr. Burke did not answer.

But he took from his pocket two crisp five dollar bills, and handed one to the judge and one to his clerk.

"Ryan," he said, "has my bank-book and jewelry. The jailer has my life insurance policy. I leave the court a poor but a free man."

* * *

The feminine character is everything that is true, loyal, loving, noble and sincere. The woman waited. They were married. Children blessed their union, and now play sometimes with the gun which is waiting for Ryan in the hall. But the lawyer's clerk has moved to Ohio, and has the people of the United States for a client just now. Mr. Burke says that the day that case is called up for trial in the Court of Appeals, he will send Clerk Perrin a card of which this is a copy:

Mr. and Mrs. Fortunatus Burke,

(And don't you forget it.)

ERNEST HARVIER.

TYPOGRAPHICAL ART.

We wish it to be distinctly understood that the letterpress department of this paper is not going to be trampled on by any tyranical crowd of artists in existence. We mean to let the public see that we can lay out, in our own typographical line, all the cartoonists that ever walked. For fear of startling the public we will give only a small specimen of the artistic achievements within our grasp, by way of a first instalment. The following are from Studies in Passions and Emotions. No copyright.

Joy. Melancholy. Indifference. Astonishment.

A NUISANCE AND ITS REMEDY.

THE HOLY KISS.

THE MANLY KICK.

END OF THE WORLD.

"Say, what is there in this talk about Old Mother what-you-call-her, the conjugation of the planets, and the world comin' to an end this year?" asked a grizzled old '49er, stopping Prof. Legate as he was turning the corner of G and Union streets with a big telescope under his left arm. "Do you think the old world is going to pass in her checks?"

"Well," said the Professor, "we certainly have had, during the last year, some remarkable movements in the principal planets."

"Anything liable to bust loose very soon?"

"Before long. Let me see—at 9 o'clock on the night of April 21, Saturn will be in conjunction with the sun."

"Good for a starter. What next?"

"At 7 o'clock next morning Saturn and Jupiter will be in conjunction."

"Bully! That's business."

"At 9 o'clock that morning Jupiter will come into conjunction with the sun."

"Hurrah! All getting in their work on the sun. I can see old Sol beginning to get shaky on his pins. What next?"

"On the second of May Venus comes into conjunction with the sun."

"Glory! The old gal gets in her lick on the sun, too. It's gettin' hot now. Hit him again, old gal!"

"On the 11th of May Neptune will be in conjunction with the sun."

"Tiptop; old Nep and all of 'em goin' square at the sun, like so many butting billy goats. I'll live to see it yet. Who goes at him next?"

"On the 14th of May Mercury comes into conjunction with the sun, and Uranus will be at right angles."

"My what will be at right angles?"

"Uranus."

"The h—l! Then I'll be in the grand bust up, sure. Is that all?"

"Those will be the principal occurrences." —*Virginia (Nev.) Enterprise.*

"Is the Oilymargarine all out?" asked farmer Traddles of his wife at the breakfast table the other morning. "Yes," replied the good woman; "John, the hired man, took the last lump yesterday to grease the axles of the cart." "Well, John is getting altogether too economical," petulantly exclaimed Mr. Traddles. "He thinks common tar is too good for axle grease." —*Norristown Herald.*

NEW HAVEN people will remember the big whale that passed through this city on a couple of flat cars a few weeks ago. Well, it is on exhibition in Cincinnati, and one of the wicked papers of that city suggests that some one take the character of Jonah and give a Sunday-school entertainment. —*New Haven Register.*

PRESIDENT CHASE, of Haverford College, says the Bible has 120,000 errors which the new revision will make straight. Considering how our forefathers were handicapped, it is a wonder how any of them figured out their eternal peace. —*Somerville Journal.*

THE Parisian Jardin Mabille is to be closed. We were going over to Paris in company with three deacons to study the art works in the Louvre, but we have given up the idea. —*Boston Post.*

Emoticons

Puck Magazine

A century before writers in the computer age began adorning their emails with graphic symbols to indicate their feelings, an editor at an American humor magazine introduced a few funny examples of typographic art into some of their articles—early emoticon diagrams.

Emoticons (a portmanteau of the words "emotional" and "icon") are small pictorial signs, usually created by combining various keyboard symbols, to visually indicate certain feelings or emotional reactions. They are sometimes inserted with a message to suggest how the messenger feels about a particular comment or issue.

Most readers are familiar with a few basic graphic representations that portray a person's mood or facial expression through the use of punctuation keys. However, some writers have created a wide assortment of ingenious emoticons to convey all sorts of complex emotions. The origins of the coded shorthand go back to at least the 19th century. In 1859 Western Union adopted its "92 Code" which used numerous numerical symbols as substitutes for various common phrases, such as the use of 88 to denote "love and kisses."

On March 30, 1881, the *Puck* humor magazine published a brief notice, entitled TYPOGRAPHIC ART, informing readers that it was inserting a few typographical symbols to clearly lay out the editors' feeling of joy, melancholy, indifference, or astonishment on certain issues of the day. The symbols became popular with readers of the magazine and spread elsewhere.

In 1963 an American commercial artist, Harvey Ball, is credited (or blamed) for introducing the iconic image of a smiling yellow face for one of his clients to use as a mood setting device in an advertising campaign. The "smiley face" became one of the most widely used symbols of the information age. As early as 1972, PLATO, an early computer-assisted instruction system, had incorporated similar digital symbols into its courses. A few of the most common emoticons used today include the following:

:-) or :)	Smile
:-(or :(Sad
:-O or :o	Surprised

Today emoticons are a common feature used in emails among peers and friends.

OPPOSITE: Emoticons made a discreet entrance, arriving in print for the first time in this March 30, 1881 issue of Puck. The small item in the middle of this page gives four examples of "typographical art"—joy, melancholy, indifference, and astonishment.

(1883)
Treasure Island Map

Robert Louis Stevenson

The author of the classic adventure story gave the delightful but mistaken impression that pirates had used diagrams with clues to reveal the location of their buried treasure.

Before he had ever published a word, the Scotsman Robert Louis Stevenson (1850–94) imagined and sketched an elaborate and beautifully colored map of a "Treasure Island" to amuse his stepson. But the more Stevenson studied his creation, the more alive and expanded it became in his mind. He later referred to this diagram to write a picaresque story that was serialized in the children's magazine *Young Folks* between 1881 and 1882 under the title, "The Sea Cook: Treasure Island; or the Mutiny of the Hispaniola," where it appeared without woodcuts and attracted only a few readers. But someone saw his story had promise. When the time arrived for the work to be republished as a book, however, Stevenson was crushed to hear that the map had been lost, and he struggled to recreate it based on the tale he had penned. The final work contained a revised version of the map, dated "20 July 1754" by the character "W.B." Its appearance resembled an 18th-century sea chart. First published as *Treasure Island* on May 23, 1883, the book went on to become one of the most beloved adventure stories of all time, bringing him enormous fame and fortune.

Stevenson's coming-of-age story was packed with exotic atmosphere, memorable characters and dramatic action, and it spawned a rich mythology of iconic figures and colorful lore. Devotees continue to speculate about what actual places may have inspired the author. Some say he had been intrigued by the mention of "Dead Man's Chest Island" in a book by Charles Kingsley; others claim that his Skeleton Island bore a resemblance to the isle of Unst in Shetland, where Stevenson had visited shortly before writing his book.

While there is no evidence of real pirates ever leaving a "treasure map" showing where they had buried their stolen goods, with "X" marking the spot, the notion has continued to excite generations of children to this day. And Stevenson's vision has gone on to become one of the most dramatized scenarios of stage and screen. The celebrated author went on to write such other classic novels as *Kidnapped* (1886), *The Strange Case of Dr. Jekyll and Mr. Hyde* (1886), and *The Black Arrow* (1888), until his premature death in Samoa ended his brief but meteoric career on a tragic note.

{ OPPOSITE: *While there is no evidence of real pirates ever leaving a "treasure map" showing where they had buried their stolen goods, with "X" marking the spot, Stevenson's fictional device has continued to excite generations of children to this day.* }

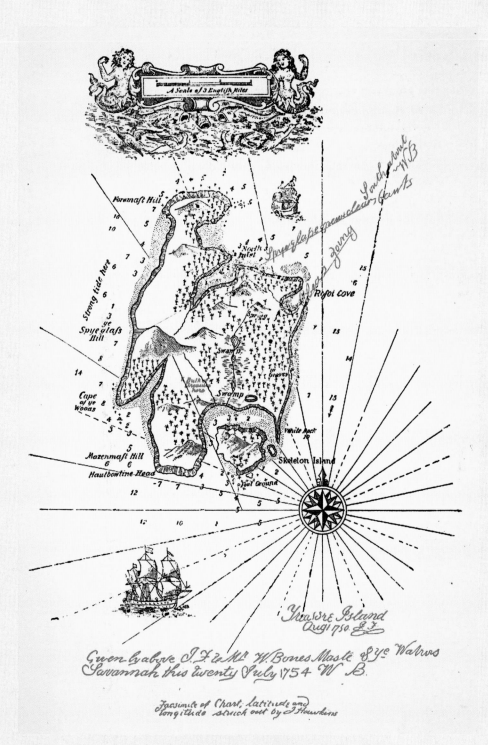

A Scale of 3 English Miles

Foremast Hill

North Inlet

Spyglape tree seen clear ys Ears

Strong tide here

Spye glafs Hill

Rifol Cove

Cape of ye Wooas

Swan D.

Swamp

White Rock

Skeleton Island

Mazenmast Hill

Haulbowline Head

Foot Ground

Treasure Island
Augt 1750. J.F.

Given by above J.F. to Mr. W. Bones Maste of ye Walrus
Savannah this twenty July 1754 W. B.

Facsimile of Chart; latitude and
longitude struck out by J Hawkins

CATTLE.

Number, millions.

United States 56
Russia 45
River Plate 32
Germany 22

Austria 20
France 17
United Kingdom 16
Australia 16
Spain 6
Italy 5

Cattle per inhabitant.

River Plate 10·76
Australia 5·73
Cape Colony
U. States

Canada
Russia
Austria
Germany 0·50
France
U. Kingdom

See Table D, page 76 The above includes cows, horses, sheep, &c., reduced to common denominator.

RAILWAYS.

Capital employed (1882).

France 494
United Kingdom 770
United States 1,190
TOTAL 4,444

Germany 467
Russia 309
Austria 255
Italy 108
Spain 79
Canada 72
Belgium 61
Australia 58

The figures express millions £.

Traffic.

TOTAL 2,537

United Kingdom 910
United States 560
Germany 340

Spain 30
Italy 40
India 60
Russia 70
Belgium 80
Austria 90
France 230

The numbers express millions of passengers and tons of cargo added together.

Pictogram Graphs

Michael George Mulhall

A 19th-century Irish writer developed the use of pictorial statistics, including the pictogram graph, for representing data by icons proportional to a number.

As noted throughout this book, pictures have been used for thousands of years as symbols or icons to convey some sort of special meaning. A few examples include hieroglyphics and cuneiform writing in ancient Egypt and Mesopotamia, ancient Indian glyphs in parts of what is now Latin America, and symbols used in medieval heraldry. Since the introduction of the printing press, many book publishers and newspapers have also utilized small symbolic ornamental signs, called vignettes, to serve as motifs for certain subjects. In 1658 the Moravian educator Johann Amos Comenius (1592–1670) published *Orbis sensualium pictus* (*The World Explained in Pictures*), an atlas of the visible world that used extensive illustrations that were geared to teach children by means of pictures (tableaus). Beginning in the 19th century, some writers pioneered the use of pictorial statistics or statistical charts to convey meaning. William Playfair (see pages 120–123), for instance, developed graphic charts in his *Commercial and Political Atlas* (1786) and the pie chart in his *Statistical Breviary* (1801).

Another influential use of pictorial statistics was devised by the Irish journalist and statistician Michael George Mulhall (1836–1900), whose *Dictionary of Statistics* (1884) went on to become a standard reference work. In it, Mulhall introduced the pictograph, or pictogram chart, which is now a commonly used graphics tool. One of his best-known early diagrams uses color-coded and numbered pictures of railway cars to convey the amount of capital employed and the volume of passengers and tons of cargo moved by different nations' railways in 1882. Each railway car is sized in proportion to the number it represents.

A pictogram graph conveys its meaning through its pictorial resemblance to a physical object combined with its statistical significance. This technique is intended to facilitate understanding and enable the reader to quickly grasp the numbers' meaning in the context that is being shown.

{

OPPOSITE: Two pages from Mulhall's Dictionary of Statistics (1884). His book introduced the pictograph, which conveys its meaning through its pictorial resemblance to a physical object combined with its statistical significance.

}

Car

Karl Benz

In 1886, a German inventor inspired by the bicycle received a patent for the three-wheeled motorwagen—the world's first practical horseless carriage powered by an internal-combustion engine, and the invention that launched Mercedes-Benz.

Karl Friedrich Benz (1844–1929) was a German engine designer whose fondness for the bicycle had inspired him to invent an off-shoot motor-powered vehicle. On December 31, 1878, he created a reliable gas two-stroke engine for which he was granted a patent in 1879. In 1883, he founded Benz & Company to produce industrial engines in Mannheim. Benz then began designing a "motor carriage" with a four-stroke engine. One invention led to another, and he quickly patented all of the processes that made the internal combustion engine feasible for use in a horseless carriage, including a speed regulation system, an ignition system using white power sparks with battery, a spark plug, carburetor, clutch, gear shift and water radiator.

In 1885 Benz started work on his first carriage-like automobile, which he called the Benz patent motorwagen. Constructed of steel tubing with woodwork panels, it somewhat resembled a bicycle, with three steel-spoke wheels and solid rubber tires. But the vehicle contained many innovations. Its greatest breakthroughs included a four-stroke engine between the rear wheels, with a very advanced coil electric ignition and water cooling rather than a radiator. Power was transmitted by means of two roller chains to the rear axle. The Benz 954 cc single-cylinder four-stroke engine ran on gas or petrol and the engine only weighed about 220 lb (100 kg). Yet this motor produced ⅔ hp (½ kW) at 250 rpm. Steering was accomplished by means of a toothed rack that pivoted the unsprung front wheel.

The Motorwagen was patented on November 2, 1886 as DRP-37435: "automobile fueled by gas," and was widely regarded as the first motor car. Although the initial version proved difficult to control and customers could only buy gasoline from pharmacies that sold small quantities as a cleaning product, in 1888 an improved model became the first commercially available automobile in history.

OPPOSITE: *Karl Benz's patent for an "automobile fueled by gas" was filed on January 29, 1886 and granted on November 2, 1886. His motorized "tricycle" is now regarded as the world's first motor car.*

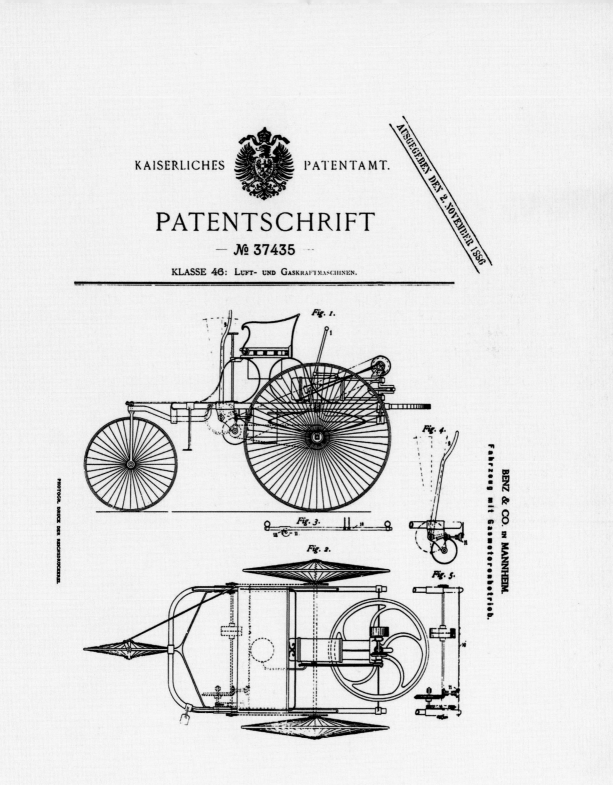

KAISERLICHES PATENTAMT.

PATENTSCHRIFT

— № 37435 —

KLASSE 46: LUFT- UND GASKRAFTMASCHINEN.

AUSGEGEBEN DEN 2. NOVEMBER 1886.

Fig. 1.

Fig. 4.

Fig. 3.

Fig. 2.

Fig. 5.

PHOTOGR. DRUCK DER REICHSDRUCKEREI.

BENZ & CO. IN MANNHEIM.

Fahrzeug mit Gasmotorenbetrieb.

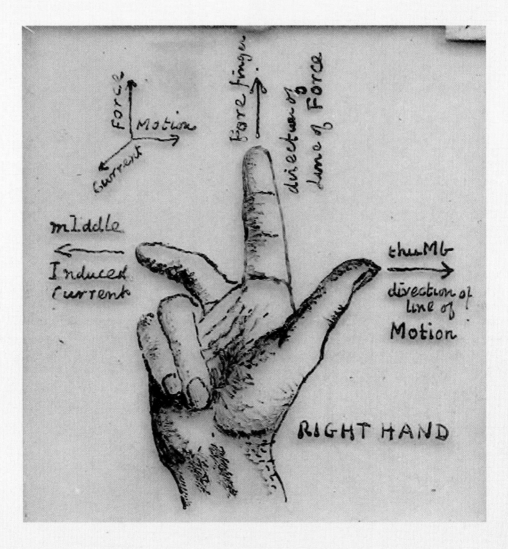

Right-Hand Rule

John Ambrose Fleming

The scientist who would later become famous as the "father of electronics" invented a simple mnemonic rule to instruct his students how to determine the direction of electric current in an electric generator, thereby translating his diagram into a recognizable finger motion.

In the 1890s, John Ambrose Fleming (1849–1945) was an eminent English electrical engineer and physicist who served as a leading consultant to Thomas Edison's burgeoning electric power industry. To more easily teach his students electrical engineering at University College London, Fleming devised a memory tool to help them remember the relationship between the direction of a magnetic field, the motion of the conductor, and the resulting electromotive force.

Fleming's right-hand rule, pertaining to electric dynamos (generators), uses the thumb, central finger and first finger for direction identification, as follows: For a moving wire in a magnetic field, such as the wire on the armature of a generator, if the thumb, first, and second fingers of the right hand are extended at right angles to one another, with the first finger representing the direction of magnetic Lines of Force and the second finger representing the direction of Induced Current, the thumb will be pointing in the direction of the Line of Motion of the wire. In other words, the right-hand rule shows how a current-carrying wire generates a magnetic field. If you point your thumb in the direction of the current and let your fingers assume a curved position (known as the right-hand grip rule), the magnetic field circling around those wires flows in the direction in which your four fingers point.

Fleming also devised a left-hand rule for electric motors. The first finger represents the direction of the magnetic Field, the second finger represents the direction of the Current, and the thumb represents the direction of the resultant Motion. The left-hand rule shows what happens when charged particles (such as electrons in a current) enter a magnetic field. If your first finger points in the direction of a magnetic field, and your second finger, at a 90 degree angle to your index, points in the direction of the charged particle (as in an electrical current), then your extended thumb (forming an L with your index) points in the direction of the force exerted upon that particle.

Fleming's diagram has been reproduced in countless physics schoolbooks and has been used to train generations of electrical engineers.

OPPOSITE: Fleming's diagram is held at University College London, where he taught electrical engineering. Fleming's rule helped his students determine the direction of a magnetic field, the motion of the conductor, and the resulting electromotive force.

Powered Plane

Wright Brothers

Two high-school dropouts from Ohio, Orville and Wilbur Wright, diagrammed, built and tested the world's first successful flying-machine at Kitty Hawk, North Carolina. Three years later, they received one of the world's most coveted patents.

After reading about successful gliding experiments in Germany, in 1899 Wilbur Wright (1867–1912) and Orville Wright (1871–1948) began pursuing the dream of motorized flight. Once they had worked their way up to mastering gliding and building their own biplane gliders, they began efforts to build an engine-powered airplane that could fly. The pair selected beaches on North Carolina's Outer Banks because they were windy, sandy, hilly, and remote. After extensive trial-and-error experiments, they achieved a crucial breakthrough: the ability to control and maneuver their aircraft by means of wing warping (arching the wingtips slightly to control the aircraft's rolling motion and balance).

On March 23, 1903, the Wrights filed a patent application with the US Patent Office. Besides wing warping, the patent drawings and text included several key features: the gas tank; engine (which ran at only one speed); a water reservoir to prevent the engine from overheating; a movable rudder to allow the aircraft to bank and turn; propellers (which worked as rotating wings, with a spinning motion that produced a horizontal lift or "thrust" that pushed the plane through the air; a hip cradle (to enable the pilot to steer by moving his hips from side to side); the elevator to control pitch; a bicycled wheel hub for takeoffs and landings; and a few instruments (a stop watch, a "Veedor" engine-revolutions counter to measure engine rpms, and an anemometer to measure distance). Figure 1 is a perspective view of an apparatus embodying the invention in one form.

On the morning of December 17, 1903, the Wright brothers managed to get their flying machine with an engine, *Flyer*, to achieve history's first powered, sustained and controlled airplane flights from level ground without any assistance at takeoff. A local lifeguard standing nearby used a camera to photograph Orville Wright in glorious full flight. The wooden craft soared to an altitude of 10 ft (3 m), traveled 120 ft (36.6), and landed safely 12 seconds after takeoff. The brothers flew their *Flyer* four times that day, with their longest flight lasting 59 seconds and covering 852 ft (260 m). With these flights, the Wright brothers became the first humans to successfully pilot a power-driven, heavier-than-air machine. Patent 821,393 for a "Flying Machine" was granted on May 22, 1906.

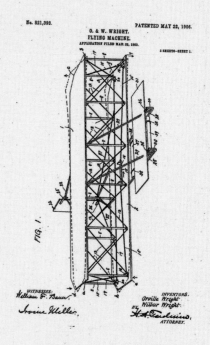

ABOVE: The Wright brothers' "Flying Machine" patent was granted on May 22, 1906.

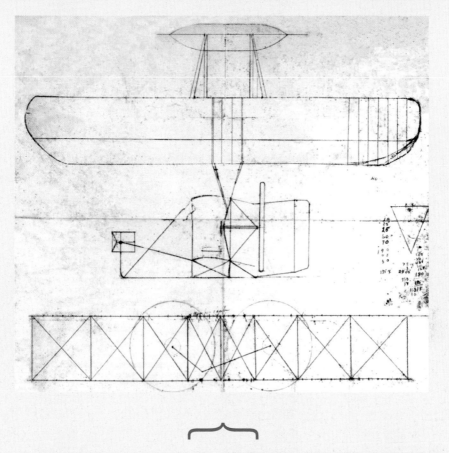

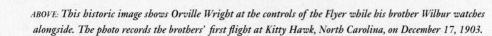

ABOVE: *While no professionally drawn plans or blueprints of the Flyer exist, the Wright brothers made this preliminary drawing in 1903. Views of the top, side, and front of the Flyer are accompanied by Wilbur's calculations.*

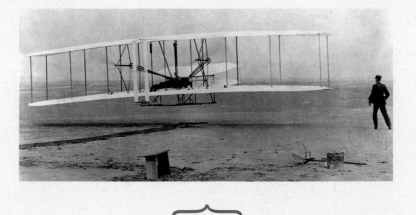

ABOVE: *This historic image shows Orville Wright at the controls of the Flyer while his brother Wilbur watches alongside. The photo records the brothers' first flight at Kitty Hawk, North Carolina, on December 17, 1903.*

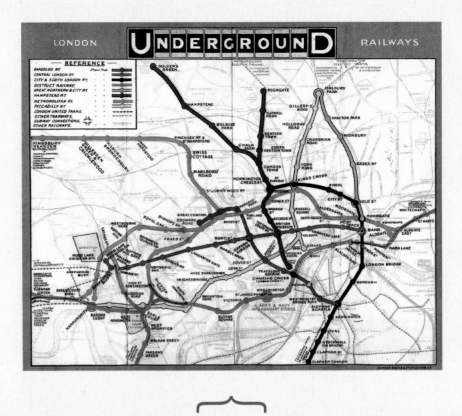

ABOVE: *The first London Underground map of 1908. The eight color-coded railway lines were printed on top of a fainter map showing London's major landmarks, department stores, post offices, and hospitals.*

ABOVE: *Harry Beck's map dispensed with all background features to focus purely on the Tube lines themselves. A design classic, Beck's map is recognizable the world over as a symbol of London.*

London Underground Map

The unification of London's underground railway lines prompted the interconnected companies to issue the first complete map of the subway system, showing passengers all of the trains' routes and stations. It was the inaugural version of one of the easiest-to-use and most relied-upon diagrams in the world.

London's Metropolitan Railway—the world's first underground train line—opened for business on January 10, 1863. Following its opening, London's underground railways developed in independent spurts that caused passengers terrible confusion and inconvenience until the operators finally unified. In 1908, the underground railway companies began pooling their resources to publish joint advertisements and create a free publicity map of their new "Underground" network.

The handy first pocket map showed eight railway lines, each of which was labeled and color-coded, along with the relative positions of their stations along the lines, the stations' connective relations with each other, and fare zones. When spread out, the map offered a list of important destinations—hospitals, principal theaters, hotels and even cemeteries—to better serve its fare-paying passengers. This popular route map continued to be developed and was issued in various formats and artistic styles until 1920, when, for the first time, the geographic background detail was omitted in a map designed by MacDonald Gill.

In 1931, an engineering draftsman at the London Underground Signals Office, Harry Beck (1902–74), drew up a different sort of diagram in his spare time. Beck introduced the novel idea of abandoning geography entirely in order to present the ever-expanding underground network as a circuit diagram rather than as a conventional geographical map. Everything was simplified in order to make it easier to follow the routes; the stations all appeared on straight-line segments that ran only vertically, horizontally, or on 45-degree diagonals. To make the map clearer and to emphasize connections, Beck differentiated between ordinary stations (marked just with tick marks) and interchange stations (marked with diamonds). The map also featured excellent color printing and classic typography, which are still hallmarks of London Underground's posters and maps.

Updated versions of the distinctive London tube map appear throughout the railway cars, in stations, on pocket maps, in London guidebooks and diaries, and in countless other locations, making it one of the most recognizable images in Europe—an iconic design.

Spacetime Diagrams

Hermann Minkowski

A mathematical genius known for solving difficult problems shook the scientific world by reformulating Albert Einstein's new theory of special relativity; he introduced a four-dimensional (spacetime) non-Euclidian geometry as a visual aid to make the concept more understandable—and more acceptable to mathematicians.

Hermann Minkowski (1864–1909) was an eminent German mathematician whose students at the Polytechnic in Zürich had included the young physicist Albert Einstein (1878–1955). In 1905, Einstein published the theory of special relativity, which explains how to interpret motion between different places that are moving at constant speeds relative to each other. Einstein showed that the laws of physics and the speed of light must be the same for all uniformly moving observers, regardless of their state of relative motion, and thus, for this to be true, space and time can no longer be independent. Rather, they are "converted" into each other in such a way as to keep the speed of light constant for all observers. Shortly afterward, Minkowski realized that Einstein's physics-based concept could be best understood in mathematical terms.

On September 21, 1908, Minkowski gave a historic lecture to an assembly of Germany's leading scientists and mathematicians in Cologne. "Henceforth," he told his audience, "space by itself, and time by itself, are doomed to fade away into mere shadows, and only a kind of union of the two will preserve an independent reality… We should then have in the world no longer 'space,' but an infinite number of spaces, analogously as there are in three-dimensional space an infinite number of planes."

To explain what he meant, Minkowski offered three mathematical diagrams to illustrate the properties of space and time in the theory of special relativity. Minkowski explicitly used a quadratic form from geometry to present a primitive model of spacetime near a given event taken as the origin of a four-dimensional coordinate system. This model displayed relativity of simultaneity through the geometric concept of a simultaneous hyperplane that depends on the velocity of the traveler through the event.

Minkowski's lecture with diagrams added a new dimension to the discussion of relativity. Einstein initially dismissed Minkowski's interpretation of his theory as "superfluous learnedness," but he later changed his mind and incorporated Minkowski's ideas to formulate his general theory of relativity.

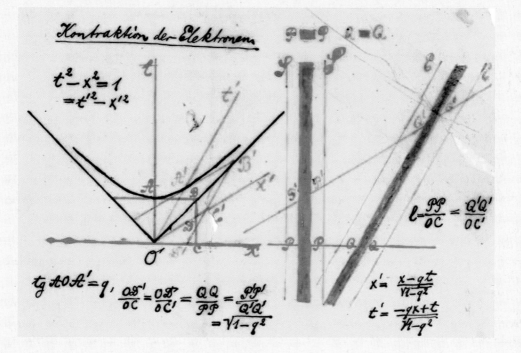

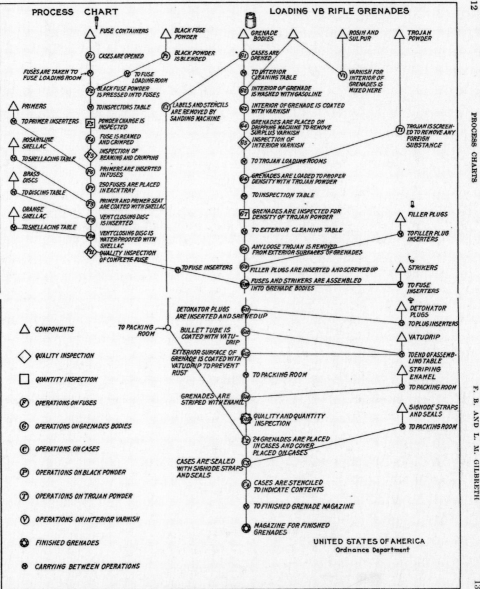

FIG. 5 PROCESS CHART FOR LOADING RIFLE GRENADES

Flow Chart

Frank Gilbreth and Lillian Moller Gilbreth

As part of their advocacy of scientific management, a married American couple who were conducting an early time-and-motion study developed a new visual tool for documenting workflow—the flow process chart or flow chart, which soon became a common diagramming device for businesses, military units, and other complex organizations.

Frank Bunker Gilbreth, Sr. (1868–1924) had no formal education beyond high school, but he evolved into a highly regarded consultant on business management. He often collaborated on scientific management studies with his wife, Lillian Evelyn Moller Gilbreth (1878–1972), who was an industrial engineer and psychologist known as a pioneer in industrial psychology. Together they studied the work habits of manufacturing and clerical employees in an effort to develop increased productivity and make their jobs easier.

While conducting time and motion studies designed to improve worker efficiency, the Gilbreths devised a new diagrammatic tool for mapping process flow on the job. They would observe a physical process, such as assembly-line labor in an industrial plant, and carefully record each worker's every motion or action in an effort to accurately document the work process. The Gilbreths utilized a number of elementary graphic symbols to indicate the process in a time sequence, marking such endpoints as start and finish; they also broke down the work process into common steps and decision points (often depicted in boxes), and used arrows and other standard symbols to indicate the sequence of actions and flow of work. The Gilbreths often utilized these flow process charts in their management consultant reports to document the decision-making process. In December of 1921, the couple explained their purpose in a speech they gave to the American Society of Mechanical Engineers under the title "Process Charts, First Steps in Finding the One Best Way to Do Work," which made their invention public. "The Process Chart," they said, "is a device for visualizing a process as a means of improving it. Every detail of a process is more or less affected by every other detail; therefore the entire process must be presented in such a form that it can be visualized all at once before any changes are made in any of its subdivisions."

Within a few years, flow process charts were being regularly employed by management consultants, business professors, and other professionals to map work flow and other complex actions. In the computer age, the technique was adapted to chart data flow.

{
OPPOSITE: A sample spread from the handout that accompanied the Gilbreths' presentation on "process charts." Their innovative method for presenting workflow is now commonly used in businesses, military units, and other organisations around the world.
}

Id, Ego, Super-Ego

Sigmund Freud

Freud's diagram of the organization of the human psyche suggests that personality is composed of three elements: the id (the set of uncoordinated instinctual trends); the ego (the organized, realistic part); and the super-ego (the critical and moralizing role).

After writing *Jenseits des Lustprinzips* (*Beyond the Pleasure Principle*) in 1920, the Viennese psychoanalyst Sigmund Freud (1856–1939) focused his attention on developing another groundbreaking work. He wanted it to be the most detailed analysis of mental structure and functioning yet offered. Although in his mid-60s, Freud the theorist worked tirelessly at his task, stoking one cigar after another in his book-lined study.

The outlines of the theory were already taking shape in his mind. He was conceptualizing a conflict between forces he would call the "I" and the "It." In a letter dated April 17, 1921 to his fellow analyst Georg Groddeck, Freud illustrated his tentative new view of the "I" with a suggestive little diagram of mental structure, and commented, "The 'I' is in its depths also deeply unconscious and still flows together with the core of the repressed." Two years later he inserted a revised version of this sketch in the published work, *Das Ich und das Es* (*The Ego and the Id*). The ego, the id and the super-ego were not the German terms that Freud had used in his diagram; in fact, they were later latinized by his translator,

James Strachey. Freud himself wrote of "das Es," "das Ich," and "das Über-Ich"—respectively, "the It," "the I," and the "Over-I" (or "I above").

Freud's diagram of his theory shows these three main structural parts of the psyche. The id is present at birth and thinks in visual and irrational terms. Part of the id later differentiates into the ego. This is secondary process thinking. The last structure to develop is the superego (the conscience), which is the result of the resolution of the Oedipal complex, and the internal representation of parental and societal values. The psyche is also structured into conscious, preconscious, and unconscious layers. According to this model, the partition of the psyche cuts across the topographical model's partition of "conscious" versus "unconscious." "The ego," he wrote, "is not sharply separated from the id; its lower portion merges into it... But the repressed merges into the id as well, and is merely a part of it. The repressed is only cut off sharply from the ego by the resistances of repression; it can communicate with the ego through the id."

Freud's paradigm helped to provide structure for his complex theories of psychoanalysis.

{ OPPOSITE: *Freud's evolving vision of the human psyche. Top left: an initial sketch (1921); top right and bottom left: German and English publications of The Ego and the Id (1923); bottom right: from The Dissection of the Psychical Personality (1931).* }

J. L. BAIRD

2,006,124

TELEVISION APPARATUS

Original Filed Dec. 31, 1926

Fig.1.

Fig.2.

Fig.3.

INVENTOR

By John L. Baird.

Watson, Coit, Morse & Grindle,
ATTYS

Television

John Logie Baird

A Scottish engineer demonstrated his "Televisor" in 1926; his invention was the world's first practical television system.

In 1923, the Scottish engineer and entrepreneur John Logie Baird (1888–1946) began contemplating ways to send wireless images. Soon he was sketching diagrams for a series of mechanical video systems that could scan (and thus transmit and receive) moving images, and the following year he achieved his first transmissions of simple face shapes using mechanical television. On March 25, 1925, he held a small demonstration of "television" at the Selfridges department store on London's Oxford Street, but the moving pictures lacked adequate half-tones and only silhouettes were visible, so he kept at it. On October 2 Baird conducted a test at his laboratory in Soho. His test subject was a ventriloquist's dummy, "Stooky Bill," which was placed in front of the camera apparatus. "The image of the dummy's head formed itself on the screen with what appeared to me an almost unbelievable clarity," Baird later recalled. "I had got it! I could scarcely believe my eyes and felt myself shaking with excitement."

After much discussion with his business associates, and further improvements, on January 26, 1926, Baird publicly demonstrated his new "Televisor" apparatus to members of the Royal Institution and a reporter for *The Times*. Baird's diagram of his new invention shows the transmitting apparatus on the left and the receiving apparatus at right. The system used a rotating mechanical disk with a series of holes in a spiral to break up the picture into areas to record and transmit. The information was transmitted using radio waves. At the receiver, the information is used to build up the image, which is observed through the holes of another rotating disc. Just as in the laboratory experiment, the image was transmitted to the portable receiver in another room, where it was clearly visible—the moving head of a ventriloquist's doll. More diagrams of his invention appeared in newspapers throughout the world.

Baird went on to devise many other important inventions, including early versions of color television, the video disc, large screen television, stereo television, televised sports, pay television by closed circuit, radar and many others. But his most famous was television.

ABOVE: *Baird's camera apparatus and his test subject, the ventriloquist's dummy, "Stooky Bill."*

OPPOSITE: *Baird's "Television Apparatus" patent was filed on December 31, 1926. Between 1925 and 1926, Baird's mechanical scanning television system had progressed from transmitting crude silhouetted shapes to recognizable faces.*

Nazi Propaganda Map

Rupert von Schumacher

After a young Austrian aristocrat and cartographer developed the notion of a "suggestive map" to sway public opinion, the Nazis put it to use as a propagandistic tool to justify their imperialistic aims.

Karl Ernst Haushofer (1869–1946) was a German general, geographer, and political scientist who became a leading voice for the expansionist ideology of *geopolitik* after his country's defeat in the First World War. Some of his ideas, such as the strategy and justifications for *lebensraum* ("breathing room"), influenced one of his students, Rudolf Hess, who in turn passed them on to Adolf Hitler. Haushofer also spread his geopolitical thinking through books, articles, and magazines, including the influential monthly journal *Zeitschrift für Geopolitik*, which supplied many arguments, buzz words and maps that would end up being adopted by the early Nazi regime.

In its November 1934 issue, *Zeitschrift für Geopolitik* published an article by a young Austrian aristocrat and cartographer, Rupert von Schumacher, who argued for the use of "suggestive maps" that were designed to persuade the general public using pictorial symbols and other techniques. His piece reflected *geopolitik* thinking in favor of Germany's rearmament and need for territorial expansion. Claiming that conventional maps showing the range of foreign air power had not proved very effective in rousing public opinion, von Schumacher proposed instead a more powerful design that gave the impression

that even a lesser state could destroy Germany using air power. Using pictorial symbols to convey his message, his map entitled "Ein Kleinstaat Bedroht Deutschland" ("A Minor State Threatens Germany") showed Germany's vulnerability to air attack from Czechoslovakia, even though that country's meager air force presented no such threat.

Over the next few years, the Nazis circulated the map through leaflets, books, articles, postcards and posters outside Germany in order to help sell the world on Germany's need for annexation of the Sudetenland and its seizure of Czechoslovakia.

Persuasive cartography became a regular feature of Nazi propaganda efforts in their pursuit of world conquest, due in part to the work of Haushofer and von Schumacher.

OPPOSITE: Not all maps tell the truth. This diagram ("A Small State Threatens Germany") shows how bomber aircraft from Czechoslovakia could reach all of Germany. In reality, the Czech air force did not posses any such aircraft.

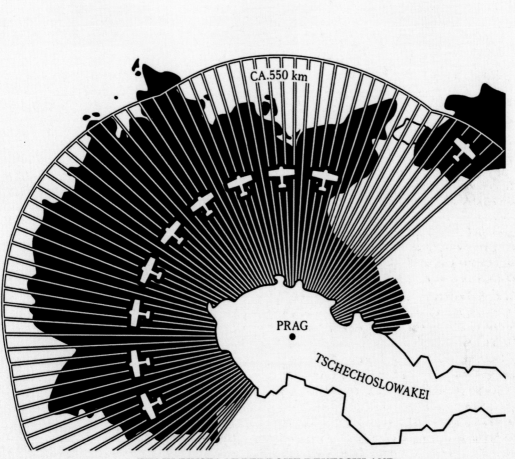

CA.550 km

PRAG

TSCHECHOSLOWAKEI

EIN KLEINSTAAT BEDROHT DEUTSCHLAND

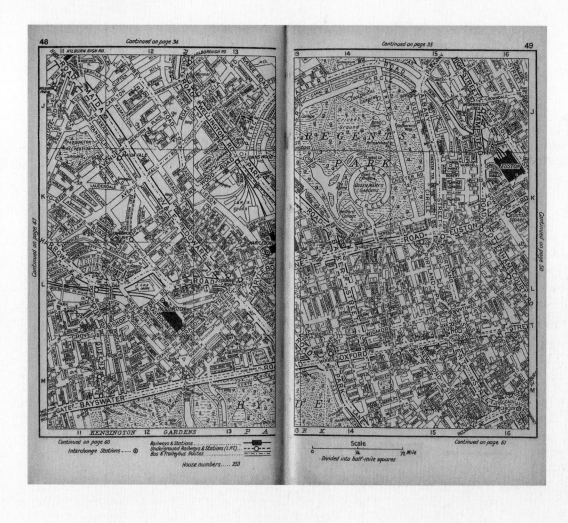

ABOVE: Pearsall worked 18-hour days and walked 3,000 miles to map the 23,000 streets of 1930s London. Pre-war editions of the A–Z give an unparalleled view of London's pre-Blitz layout.

London A–Z

Phyllis Pearsall

Covering every street of the city on foot, a fledgling artist and self-taught cartographer roamed London for a year to prepare a new type of street atlas, which has revolutionized the business of mapping cities and is still published today.

Phyllis Gross Pearsall (1906–96) was an impoverished young artist and freelance writer in London when her estranged father asked her to work for his struggling map company on Fleet Street. Soon she became immersed in every facet of map production, including drafting, printing, sales, and marketing, trying to learn by her own experience. One evening in the early 1930s, while on her way to a party, Pearsall became led astray by an Ordnance Survey map and was lost in a maze of unfamiliar city streets. After finally reaching the party, she began to conceive the idea of creating an accurate street atlas for London.

To achieve her goal, Pearsall began traveling systematically through each part of the city, visiting all of its 31 Borough Surveyors departments to collect mapping data that she added to her father's existing map books using tracing paper and ink. She also walked every street to hand plot the locations of any new byways and locations. Over the course of a year, Pearsall walked approximately 3,000 miles over 23,000 streets, collecting street names and house numbers, bus and tram routes, station locations, and other identifying information about key buildings, museums, and historical sites. She compiled the massive alphabetized street index on file cards. But in view of London's enormous size and growth into the suburbs, she opted to divide the work into different coded sections, all of which could be easily referenced. The city

is divided into rectangular zones, which are numbered and indexed with corresponding details. With help from her father's top map draughtsman, James Duncan, she acted as its researcher, designer, printer, and distributor.

The first copies were run off the press in 1936 as *A–Z Atlas and Guide to London*. It became a huge success, selling millions of copies over the years and establishing a new prototype that others have tried to replicate for additional cities and metropolitan areas across the globe.

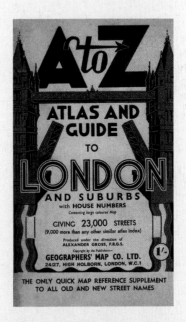

ABOVE: *Pearsall self published the first edition of her A–Z after failing to find a publisher.*

Cubism and Abstract Art

Alfred Barr

The founding director of the Museum of Modern Art charted the evolution of cubism and abstract art in an authoritative diagram that defined the canon of modern art in ways the general public could understand; the drawing itself also became an icon of the art world.

The scholarly art historian Alfred H. Barr, Jr. (1902–81) was appointed as first director of The Museum of Modern Art in New York City in 1929 and served as a leading promoter of the works of such great modernist painters as Van Gogh, Gauguin, Matisse, and Cézanne. In 1935 while preparing for a major exhibition on "Cubism and Abstract Art," he sought ways to define the new art form to the general public. Art lovers were familiar with cubism, which had been developed by Pablo Picasso and Georges Braque between 1907 and 1911 and continued to be highly influential, but the history and nature of modern art still had not been adequately explained.

To achieve this end, Barr drew a detailed diagram that traces the genealogy of modern art from 1890 to 1935, showing how it developed from Japanese prints, synthetism, and neo-impressionism, to fauvism, cubism and various strands of modern architecture. Using color to distinguish among internal (black) and external (red) influences in cubism and abstract art, it maps several nouns representing schools, artists, and places along with the various types of art (abstract impressionism, futurism, and so on) on a grid of time. Nouns vary in size in proportion to their artistic relevance. Paths of artistic influence are shown by 51 links (49 solid line-arrows and

two dotted arrows) which look more like a map of a battle skirmish than a geometric or scientific representation. The diagram delineates its complex interlocking movements. Surprisingly to many viewers, the only named artists who are included are six deceased greats. It also places modern art strictly within the context of its own artistic development, without seeking to place it in the cultural or political history of the time.

Barr's chart served as a guiding force for the organization of the exhibition; it also was used as a poster, catalog cover, and frequent reference throughout the display.

Barr's diagram stimulated discussion and helped to shape the way that modern art was viewed in the course of art history. The drawing became an icon and the diagram itself became an artifact and art object in its own right.

> OPPOSITE: *Barr's striking diagram highlighted the role that cubism had played in the development of modernism. Like the exhibition and book that accompanied it, Barr's diagram was a watershed in the history of 20th-century modernism.*

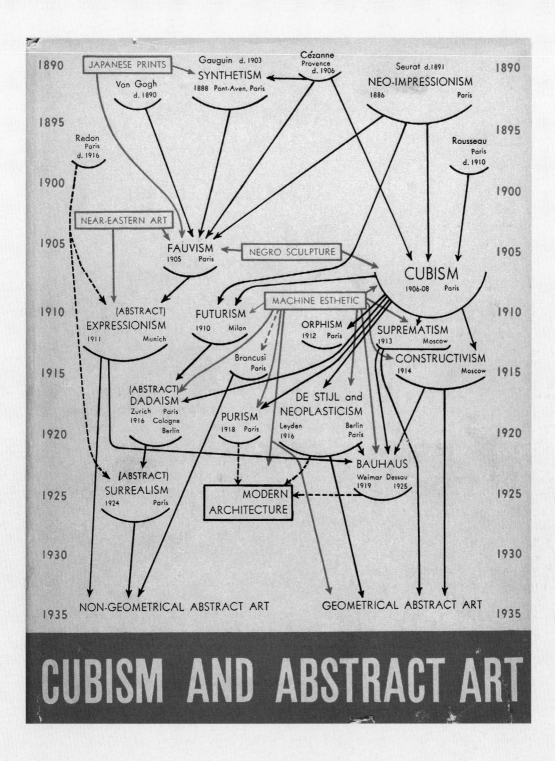

| 1890 | | | | 1890 |

JAPANESE PRINTS

Gauguin d. 1903
SYNTHETISM
1888 Pont-Aven, Paris

Cézanne
Provence
d. 1906

Seurat d.1891
NEO-IMPRESSIONISM
1886 Paris

Van Gogh
d. 1890

Redon
Paris
d. 1916

Rousseau
Paris
d. 1910

NEAR-EASTERN ART

FAUVISM
1905 Paris

NEGRO SCULPTURE

CUBISM
1906-08 Paris

(ABSTRACT)
EXPRESSIONISM
1911 Munich

FUTURISM
1910 Milan

MACHINE ESTHETIC

ORPHISM
1912 Paris

SUPREMATISM
1913 Moscow

CONSTRUCTIVISM
1914 Moscow

Brancusi
Paris

(ABSTRACT)
DADAISM
Zurich Paris
1916 Cologne
 Berlin

PURISM
1918 Paris

DE STIJL and
NEOPLASTICISM
Leyden Berlin
1916 Paris

BAUHAUS
Weimar Dessau
1919 1925

(ABSTRACT)
SURREALISM
1924 Paris

MODERN
ARCHITECTURE

NON-GEOMETRICAL ABSTRACT ART

GEOMETRICAL ABSTRACT ART

CUBISM AND ABSTRACT ART

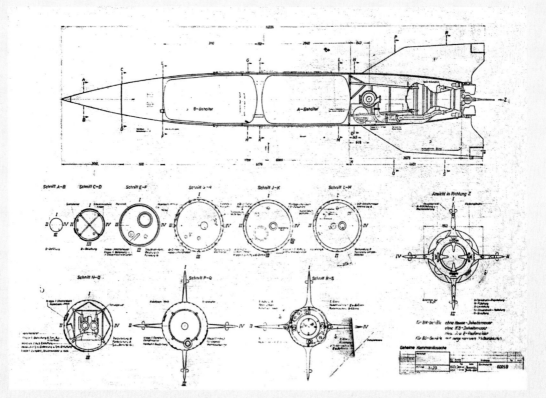

ABOVE: *A blueprint of the Vergeltungswaffe 2. The V2 was perhaps the only weapon system to have caused more deaths by its production than its deployment. It was produced using a brutal concentration-camp system of slave labor.*

V2 Rocket

German Armed Forces

The culmination of thousands of scientific diagrams, Hitler's liquid-propellant rocket was the world's first long-range combat-ballistic missile and the first known human device to enter outer space.

In 1933 Wernher von Braun (1912–77) was a brilliant and driven young doctoral student in physics aerospace engineering at the University of Berlin when he was taken under the wing of the powerful Army artillery officer Walter Dornberger and awarded major funding to support his secret research on liquid-propelled rockets. Von Braun's rise to power within the Nazi military establishment quickly proved as meteoric as his rockets'. Over the next several years, he spearheaded top-secret military-related rocket research inside the Army Research Center at Peenemünde on the Baltic Sea.

In collaboration with the Luftwaffe, the Peenemünde group developed liquid-fuel rocket engines for aircraft and jet-assisted takeoffs. They also created the long-range Aggregat-4 (A4) ballistic missile and an anti-aircraft missile. Von Braun's team had invented the ultra-advanced technologies essential to the success of the A4: large liquid-fuel rocket engines, supersonic aerodynamics, gyroscopic guidance and rudders in jet control to name a few. As the diagrams indicate, each rocket contained a plethora of extraordinarily complex and superbly designed systems all working together in perfect unison.

On December 22, 1942, Adolf Hitler ordered the production of rockets as a "vengeance weapon" to target London, and their names were changed to the V1 and the V2. The German V-weapons (V2 and its predecessor the V1 "flying bomb") ended up costing $3 billion (wartime dollars), making the program more expensive than the Manhattan Project that produced the atomic bomb ($1.9 billion). It consumed vast portions of Germany's scarce vital resources. A total of 6,048 V2s were built and 3,225 were launched. The production program (Mittelwerk GmbH) also utilized a brutal concentration-camp system of slave labor, making the V2 perhaps the only weapon system to have caused more deaths by its production than

its deployment. Yet the V2 was a fearsome weapon. As the world's first ballistic missile, rising into the stratosphere before plunging down to the target, it travelled faster than the speed of sound, gave no warning before impact, no possibility of defense and there was no risk of attacking pilot and crew casualties.

Von Braun later claimed that his motivation had only been to explore outer space. After the war, he and many of the other German scientists involved in rocket development ended up working for their captors, the Americans or the Soviets. Many of the diagrams they had devised contributed to the arms race and the space race.

ABOVE: A sketch from the papers of Helmut Zoike, one of the engineers who worked on the V2.

Feynman Diagrams

Richard Feynman

A leading atomic scientist devised a pictorial scheme to help in simplifying lengthy calculations in one of the most complex areas of physics—quantum electrodynamics. In time, his indispensable diagrammatic technique revolutionized nearly every aspect of theoretical physics.

Richard Phillips Feynman (1918–88) was a Nobel Prize-winning American physicist known for his genius work in quantum electrodynamics (QED), path integral formulation of quantum mechanics, particle physics, nanotechnology, and other hard-to-comprehend areas of science. After working on the Manhattan Project that built the first atomic bombs, he became renowned for his ability to explain the most difficult concepts in theoretical physics in ways that could become more commonly understood.

While teaching at Cornell University, Feynman developed a pictorial representation scheme for the mathematical expressions governing the behavior of subatomic particles—an area of physics that had been regarded as impossibly incomprehensible and esoteric. Abandoning traditional approaches, he devised a practical method of diagramming the events in terms of particle interactions, such as the interactions between colliding electrons and positrons. In 1948 Feynman introduced his diagramming method at an exclusive gathering of top theoretical physicists that was held at a motel in Pennsylvania's Pocono mountains, attempting to demonstrate how a simple diagram could provide a shorthand for a uniquely associated mathematical description in quantum electrodynamics. At first his method was not fully understood, even by his most brilliant peers. But in time, one of Feynman's associates, Freeman Dyson, began exploring how the diagrams could be used; he even offered step-by-step instructions for how the diagrams should be drawn and how to translate each piece into an accompanying mathematical expression. Soon the diagrams gained adherents throughout the fields of nuclear and particle physics as well; they were also used for solving many-body problems in solid-state theory and gravitational physics.

By using lines and symbols in a highly abstract way, so-called Feynman diagrams enable physicists to understand complicated events that otherwise would have taken weeks to calculate. It was not until the diagrams had been used for decades that physicists got around to analyzing the nodes of the Feynman diagrams more closely. What they found surprised them: the diagrams' resulting predictions have proved remarkably accurate. Like computer-enabled computation, Feynman diagrams have given physicists a powerful tool to calculate things that they never before dreamed possible.

*OPPOSITE: **The first published Feynman diagram (above) shows two electrons exchanging a virtual photon. Feynman's diagrams illustrate particle interactions schematically while also representing terms in particle physics equations. A 2005 USA stamp (below) commemorating Feynman.***

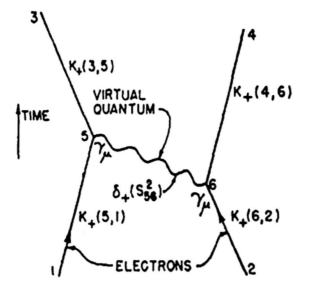

FIG. 1. The fundamental interaction Eq. (4). Exchange of one quantum between two electrons.

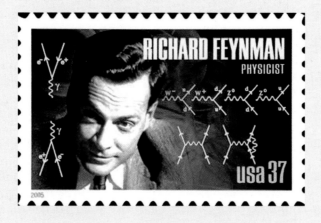

equipment, and to Dr. G. E. R. Deacon and the captain and officers of R.R.S. *Discovery II* for their part in making the observations.

[1] Young, F. B., Gerrard, H., and Jevons, W., *Phil. Mag.*, **40**, 149 (1920).
[2] Longuet-Higgins, M. S., *Mon. Not. Roy. Astro. Soc., Geophys. Supp.*, **5**, 285 (1949).
[3] Von Arx, W. S., Woods Hole Papers in Phys. Oceanog. Meteor., **11** (3) (1950).
[4] Ekman, V. W., *Arkiv. Mat. Astron. Fysik.* (Stockholm), **2** (11) (1905).

MOLECULAR STRUCTURE OF NUCLEIC ACIDS

A Structure for Deoxyribose Nucleic Acid

WE wish to suggest a structure for the salt of deoxyribose nucleic acid (D.N.A.). This structure has novel features which are of considerable biological interest.

A structure for nucleic acid has already been proposed by Pauling and Corey[1]. They kindly made their manuscript available to us in advance of publication. Their model consists of three inter-twined chains, with the phosphates near the fibre axis, and the bases on the outside. In our opinion, this structure is unsatisfactory for two reasons : (1) We believe that the material which gives the X-ray diagrams is the salt, not the free acid. Without the acidic hydrogen atoms it is not clear what forces would hold the structure together, especially as the negatively charged phosphates near the axis will repel each other. (2) Some of the van der Waals distances appear to be too small.

Another three-chain structure has also been suggested by Fraser (in the press). In his model the phosphates are on the outside and the bases on the inside, linked together by hydrogen bonds. This structure as described is rather ill-defined, and for this reason we shall not comment on it.

We wish to put forward a radically different structure for the salt of deoxyribose nucleic acid. This structure has two helical chains each coiled round the same axis (see diagram). We have made the usual chemical assumptions, namely, that each chain consists of phosphate di-ester groups joining β-D-deoxyribofuranose residues with 3',5' linkages. The two chains (but not their bases) are related by a dyad perpendicular to the fibre axis. Both chains follow right-handed helices, but owing to the dyad the sequences of the atoms in the two chains run in opposite directions. Each chain loosely resembles Furberg's[2] model No. 1; that is, the bases are on the inside of the helix and the phosphates on the outside. The configuration of the sugar and the atoms near it is close to Furberg's 'standard configuration', the sugar being roughly perpendicular to the attached base. There

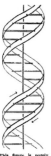

This figure is purely diagrammatic. The two ribbons symbolize the two phosphate—sugar chains, and the horizontal rods the pairs of bases holding the chains together. The vertical line marks the fibre axis

is a residue on each chain every 3·4 A. in the z-direction. We have assumed an angle of 36° between adjacent residues in the same chain, so that the structure repeats after 10 residues on each chain, that is, after 34 A. The distance of a phosphorus atom from the fibre axis is 10 A. As the phosphates are on the outside, cations have easy access to them.

The structure is an open one, and its water content is rather high. At lower water contents we would expect the bases to tilt so that the structure could become more compact.

The novel feature of the structure is the manner in which the two chains are held together by the purine and pyrimidine bases. The planes of the bases are perpendicular to the fibre axis. They are joined together in pairs, a single base from one chain being hydrogen-bonded to a single base from the other chain, so that the two lie side by side with identical z-co-ordinates. One of the pair must be a purine and the other a pyrimidine for bonding to occur. The hydrogen bonds are made as follows : purine position 1 to pyrimidine position 1; purine position 6 to pyrimidine position 6.

If it is assumed that the bases only occur in the structure in the most plausible tautomeric forms (that is, with the keto rather than the enol configurations) it is found that only specific pairs of bases can bond together. These pairs are : adenine (purine) with thymine (pyrimidine), and guanine (purine) with cytosine (pyrimidine).

In other words, if an adenine forms one member of a pair, on either chain, then on these assumptions the other member must be thymine ; similarly for guanine and cytosine. The sequence of bases on a single chain does not appear to be restricted in any way. However, if only specific pairs of bases can be formed, it follows that if the sequence of bases on one chain is given, then the sequence on the other chain is automatically determined.

It has been found experimentally[3,4] that the ratio of the amounts of adenine to thymine, and the ratio of guanine to cytosine, are always very close to unity for deoxyribose nucleic acid.

It is probably impossible to build this structure with a ribose sugar in place of the deoxyribose, as the extra oxygen atom would make too close a van der Waals contact.

The previously published X-ray data[5,6] on deoxyribose nucleic acid are insufficient for a rigorous test of our structure. So far as we can tell, it is roughly compatible with the experimental data, but it must be regarded as unproved until it has been checked against more exact results. Some of these are given in the following communications. We were not aware of the details of the results presented there when we devised our structure, which rests mainly though not entirely on published experimental data and stereo-chemical arguments.

It has not escaped our notice that the specific pairing we have postulated immediately suggests a possible copying mechanism for the genetic material.

Full details of the structure, including the conditions assumed in building it, together with a set of co-ordinates for the atoms, will be published elsewhere.

We are much indebted to Dr. Jerry Donohue for constant advice and criticism, especially on inter-atomic distances. We have also been stimulated by a knowledge of the general nature of the unpublished experimental results and ideas of Dr. M. H. F. Wilkins, Dr. R. E. Franklin and their co-workers at

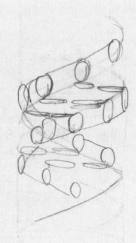

ABOVE: Francis Crick's initial sketch of DNA structure.

ABOVE: Odile Crick's diagram as published in the April 25, 1953 issue of Nature. Most experts have regarded Odile Crick's diagram as accurately portraying the spacing of the helixes and the locations of the nucleic acids.

DNA Double Helix

James Watson, Francis Crick, and Odile Crick

During a frenzied race to answer the biggest question in biology—what is the structure of DNA, the building block of life?—two exhilarated geneticists called upon an accordion-playing portrait painter to draw the image of the double helix for their scientific journal article. Her sketch was not only accurate; it also became an iconic image.

In 1953 the geneticists James Watson (1928–) and Francis Crick (1916–2004) were grappling with the heady task of revealing to the world for the first time how the components of DNA (deoxyribonucleic acid) fit together in a double helix, as part of their soon-to-be-submitted article for the scientific journal *Nature*. Both knew they needed to include a black-and-white visual representation of DNA's structure, based on their mathematical analysis of a pattern of spots revealed by a process called X-ray crystallography. And they needed it now. Francis Crick drew a rough sketch of what he had in mind but it wasn't quite up to scratch.

So Crick discussed the matter with his wife, Odile (1920–2007), who was an artist whose paintings usually consisted of nude women, and he tried to impress upon her the historic importance of his discovery and the urgent need for a suitable illustration. She was used to having him come home and spout excited talk about his work, so she "thought nothing of it" and simply went about drawing the diagram of DNA for their paper.

The double helix consists of two chains of DNA spiraling in opposite directions, each made up of four types of chemical units that are linked together. Odile Crick's sketch appeared in the April 25, 1953 issue of *Nature* as part of the article, "Molecular Structure of Nucleic Acids—A Structure for Deoxyribose Nucleic Acid." The sensuous drawing was accompanied by the following caption: "This figure is purely diagrammatic. The two ribbons symbolize the two phosphate-sugar chains, and the horizontal rods the pairs of bases holding the chains together. The vertical line marks the fibre axis."

Most experts ever since have regarded Odile Crick's early sketch as accurately portraying the spacing of the helixes and the locations of the nucleic acids. It has been reproduced widely in textbooks and scientific articles and has become the symbol for molecular biology. Francis Crick and Watson were awarded the Nobel Prize for medicine in 1962 for what many biologists consider as the greatest scientific discovery of the 20th century.

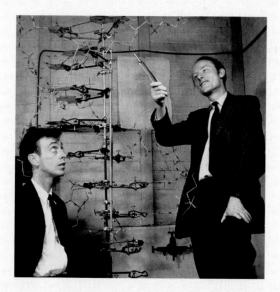

ABOVE: Watson (left) and Crick (right) with their DNA model. Odile Crick's diagram is on the wall behind.

Flat-Pack Furniture

Gillis Lundgren, IKEA

Upon discovering that a table he had built was too big to be delivered using his own car, a young Swedish carpenter drew plans for a disassembled version—and thereby inadvertently gave rise to the enormously successful industry of flat-pack furniture.

In 1956 Gillis Lundgren (1929–) was an ingenious young draughtsman living in the remote farming village of Älmhult, Sweden, when he designed and built a low coffee table for the local furniture dealer he was working for. Lundgren crafted the rich, veneered table easily enough, but he discovered that the object would not fit into the trunk of his Volvo PV 445 Duet Station Wagon. So he took off the legs, packed them in a flat box with the tabletop, and drove off. Lundgren's simple design for the Lovet table became IKEA's first successful mass-produced product.

IKEA's easy-to-follow assembly instructions are a central ingredient in the company's success. Clear line diagrams of the finished piece and all of its components are included along with graphic signs and symbols that allow the customer to build the piece of furniture with only a few basic tools.

This formula for manufacturing and distributing prefabricated furniture, known as "flat-packing," proved enormously successful, in part because it greatly facilitated the shipment and storage of pieces that otherwise took up much more space, thus avoiding considerable expense. The cost savings meant that consumers could purchase stylish new furniture at lower prices. IKEA expanded its approach into other products as well, making the company hugely successful and launching Kamprad to become one of the world's richest men.

Flatpacking also spawned its own aesthetic of simplicity and efficiency—concepts reflected in IKEA's whole design and marketing approach. The method has been adopted by innumerable other business enterprises, transforming the way that products are made and sold in the global marketplace. Due to IKEA's introduction of self-assembly furniture, today's customers are familiar with opening a flat package to find a disassembled product with an assembly diagram and instructions.

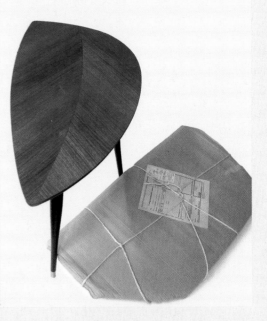

ABOVE: Lundgren's Lovet table, designed for IKEA in 1956, was the world's first flat-packed item of furniture.

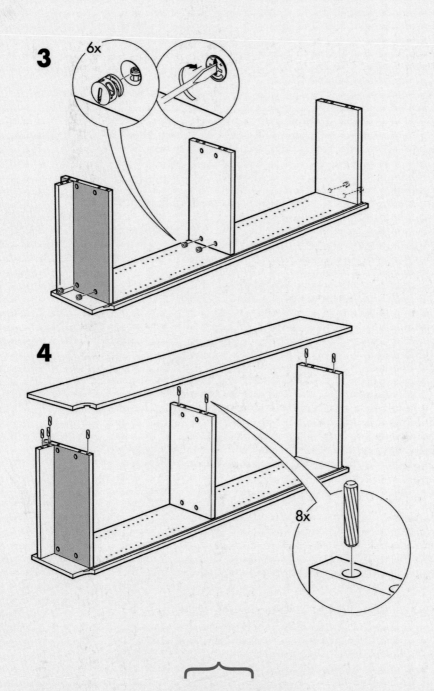

ABOVE: *Assembly instructions for IKEA's Billy bookcase, which Gillis Lundgren originally drew up on a napkin in 1979—"Ideas are perishable and you have to capture the moment as soon as it arrives." By 2009 IKEA had sold 41 million Billy bookcases. Today, one Billy bookcase is manufactured every four seconds.*

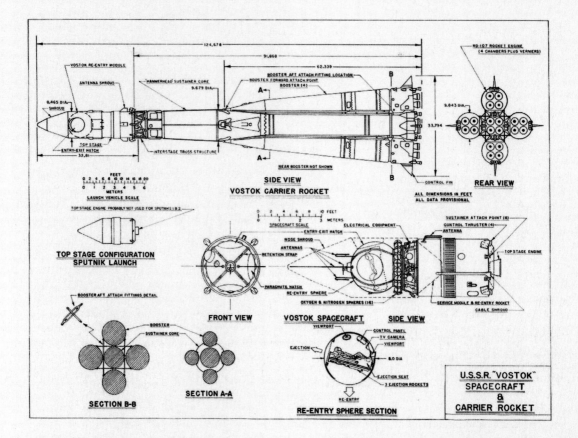

VOSTOK CARRIER ROCKET

SIDE VIEW

124.678

91.868

62.339

VOSTOR RE-ENTRY MODULE

ANTENNA SHROUD

8.465 DIA. SHROUD

TOP STAGE ENTRY-EXIT HATCH

32.81

HAMMERHEAD SUSTAINER CORE

9.679 DIA.

INTERSTAGE TRUSS STRUCTURE

BOOSTER AFT ATTACH FITTING LOCATION

BOOSTER FORWARD ATTACH POINT

BOOSTER (4)

NEAR BOOSTER NOT SHOWN

A-A

B

B

CONTROL FIN

ALL DIMENSIONS IN FEET
ALL DATA PROVISIONAL

RD-107 ROCKET ENGINE
(4 CHAMBERS PLUS VERNIERS)

9.843 DIA.

33.794

REAR VIEW

FEET
0 2 4 6 8 10 12 14 16 18 20

METERS
0 1 2 3 4 5 6

LAUNCH VEHICLE SCALE

TOP STAGE ENGINE PROBABLY NOT USED FOR SPUTNIKS 1 & 2

TOP STAGE CONFIGURATION
SPUTNIK LAUNCH

SPACECRAFT SCALE

1 2 3 4 5 6 8 10 FEET

0 1 2 3 METERS

ENTRY-EXIT HATCH

ELECTRICAL EQUIPMENT

NOSE SHROUD

ANTENNAS

RETENTION STRAP

PARACHUTE HATCH

RE-ENTRY SPHERE

OXYGEN & NITROGEN SPHERES (16)

SUSTAINER ATTACH POINT (8)

CONTROL THRUSTER (4)

ANTENNA

TOP STAGE ENGINE

SERVICE MODULE & RE-ENTRY ROCKET

CABLE SHROUD

FRONT VIEW

VOSTOK SPACECRAFT

SIDE VIEW

BOOSTER AFT ATTACH FITTINGS DETAIL

BOOSTER

SUSTAINER CORE

SECTION B-B

SECTION A-A

VIEWPORT

CONTROL PANEL

T.V. CAMERA

VIEWPORT

8.0 DIA

EJECTION

EJECTION SEAT

3 EJECTION ROCKETS

RE-ENTRY

RE-ENTRY SPHERE SECTION

U.S.S.R. "VOSTOK"
SPACECRAFT
&
CARRIER ROCKET

ABOVE: Vostok was designed by Experimental Design Bureau No. 1, headed by Sergei Korolev. Korolev's powerful design called for a two-module spacecraft. His diagrams show that the spherical "reentry apparatus" was meant to carry a single pilot in a spacesuit with sufficient life support for a 10-day flight in space.

Vostok 1

Sergei Korolev

A former Gulag prisoner designed the big booster and manned spacecraft that launched the first human into space.

Today, Sergei Pavlovich Korolev (1907–1966) is revered in Russia as the father of the Soviet space program—the person who created the first long-range ballistic missile, the first space launcher, the first artificial satellite, and put the first man in space. But his government did not always treat him well.

Born in the Ukraine, Korolev built his first glider at age 17, and in 1933 he designed and successfully launched Russia's first rocket-propelled manned aircraft. But in 1938 Korolev became ensnared in one of Josef Stalin's insane purges, and he was sentenced to 10 years' forced labor in the Kolyma mines. During the ordeal he suffered a broken jaw, lost most of his teeth, and had a heart attack, but he survived long enough to be conscripted into the war effort. The hard-working Korolev proved himself a dynamic force, quickly becoming deputy director of the Soviet rocket program even though he was technically still an inmate. Although not "fully rehabilitated," Korolev's relentless drive and enormous organizational abilities ensured his rise within Soviet rocket and missile circles. After Stalin's death, he was made a colonel in the Red Army and put in charge of captured German rocket engineers. His new assignment became that of developing a spacecraft to achieve manned flights at the earliest possible date. The name of the program he headed was called Vostok (the Russian word for east).

Bit by bit, Korolev copied and improved upon the Germans' intricate V2 design. Although the Americans enjoyed several advantages over their Soviet rivals, Korolev pushed his nation's rocket program to unparalleled heights, developing the first intercontinental missile and then launching the world's first satellite, Sputnik 1, in 1957. The space race was on.

In 1961, Soviet engineers guided by Korolev readied Vostok 1 on a 20-stories-high launch-pad. Korolev's powerful design for Vostok 1 called for a two-module spacecraft. His diagrams show that the spherical "reentry apparatus" was meant to carry a single pilot in a spacesuit with sufficient life support for a 10-day flight in space. A conical "instrument compartment" was connected to the sphere and contained various subsystems, such as the main engine to return the ship to Earth. Manned by the smiling cosmonaut Yuri Gagarin, and with Korolev at the command post in the Baikonur launching facility control bunker, Vostok 1 became the first human spaceflight in history, and the first time a person had orbited the Earth from outer space. The flight lasted one hour and 48 minutes. Korolev led the Soviet space program to other milestones as well. But his death in 1966 set back the Russians' cause in the space race, enabling the United States to become the first nation to put a manned spacecraft on the Moon.

Cuban Missile Crisis

Central Intelligence Agency

Analyzed and diagrammed photos taken by US spy planes showing the presence of Soviet nuclear missiles in Cuba sparked a major confrontation between the US and the Soviet Union that brought the world to the brink of nuclear war.

On October 14, 1962, a U2 spy plane piloted by US Air Force Major Richard S. Heyser of the 4080th Strategic Reconnaissance Wing flew over communist Cuba at about 70,000 ft (21,336 m) on a secret surveillance mission. The next day, analysts at the CIA's National Photographic Intelligence Center urgently reviewed 928 photographs taken by the craft in an effort to identify suspicious objects located at a construction site at San Cristóbal in western Cuba. The analysts also prepared captions and other indicators explaining their interpretation.

The shocking results were rushed to the Department of State and National Security Advisor McGeorge Bundy in the White House. Within hours, Bundy and Secretary of Defense Robert McNamara showed President John F. Kennedy the U2 photographs and briefed him on the CIA's analysis. The images were interpreted as the first photographic evidence of Soviet medium-range nuclear warhead missiles in Cuba—and potentially an act of war against the United States.

In response, President John F. Kennedy convened an emergency meeting of his top military advisors, starting what would soon become known as the Cuban Missile Crisis. Over the next two weeks, tensions between the United States and the Soviet Union reached their worst level in the Cold War. On October 22, President Kennedy delivered a nation-wide televised address announcing the discovery of the missiles; communiqués between the two super-powers and their allies also brought the world to the brink of nuclear war.

The public drama reached a high point on October 25, when America's United Nations Ambassador Adlai Stevenson confronted the Soviet ambassador at an emergency meeting of the United Nations Security Council. Stevenson unveiled poster-boards containing enlarged and grainy black-and-white photographs festooned with arrows and captions that he said constituted incontrovertible before-and-after evidence of Soviet missile installations in Cuba. As the world anxiously awaited what would happen next, images of the diagrams had a staggering effect on world opinion. Within a few days of the photos' display, Soviet premier Nikita Khrushchev agreed to remove the missiles in return for a secret commitment from the US to withdraw its own missiles from Turkey and to never invade Cuba again.

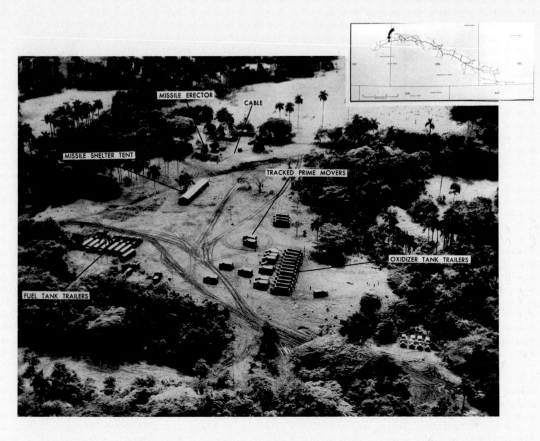

ABOVE: *One of the US Air Force photographs that was shown to John F. Kennedy. The photos were annotated and maps were added to help identify suspicious objects located at a construction site at San Cristóbal in western Cuba.*

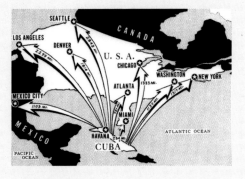

ABOVE: **This map from 1962 shows the distances of various US cities from Cuba's missile launch sites.**

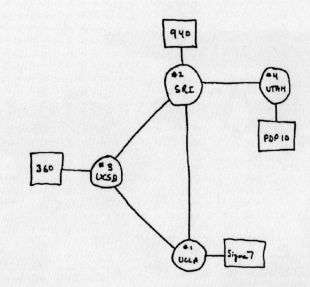

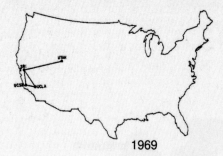

1969

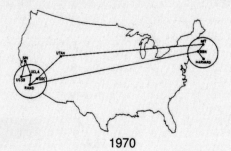

1970

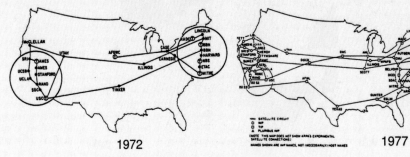

1972

1977

ARPANET

Bolt, Beranek, and Newman (BBN)

A research project funded by the US Defense Department to test new networking technologies started by linking computers at UCLA and Stanford Research Institute, then grew to four members, quickly becoming the precursor to the Internet and the World Wide Web.

In 1963, the director of behavioral sciences command and control research for the United States Department of Defense Advanced Research Projects Agency (ARPA), Joseph Carl Robnett Licklider (1915–1990), wrote memoranda and speeches in which he outlined his futuristic vision of an "intergalactic computer network" that would link computers across the globe and enable its users to quickly access data and programs from any site.

Licklider left the agency shortly thereafter. But by mid-1968, his successor at ARPA, Bob Taylor (1932–), had prepared a complete plan for a computer network called ARPANET, which was designed to be the world's first operational network utilizing the new concept of "packet switching" as opposed to the traditional telephone circuit method. After the agency solicited proposals from 140 potential bidders, in April 1969 the award went to the high-technology defense contractor Bolt, Beranek and Newman, Inc. of Cambridge, Massachusetts.

The first two nodes that formed the ARPANET involved computers at UCLA and the Stanford Research Institute. In keeping with Taylor's plan, the network was composed of small computers called Interface Message Processors (IMPs) that functioned as routers and performed store-and-forward packet switching functions. After the equipment was installed, the first host-to-host connection was made and at 10:30 PM on October 29, 1969 UCLA student programmer Charley Kline sent the first message on ARPANET from UCLA SDS Sigma 8 Host computer to SRI SDS 940 Host computer. The message he sent was "login," but the system crashed, only sending the first two letters. A new link was established on November 21, 1969.

A simply drawn ARPANET diagram from 1969 shows how the University of California at Santa Barbara and the University of Utah (with identifiers for each computer) were added to the network on December 5, 1969. All four nodes were connected by AT&T 50 kbps lines.

Starting in the 1970s and increasingly through the 1980s a variety of additional computer network methods began to emerge for commercial use. In 1990 ARPANET was totally shut down, replaced by a global system of interconnected computer networks known as the Internet. Today, the Internet has billions of users worldwide.

{ *OPPOSITE: This diagram from 1969 (above) shows all four nodes of the ARPANET network: UCLA, Stanford Research Institute, University of California at Santa Barbara, and the University of Utah. By 1977 (below) the network had reached London.* }

(1971)

Intel 4004 CPU

Ted Hoff, Stanley Mazor, Masatoshi Shima, Federico Faggin, Philip Tai, and Wayne Pickette

A multinational team of electronics wizards from the United States, Japan, and Italy collaborated to design the first commercially available microprocessor, which harnessed the latest silicon gate technology to achieve unprecedented speed.

In 1969 the Japanese calculator manufacturer Busicomp asked the Intel Corp. in California's Silicon Valley to design a set of semiconductor memory chips for a family of programmable electronic calculators. Brought together to work on the project were Masatoshi Shima (1943–), a Japanese electronics engineer, and Marcian Edward "Ted" Hoff, Jr. (1937–) and Stanley Mazor (1941–) of Intel. At first the collaborators had difficulty agreeing on the early design. But instead of following the initial plan for 12 custom chips, each of them assigned with a distinct task, the idea was eventually modified to reduce the number to four chips with a general-purpose logic device as its center, which could be programmed by instructions stored on a semiconductor memory chip—a microprocessor.

Wayne Pickette of Intel claims to have invented the principle of the computer on a chip, as noted in a diagram of September 8, 1971 that he drew up with Philip Tai for the 4004 demonstration board.

The innovation was made possible by major advances in transistor manufacturing, known as silicon gate technology, which had been spurred by the switch to self-aligned gates made from polycrystalline silicon rather than the former amorphous silicon. This new technology allowed for more transistors and greatly increased faster processing speed.

Once the chip set was agreed upon, the team hired a top chip designer and pioneer in silicon gate technology, Federico Faggin (1941–) of Italy, to transform the basic engineering design into silicon. Faggin did countless detailed diagrams (logic design, circuit design, chip layout, tester design and test program development) with help from Shima. Together the Intel team developed an architecture with over 2,300 transistors in an area of 0.1 x 0.2 in (3 x 4 mm), making the microprocessor the most complex mass-produced product ever made to that point.

The Intel 4004 CPU in November 1971 was hailed as a " micro-programmable computer on a chip," the progenitor of the microcomputer.

ABOVE: An Intel 4004 advertisement announces the "new era" of the micro computer chip.

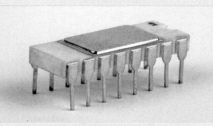

ABOVE: The Intel 4004 was the most complex mass-produced product ever made to that point.

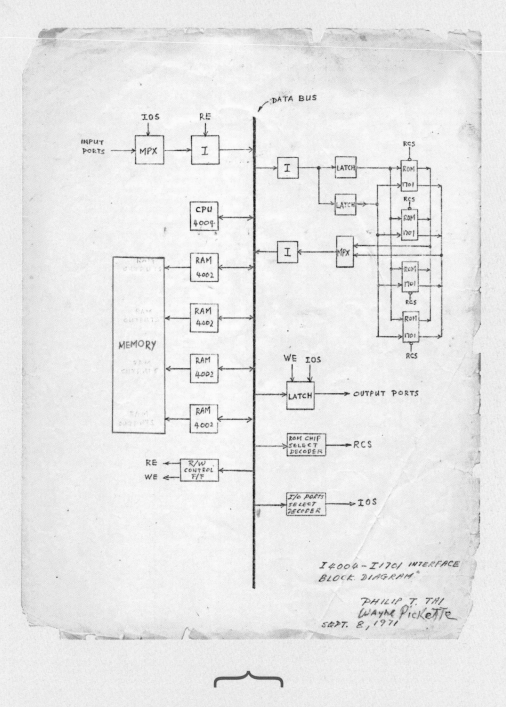

ABOVE: Wayne Pickette suggested that Intel could use a "computer on a board" for one of their projects with the Japanese company Busicom. Pickette drew this diagram with Philip Tai for the 4004 demonstration board.

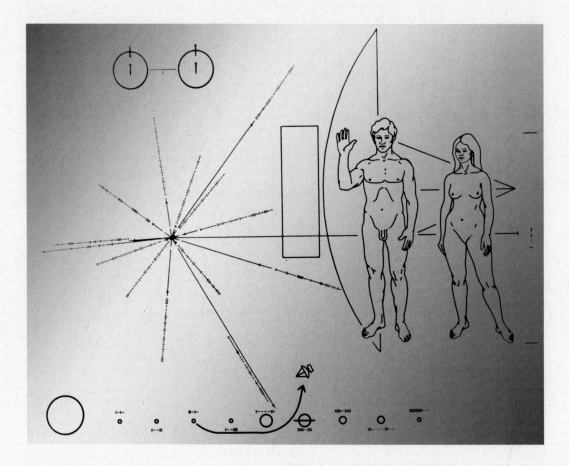

Pioneer Plaque

Carl Sagan, Frank Drake, and Linda Salzman Sagan

A metal plaque fixed to the first NASA spacecraft to leave this solar system contained a collection of carefully selected messages intended to provide advanced extraterrestrials with essential facts about the human race.

Before the National Aeronautics and Space Administration prepared to launch the first human-made object to another solar system, a consultant for the agency, Eric Burgess (1920–2005), hatched the exciting idea that the Pioneer probes should carry a message for extraterrestrial intelligences. Carl Sagan (1934–96), the well-known astronomer and popularizer of extraterrestrial contact, agreed to carry out the task and NASA gave him just three weeks to prepare a suitable message. Sagan teamed with his fellow pioneer in the search for extraterrestrials, the astronomer Dr. Frank Drake, to craft the design, and his wife, Linda Salzman Sagan (1940–) handled the artwork.

The result was etched into a gold-anodized aluminum plate measuring 6 x 9 x 0.05 in (15.25 x 22.8 x 0.127 cm) that was attached to the *Pioneer 10* spacecraft in a shielded position. This plaque is packed with vital information that is compressed into a few potent symbols. On the right side of the plaque is a line drawing of a naked human male and a human female standing in front of the Pioneer probe. The man's right hand is raised as a sign of good will and also to show his opposable thumb and indicate how he can move his limbs. A key to translating the plaque lies in understanding the breakdown of the most common element in the universe—hydrogen. This element is illustrated in the top left-hand corner of the plaque in schematic form showing the hyperfine transition of neutral atomic hydrogen.

The plaque also displays several other important clues designed to provide key information about the precise origin of the spacecraft. At the bottom of the plaque is a schematic diagram of our solar system. The spacecraft is also pictured along with its trajectory.

Launched with its message on March 2, 1972, *Pioneer 10* became the first spacecraft to cross the asteroid belt and fly past Jupiter. *Pioneer 11*, bearing a similar plaque, was launched on April 5, 1973 and last we knew it too is on its way out of our solar system.

{ OPPOSITE: *The Pioneer Plaque's diagrams communicate vital information about the human race. The plaque also aimed to provide advanced extraterrestrials with key information about the precise origin of the spacecraft it was attached to.* }

Mobile Phone

Martin Cooper / Motorola

Diagrams for the newly invented radio telephone system ushered in the wireless revolution of cell phones that were geared toward making phone calls to a person instead of a fixed land location. A federal regulator dubbed its inventor, Martin Cooper, as "the most influential person no one has ever heard of."

Martin Cooper (1928–) is an electrical engineer who went to work for Motorola, Inc. in 1954. During the 1960s, he specialized in developing portable products such as police walkie-talkies. In order to develop a radio telephone system, he needed a find a way to enable many different telephones to use the same band of radio frequencies without having them interfere with each other. Cooper solved the problem by using a system of "cells" which had been invented by Bell Labs in the 1960s. The idea was to place radio antennas around the city in a honeycomb pattern. Each antenna would serve only the small area, or cell, immediately around it, not the entire city.

In 1973 Cooper drew up the plans for an "organized radio telephone systems having a plurality of base station and portable unit, each having a predetermined coverage area, and means of adjusting the operating frequencies of the portable units to provide the optimum communications path." Among the nine diagrams he filed with the patent application, one features a honey-combed plan view of the organization of the radio telephone system of the invention, assuming uniform propagation and showing the allocation of frequencies to the various cells. Another represents a more detailed plan showing the division of some of the cells into subcells. The drawings include a plan view of the organization of a practical radio telephone system, showing the variation in spacing between the base stations and receiver sites encountered in a typical practical mixed urban and rural area.

While the company was still trying to persuade the Federal Communications Commission to allocate frequency space to private cellular communications vendors, on April 3, 1973, Cooper took his new technology to downtown Manhattan for a public demonstration. The handset, called a DynaTAC, was about the size of a brick, weighed 2.8 lbs (1.27 kg), and was capable of about 35 minutes of talk time. Standing near Rockefeller Center at Sixth Avenue and 53rd Street, Cooper called a landline located across the street and spoke with someone at the other end—all in the presence of a news reporter.

The DynaTAC was finally launched in 1983 with a whopping price tag of $4,000.

Today, over half the world's population has a mobile phone.

OPPOSITE: An overview diagram of Cooper's "Radio Telephone System" from his 1973 patent application. The handset, called a DynaTAC, was about the size of a brick, weighed 2.8 lbs (1.27 kg), and was capable of about 35 minutes of talk time.

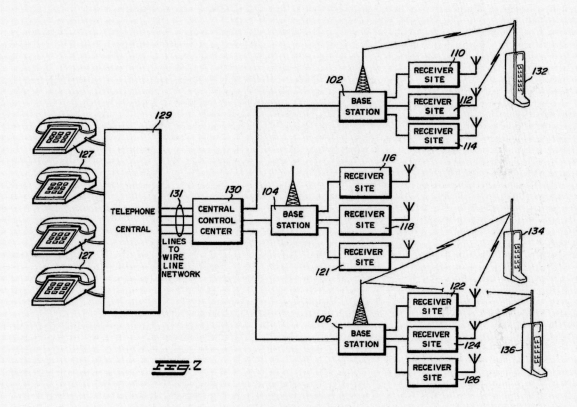

FIG. 2

Fig. 1

Fig. 2

ABOVE: *The drawings for Steve Jobs' first US patent convey the basic simplicity and intuitive ease of use that are Apple hallmarks. Patent 268,584 covers innovations introduced in Apple II and III.*

Apple Computer

By dramatically improving the ease of using the personal computer, Steve Jobs, Steve Wozniak and other members of the Apple team started the PC revolution. Jobs was only 25 when the first Apple Computer, Inc. patent was filed in 1980.

In the 1970s, a pair of young computer whizzes, Steven Paul Jobs (1955–2011) and Steve Wozniak (1950–), pooled their scant resources and started working together in a cramped garage in California's Silicon Valley to try and create their own line of computers. Wozniak hand-built the hardware, circuit boards, and operating system for their first product, a microcomputer. Forming Apple Computer Co. in 1976, they proceeded to market it as Apple I. Although it was just a hobbyist machine, and lacked several features that had to be provided by the user, the product sold enough units at $666 apiece to launch their venture. Today, some of Wozniak's intricate signed schematics, which he handed out for free to friends and admirers, turn up on eBay and other sites at hefty prices.

In 1977 Jobs and Wozniak introduced their great breakthrough, Apple II, also designed and built by Wozniak. The "Wizard of Woz" had crafted the fully realized machine to be more like a home appliance rather than an imposing high-tech gadget. Its operation manual contained the computer's complete wiring diagram and listed the monitor software source. The lid popped off the beige plastic case to allow easy access to the computer's internals, including the logic board (motherboard) with

eight expansion slots and an array of random access memory (RAM) sockets that could hold up to 48 kilobytes worth of memory chips. In terms of ease of use, innovative features and expandability, the Apple II represented a major technological advancement. But it was really its user-friendly design and graphical display that made Apple a leader in the first decade of personal computing, becoming a huge commercial success and catapulting the company into an industry leader in personal computers.

In 1980 "Steve Jobs et al" filed for a patent for the ornamental design for a new personal computer, and D268,584 was issued on April 12, 1983. It became the Apple III. As shown in the patent drawings, the design conveyed a basic simplicity and intuitive ease of use that were Apple's hallmarks. The figures simply showed how the machine looked from different viewpoints, without describing the invention's inner workings. Unlike its predecessors, however, Apple III had been designed by a committee of engineers and marketers, and it proved to be an engineering and commercial failure that prompted the company to eventually reevaluate their plan to phase out the more reliable Apple II.

ABOVE: Apple III (left); Apple I (above); Apple II (right).

Chernobyl Radioactive Fallout Map

Before the Soviet state would admit that anything had gone wrong at the Chernobyl nuclear power station near Kiev, monitors around the world started registering big spikes in radiation spreading over other countries. Scientists' innovative contamination-maps offered graphic proof of the world's worst nuclear disaster and sounded alarms that are still buzzing.

On April 26, 1986 radiation monitoring stations across the globe began detecting dangerous and growing radioactive emissions emanating from Soviet Ukraine. It took almost three days before the Soviet propaganda agency released a terse dispatch saying there had been a mishap at the Chernobyl nuclear power station.

In fact, an explosion at one of the plant's reactors had discharged huge levels of radioactive contaminates into the atmosphere for two days, setting off evacuation alarms in Sweden, 1,000 miles away. Within days of the explosion other countries of Scandinavia and Eastern Europe were also showing more than 100 times the normal background radiation. Chernobyl quickly became known as the worst nuclear accident in history. After an initial exodus of 50,000 persons from the vicinity of the damaged reactor, the number of evacuees eventually climbed to 400,000. Nobody believed the government's casualty reports. Scientists warned that some of the greatest longer-term dangers were posed by contamination of the soil and water by strontium-90 and caesium-137, which have half-lives of about 30 years.

Shortly after the explosion, a host of scientific and government organizations including IAEA, UNSCEAR,

UNEP, and US Livermore National Laboratory began efforts to determine radioactive fallout distribution levels using hydrometeorological data (wind direction, rainfall, etc.) for each subsequent day and emissions of fuel particles, aerosol particles, and radioactive gases from the destroyed reactor. They used this data to compile graphic time maps showing the shift of the radioactive clouds as they spread over the globe. The maps, reported in professional journals and later recycled through print and TV media outlets, reached hundreds of millions of people and alerted many to the dangers of nuclear power. Experts writing in the *International Journal of Cancer* in 2006 estimated the disaster might have caused 1,000 cases of thyroid cancer and 4,000 cases of other cancers in Europe, with totals that could rise to 16,000 and 25,000 respectively by 2065. However, a mega-study published by the New York Academy of Sciences in 2009 estimated that the radioactivity released between 1986 and 2004 might ultimately be responsible for 985,000 deaths.

OPPOSITE: *This stark diagram highlighted the real threat that Chernobyl's nuclear disaster posed to its neighboring countries. Scandinavia and Eastern Europe were showing more than 100 times their normal background radiation.*

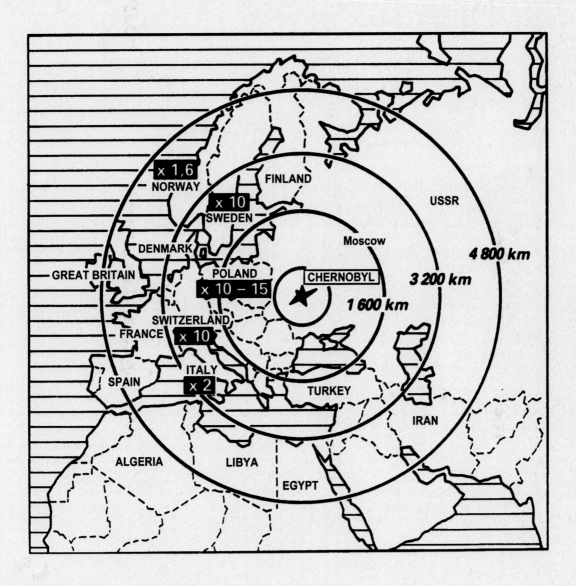

Vague but exciting ...

CERN DD/OC Tim Berners-Lee, CERN/DD

Information Management: A Proposal March 1989

Information Management: A Proposal

Abstract

This proposal concerns the management of general information about accelerators and experiments at CERN. It discusses the problems of loss of information about complex evolving systems and derives a solution based on a distributed hypertext sytstem.

Keywords: Hypertext, Computer conferencing, Document retrieval, Information management, Project control

World Wide Web

Tim Berners-Lee

A software consultant's proposal to his boss included a modest flow chart for a new kind of "mesh" information management system. After reading it, the supervisor wrote "Vague, but exciting" over the top and authorized him to proceed further. The diagram turned out to be a blueprint for the World Wide Web.

In March 1989, Tim Berners-Lee (1955–) was working as a software consultant at the sprawling European Organization for Nuclear Research (CERN), a world-class particle physics laboratory on the outskirts of Geneva, Switzerland. For several years, he had been trying to keep track of some of his organization's 800-plus scientists scattered in 60 countries with all of their many complex projects and woefully incompatible computers, and he dreamed of the day when the computers could all simply swap their information directly.

Sitting at his computer, Berners-Lee began developing the idea of a system that would enable researchers from remote sites around the world to organize and pool together information that they could all link to themselves. Documentation of a scientific and mathematical nature would become available as a "Mesh" (or web) of information held in electronic form on computers across the world. This web would simply be an application that ran on the Internet (the newly established global system of interconnected computer networks). In 1989, Berners-Lee put together a brief proposal to his boss in which he diagrammed his idea for a "Mesh" document-sharing system and explained how it might work. The schematic drawing included references to hypertext and hypermedia in the clouds. Its basic approach was to merge the evolving technologies of personal computers, computer networking and hypertext into a new, powerful and easy-to-use global information system.

The supervisor, Mike Sendall, was interested enough to authorize Berners-Lee to develop his idea with assistance from another colleague, a young student at CERN named Robert Cailliau. Together they prepared a revised version of the proposal in 1990. The pair built their first web site at CERN and put it online on August 6, 1991. From an estimated 130 web sites in June 1993, the number grew to 650,000 in January of 1997. By 2012 there were roughly 650 million active web sites.

In an article published in August of 1996, Berners-Lee wrote: "The World Wide Web was designed originally as an interactive world of shared information through which people could communicate with each other and with machines. Since its inception in 1989 it has grown initially as a medium for the broadcast of read-only material from heavily loaded corporate servers to the mass of Internet connected consumers." Within the space of just a few of years since he submitted his initial diagram, millions of users had begun surfing the World Wide Web.

OPPOSITE: Berners-Lee's proposal for the World Wide Web was presented to the European Organization for Nuclear Research in March 1989. His supervisor's handwritten note at the top is a master class in understatement: "Vague but exciting..."

iPod

Steve Jobs

After Apple CEO Steve Jobs ordered a bold new product developed on the fast track, the company assembled a team of engineers and designers who eight months later unveiled a slim, Mac-compatible widget with a 5 GB hard drive that put "1,000 songs in your pocket"—the sleek, minimalist and profoundly user-friendly iPod.

Prior to 2001, portable media players suffered from many limitations in terms of their quality and performance, with slow USB connections for downloading music from a PC, scant storage capacity, and little assistance in helping the listener navigate among the playlist; they were also clunky and unattractive in appearance.

Apple's design team sought to address all of these failures and more, aiming to create a package that would prove lucid and easy to use. Jonathan "Jony" Ive (1967–), Apple's vice president of Industrial Design and one of the world's top engineering designers, understood that it would be the product's usefulness, not technological features that would most determine its success or failure in the marketplace. He and his design team also strived to make the new device look and feel elegant, streamlined, and status-rich.

Ive's drawings, which accompanied the patent application, were a model of that usability and simplicity. The only text was as spare as the lines themselves: "FIG.

1 is a perspective view of a media player showing our new design," "FIG. 2 is a front elevational view thereof," and so on. In outward appearance, the unit's most unusual component was a two-inch-diameter thumb-wheel on the faceplate for scrolling through hierarchical menus on the six-line display. Aside from the standard headphone jack, there was only one other socket, for connecting the iPod to a computer via a special Firewire cable, which not only allowed high-speed transfers of digital files but also recharged the iPod's battery at the same time.

Sheathed in a classy and futuristic white and chrome exterior, the hermetically sealed stainless-steel and polycarbonate case contained a wealth of components: a five-gigabyte hard drive that could store the equivalent of about 100 CDs of music; a lithium-polymer battery that provided 10 hours of power between charges; and a host of other features. The new product went on the market in 2001 as the iPod, and went on to become Apple's biggest seller—one of the most popular and most appreciated products of the digital world of the early 21st century.

OPPOSITE: Apple's patent presented a package that was lucid and easy to use. The patent's drawings were a model of Apple's usability and simplicity. The iPod, which went on sale in 2001, has become one of the most successful products of the 21st century.

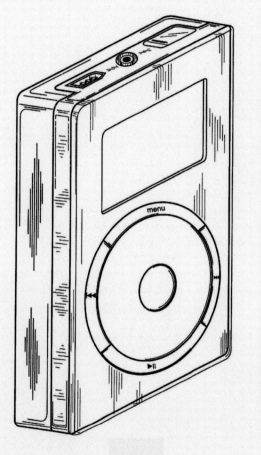
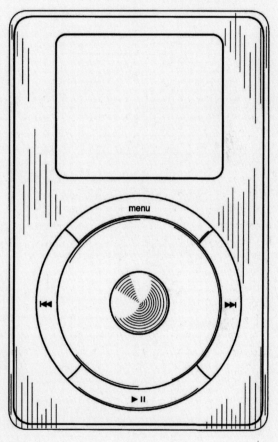

Index

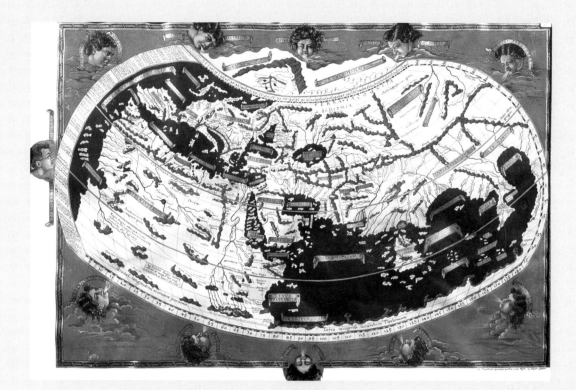

*ABOVE: **Ptolomy's World Map** (see page 42).*

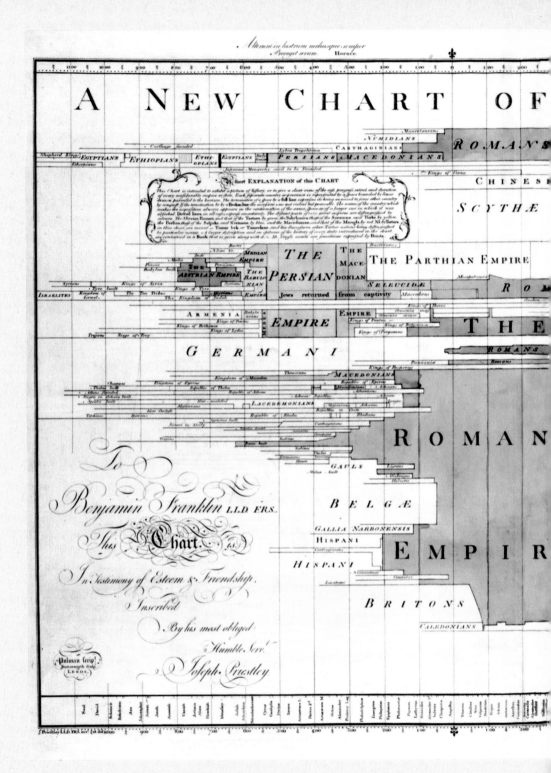

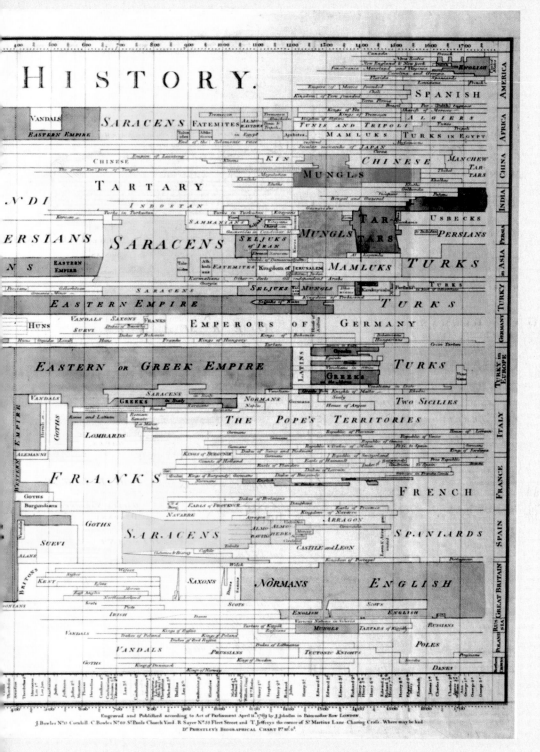

ABOVE: *A New Chart of History, Joseph Priestly (see page 116).*

Acknowledgements

I wish to thank the long line of creators responsible for the diagrams described in this work; also, the thousands of writers who introduced me to their amazing achievements. This is the fourth book I have done at the invitation of Frank Hopkinson, my publisher at Anova's Salamander Books, and it has always been an intense and enjoyable experience. Working once again with David Salmo, senior editor at Anova Books Group Ltd., has again proved quite delightful. And I am also beholden to my other talented editor on this side of the Pond, Kate Napolitano, of Plume Books. Some warm friends, Mary Anne Staniszewski and Mark Looney, helped to ease me through the rollercoaster ride of impossible deadlines. And of course, my always-supportive and ever-nurturing polymath spouse, Prof. Tamar Gordon of Rensselaer Polytechnic Institute, has once again added her incomparable voice to the song.

Picture Credits

All images are from Anova Image Library, except for the following:

A. Barrington Brown/Science Photo Library: 191
CERN: 210
Corbis: 34, 138, 179, 197 (top and bottom)
German Patent Office: 165
Geographers' A-Z Map Company Ltd. © Crown Copyright (reproduced by permission of Geographers' A-Z
 Map Company Ltd. © Crown Copyright. All rights reserved. Licence number 100017302.): 182
Geographers' A-Z Map Company Ltd (front cover image reproduced with the knowledge and permission
 of Geographers' A-Z Map Company Ltd - www.az.co.uk): 183
Getty Images: 9, 85, 18, 61, 93, 134–135, 149 (bottom), 209
IKEA Press Office (with thanks to Andrew Lim): 192, 193
Library of Congress: 71, 91, 102, 106 (bottom), 119, 130, 133 (bottom)
London Transport Museum © TfL from the London Transport Museum collection: 170
Mary Evans Picture Library: 110
Museum of Modern Art / Scala Archives, Florence: 185
NASA: 202
Nature Publishing Group: 190 (left)
Shutterstock: 17
UK Patent Office: 113
US Patent and Trademark Office: 126, 146, 152, 154, 168, 178, 205, 206, 213
Wayne D. Pickette: 201
Wellcome Library, London: 190 (right)

List of entries compiled and pictures researched by David Salmo of Anova Books.